E 93RD STREET

Jewish Museum

FIFTH AVENUE
MADISON AVENUE
PARK AVENUE
LEXINGTON AVENUE
THIRD AVENUE

Guggenheim Museum

Neue Galerie

E 85TH STREET

Metropolitan Museum of Art

DISCARD

UPPER EAST SIDE

E 79TH STREET

Gagosian Gallery

E 75TH STREET

Whitney Museum of American Art

Frick Collection

Asia Society Museum

E 70TH STREET

Americas Society

57 East 66th Street

E 65TH STREET

FIFTH AVENUE
MADISON AVENUE
PARK AVENUE
LEXINGTON AVENUE
THIRD AVENUE
SECOND AVENUE
FIRST AVENUE

53 East 59th Street

THE **ART LOVERS'** GUIDE

NEW YORK

MORGAN FALCONER

002000367510

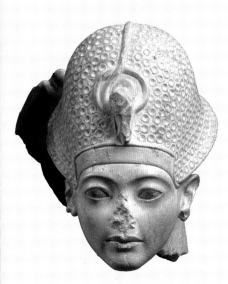

EARLY ART

THE WESTERN TRADITION

MODERN ART
128

REFERENCE SECTION

Whenever I spend a few days touring the galleries in one of the world's great cities, I invariably find myself sitting before a painting and wishing that I could lift another painting off the wall of another gallery nearby and hang it alongside. Perhaps I am at New York's Metropolitan Museum of Art, gazing at a Rembrandt self-portrait, and wish I could place beside it *The Polish Rider*, the picture that hangs in the Frick Collection a few blocks away, and that has so often been the subject of speculation – is it, or is it not, by the hand of Rembrandt? What was it that I learned about Dutch painting while I was looking at that mysterious image only a few days ago?

Traditional guidebooks offer little help. They leave the pictures hanging where they always hang. They whisk you through the museums and, as they move from gallery to gallery, so they slice up their commentary, leaping too hastily from Italian art to German to English. They never pause to consider how the objects on view compare with others elsewhere in the city, nor how they fit into the broader history of art. The purpose of this book is to help you build a deeper appreciation. We tour the city's galleries almost as if the walls have melted away and we are able to gather all the art together at once – all the Greek and Roman, all the modern and contemporary, and all the art of Asia, Africa and the Americas. If you are a connoisseur of French painting, the book directs you to everyone from Clouet to Corot. If you are an absolute beginner, it gives you an accessible introduction to the greatest art of the past 5,000 years.

The book looks in depth at individual museums, but in a way that sets the art on view in its proper history and context. If that history highlights a gap in a museum's collection, we show you where to go to fill it in. Maybe you have seen the acknowledged masters of Spanish painting at the Frick Collection and the Metropolitan but would like to be introduced to their peers. Why not visit the Hispanic Society? Or you enjoyed the small Korean gallery at the Metropolitan and want to see an even larger collection? Try the Brooklyn Museum.

Whether student, tourist, resident or culture addict, we all need to find time to immerse ourselves in history and culture, and this guidebook has been designed principally with this in mind. There are helpful maps and directories of galleries and artists, and the chapters devoted to artistic luminaries strongly associated with New York City – Edward Hopper, Jackson Pollock and Andy Warhol – reveal some of their old haunts. But the guide also serves as a general introduction to the history of art, one that will prove enriching whether or not you are visiting the galleries.

This is one of the reasons why it explores the museums' collections in their entirety. It is also why it does not linger on the favourite objects that are most often on show, nor plod about the galleries obediently following the prescribed routes – in any case, objects on view often change regularly. Unfortunately, you may not be able to find every artwork mentioned here on display in the galleries, as most museums do not have the space to permanently display all the riches they keep in storage. But it is hoped that by introducing you to particularly representative works, and by exploring their context, you will find a new appreciation not just for similar pieces that are on view, but for the whole history of art, in all its diversity.

AS A HISTORY OF ART

You can fetch it out from your bag as you stroll around the museums, or it can be read from end to end as a lively and accessible history of world art. It explores in depth the places and periods we regard as having experienced golden ages of art and culture, but it also explains what came before and after and looks at areas that have been unjustly neglected.

BY GENRE

The book is divided into three sections – Early Art, The Western Tradition and Modern Art – as well as a reference section. In the chapters on ancient art, seminal periods in the history of our civilisation are explored (sometimes also touching on how traditions established long ago have been interpreted by more contemporary artists). The chapters on the Western tradition are divided according to national schools, acknowledging the supreme importance of locality in shaping art in Europe between the Renaissance and the 19th century. Finally, the chapters on modern art take a more chronological perspective, looking at how styles and movements have been shared across the world over the past century or more.

AS AN IN-DEPTH GALLERY GUIDE

Each chapter has a section focusing on New York's largest or most spectacular collection of work in the relevant area. Several major pieces from the collection are illustrated with extended captions.

AS A SURVEY OF ALL PUBLIC COLLECTIONS OF GENRE OR PERIOD OF ART

After the in-depth guide to a single major collection, each chapter includes an illustrated section entitled See Also, which recommends other galleries and works that will expand one's

knowledge of the subject area. The only exception to this is in the chapter on Greek and Roman Art in which all that can be seen in New York is in the Metropolitan Museum.

BY LOCATION

A series of user-friendly maps help you locate the dozens of museums and galleries explored in the guide, offering you an itinerary for a day in the open air.

BY ARTIST

There are chapters devoted to three of New York's most acclaimed artists, Edward Hopper, Jackson Pollock and Andy Warhol, and also one on Picasso and Matisse, who are particularly well represented in the city's collections. At the back of the book there is also an Index of Artists, a complete directory of all the artists referenced in the guide, enabling you to shortcut to your favourites.

BY GALLERY

The Index of Museums & Galleries lists all the venues included in the main guide, with addresses and opening times, and enables you to quickly move to the relevant pages for each gallery.

EARLY ART

EGYPTIAN & NEAR EASTERN ART

Standing on a mound in Central Park, a little way from the **METROPOLITAN MUSEUM OF ART**, is an Egyptian obelisk that was originally erected in Heliopolis, around 1457 BC, by the Pharaoh Thutmose III. Sightseers sometimes look at its pitted, weather-beaten surface and chipped hieroglyphs, and marvel at its age. It is one of three so-called 'Cleopatra's Needles' that Egypt gifted to the cities of New York, London and Paris in the 19th century. Sadly, however, the obelisk has suffered more from a century of New York traffic pollution than it ever did in Egypt, and if you walk over to the Metropolitan, you will find relics of the ancient world that are a lot more delicate and yet in much better health. Most were put to rest in tombs thousands of years ago, and only saw daylight again when they were carefully removed from those same tombs by the Met's own archaeologists. History does not offer a safer passage than that.

New York is a remarkably good place to see ancient art. The **BROOKLYN MUSEUM** boasts impressive holdings of Egyptian art, and the Metropolitan's collection, which is among the museum's highlights, includes some 40,000 objects, most of which are on display, and which range in size from fragments of jewellery right up to the monumental Temple of Dendur, which sits in its own watery precinct.

Both museums established these collections in the early 20th century, at the culmination of an Egyptomania which was initiated over a century before by Napoleon's expedition to the region in 1798. Nineteenth-century Europeans came to believe that their civilisation had been passed down to them from the Egyptians, via the Greeks and Romans; and phenomena like the Cleopatra's Needles, and the foundation of huge collections of Egyptian art, no doubt solidified that impression.

But all this has obscured the almost equal importance of the ancient Near East in shaping us. Archaeologists missed the significance of it, in part because its culture was less coherent than that of the Egyptians. It encompasses a vast area of some 3 million square miles (7.77 million square kilometres) ranging from Turkey in the west to the Indus River in the east, and from the Caucasus Mountains in the north to the Gulf of Aden in the south. Throughout this region, various disparate cultures came and went over a long period, spanning from the eighth millennium BC to the 7th century AD, when Muslim armies conquered Mesopotamia, Iran and much of the Byzantine Empire. Nevertheless, despite the difficulty of comprehending Near Eastern culture, archaeologists have since come to appreciate that the ancient world indeed had two centres, one situated on the Nile, the other in Mesopotamia, in the so-called Fertile Crescent that was watered by the Tigris and Euphrates. Both these regions had for millennia been sparsely inhabited by farmers. However, suddenly, between 3500 and 3000 BC, two important developments took place: the Egyptians united under a single divine king, and the Mesopotamians began to gather in cities. Writing was invented, copper replaced stone for making tools, new forms of government were devised, foreign trade flourished, religious beliefs became more sophisticated, and monumental architecture and sculpture were invented. Here lie the origins of our art and life.

The Temple of Dendur
Early Roman period (Egypt),
c 15 BC
BROOKLYN MUSEUM
The temple at Dendur was built by the Roman emperor Augustus after he occupied Egypt and Lower Nubia, in an attempt to placate the local population. It is dedicated to Isis, to whom Augustus himself can be seen making offerings in the relief decoration.

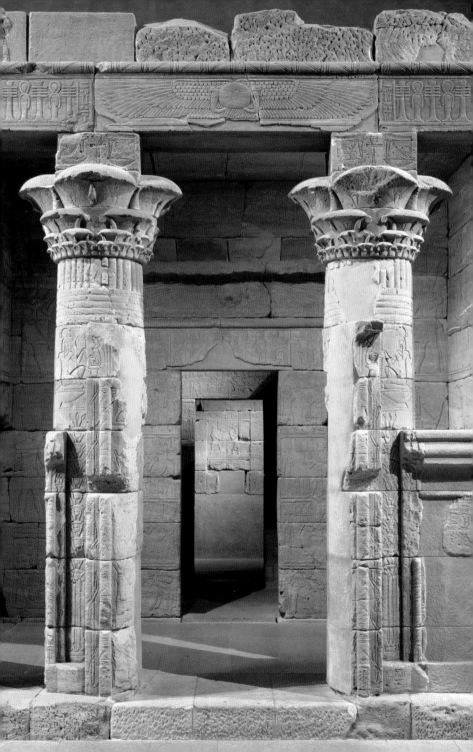

Navigating Egyptian art can be disorientating for anyone unfamiliar with the chronology of this ancient civilisation. It transports us to unfathomably long and distant eras. Tribes of nomadic farmers were moving about north Africa for millennia before they began to settle, and the characteristics of Egyptian culture started to take shape as early as the sixth millennium BC. But it was not until the second half of this Pre-dynastic period, particularly after 3500 BC, that some of the traits of Classical Egyptian civilisation began to emerge, and it is here that the Metropolitan's galleries pick up. Pottery, jewellery and tools are the most common remains of this period, and even in their rudimentary designs they suggest that many of the characteristics of Egyptian art as we understand it – rigid figures split into registers, formalised perspective – were established long before the arrival of the Pharaohs.

Archaeologists slice up the 3,000-year history of Pharaonic Egypt into eras that were recognised by the Egyptians themselves as high points (the Old Kingdom – the so-called Pyramid Age – and Middle and New Kingdoms) and low points (the Intermediate Periods, in which centralised government broke down). The Metropolitan's galleries follow the same scheme, and grappling with it can be difficult when, at first glance, so little seems to alter over that vast sweep of time. Egyptian art is extraordinary for its continuity: two millennia separate the statue of the fifth-dynasty king Shahura (c 2475 BC) from that of an official named Amenemopiemhat (c 664–610 BC), and yet they share the same rigidity and formality. Similarly, while the Temple of Dendur might seem as ancient as Shahura, in fact it was built far later by the Roman emperor Augustus. Having occupied Egypt and Lower Nubia, Augustus sought to placate the region's people by erecting this traditional cult temple, in which he is depicted making offerings to Egyptian gods.

Much remained the same in Egyptian art not because the society existed in a lifeless stasis, but simply because it was remarkably stable. In complete contrast to our modern outlook, the Egyptians saw only those things that endure as truly significant.

The lynchpin that ensured this stability was the Pharaoh. A quasi-divine figure, his myth ultimately derived from that of Osiris – who was said to be the primeval ruler of Egypt – and his son, Horus, who passed down the throne to the Pharaohs. When the kings died, they were said to join Osiris in divinity, and were hence worshipped themselves. The Metropolitan's collection is rich in imagery of the Pharaohs; in particular it has several statues of Hatshepsut, who reigned from around 1503–1483 BC, of whom perhaps more statues survive than of any other Pharaoh – not because she was, arguably, the most powerful woman ever to rule Egypt, but, ironically, because her nephew and

Panel with striding lion
Neo-Babylonian
(Mesopotamia),
c 604–562 BC
Nebuchadnezzar is best
known to us today as the
Babylonian ruler who
deported the Jews to Babylon
after the capture of
Jerusalem, but during his
reign he also transformed
Babylon with a programme of
building. This panel of glazed
bricks comes from the city's
Processional Way.

successor Thutmose III had all statues of her destroyed in an attempt to make his own temple the primary repository of the god Amun. When the Metropolitan's excavators began work on a site in Thebes in the 1920s, they just kept on finding more.

Egyptian beliefs about the afterlife are fascinating, and the Metropolitan's collection contains some wonderful insights. There is the coffin of Ukhotpe, a high-ranking official of the 12th dynasty (*c* 1991–1786 BC), which contains the texts of spells that were intended to lend him magical powers in the afterlife. Also on display is his mummified body, which was wrapped in bandages and shrouded in linen, his face covered with a funeral mask. Also remarkable are some of the models which were found in the tomb of Mekutra, a chancellor who served during the

11th dynasty (2133–1991 BC). Some feature minutely detailed houses with scenes of animals being butchered; others include boats that depict the tomb's incumbent being restfully ferried along (the Nile being the central fact of Egyptian life, they were unable to imagine an afterlife without it).

If the Egyptian arts suggest a society preoccupied with other worlds, then the arts of the ancient Near East reveal one very concerned with this one. Mesopotamia was the heart of the region, and it was here, during the fourth millennium BC, that cities first developed. The Metropolitan's collection includes some of the characteristic glazed tiles that adorned the city walls. One can also glimpse the elaborate commercial and legal structures of the period in the many stone seals they created. Generally taking the form of cylinders which were rolled rather than stamped, these

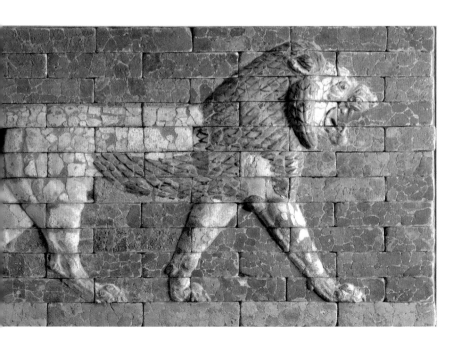

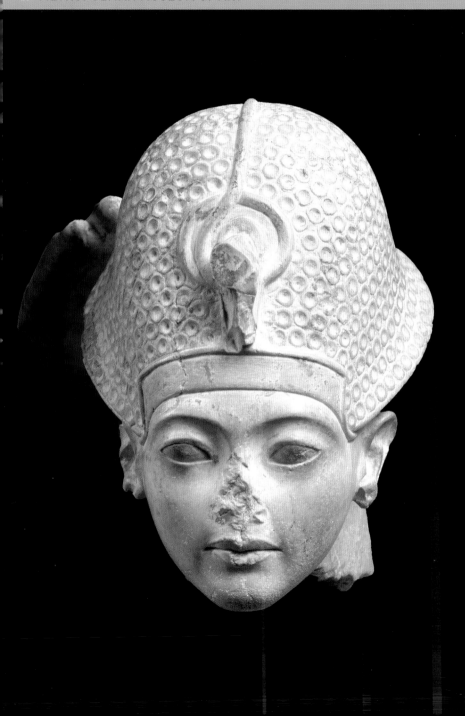

Tutankhamun wearing the Blue Crown
18th dynasty (Egypt),
c 1336–1327 BC
Tutankhamun married at the age of 9 or 10, ruled Egypt in his teenage years (c 1361–

1352 BC), and died before he was 20. He was buried with fabulous treasures, which were famously discovered in 1922. This head comes from a sculpture that remembers his coronation.

Human-headed winged lion
Neo-Assyrian (Nimrud, Mesopotamia),
c 883–859 BC
This lion was found in the ruins of the palace of the Assyrian king Assurnasirpal II. The creature's divinity is indicated by its horned cap. Its five legs are likely to serve a more formal than symbolic purpose: from the front, he seems imposing, from the side he appears to stride forth.

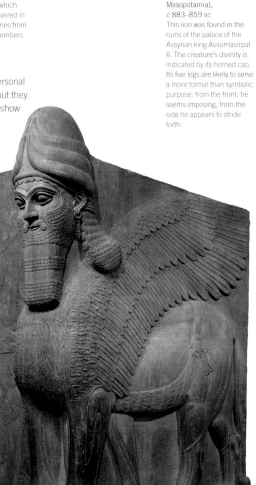

served a practical function in imprinting a personal seal on legal and commercial transactions; but they also had the character of charms, and often show divine figures or heroes battling animals.

A succession of local dynasties came and went in Mesopotamia, but they maintained a remarkably coherent style. Pattern and figurative designs are characteristic of their early pottery: look at the ovoid jar from Iran (c 3400–3100 BC), which is embellished with the profile of an ibex with huge arching horns, or perhaps at the Sumerian standing male figure (c 2750–2600 BC), a worshipper carved from gypsum in the rounded geometric forms that would remain characteristic of sculpture from the region.

The ancient Near East is also noted for its use of precious metals, and the Metropolitan's collections include a series of gold pendants that represent deities. Ancient Turkey, or Anatolia, had abundant reserves of ores, and one example of this region's output is a silver vessel in the form of a stag (c 1400–1200 BC), an object that is thought to have been used in religious ceremonies.

Ivory, which was taken from elephants west of Assyria, was also put to use, but craftsmen often used to cover the objects in gold leaf since it was prized more for the detail that could be worked into it than its inherent colour and texture. The gold has gone from most of the Metropolitan's ivories, but one can still appreciate their beauty in a plaque from the 8th century, carved in a typically Phoenician style, with griffins surrounded by lotuses and curving branches.

SEE ALSO

Portrait of a noblewoman
Roman, *c* 150
Rome ruled Egypt during the time this portrait was created, and the dress, hairstyle and jewellery of the woman reflect the fashions of the imperial court. Although remarkably lifelike, it is an idealised portrait, and would have been slipped into the wrappings of the mummy over the face of the deceased.

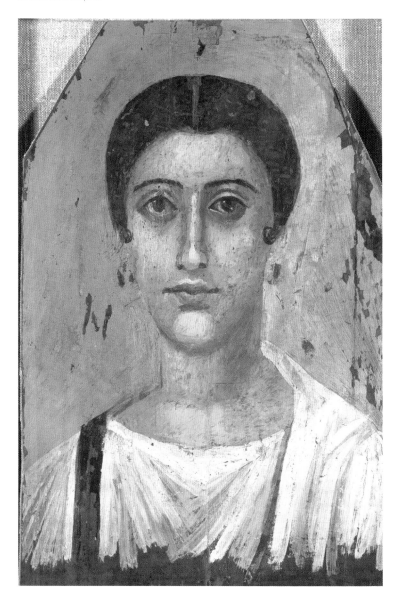

Female figurine
Naqada period (Egypt),
c 3650–3330 BC
BROOKLYN MUSEUM
A rare survival from the Pre-
dynastic period, scholars
have long speculated on the
significance of this figurine.

Is she a fertility symbol? Or is
she a dancer, or a servant?
Or possibly a god: size
mattered in Egyptian art, and
in comparison with similar
male figures, this creature
was clearly important.

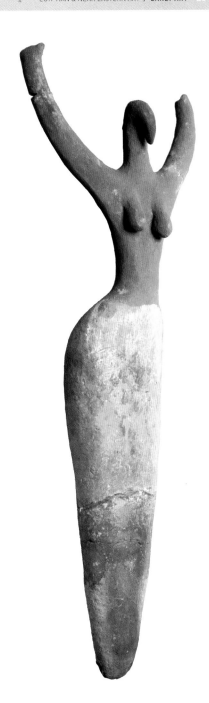

A 23-year-old English diplomat was sailing up the
Tigris, just north of Baghdad, in 1840, when he
spotted a strange mound on the banks of the river.
Unable to excavate it then and there, he vowed to
return, and when he did he uncovered the
remnants of the palace of King Ashurnasirpal II,
who reigned from 883–859 BC. The bulk of the
find consisted of massive carved alabaster panels
which originally adorned the king's palace, and
which show him engaged in various activities –
warfare, hunting, banqueting and so on. Cuneiform
script, which lends elegant texture to the panels,
informs us of his lineage and triumphs. The panels,
which are typical of the most complex and
elaborate arts in Mesopotamia, originally went to
the British Museum, but the find was so rich that
several were put on sale. The Metropolitan
Museum acquired a number of them, and the
installation that displays them forms a wonderfully
evocative entrance to their ancient Near Eastern
collections; but the **BROOKLYN MUSEUM** also
has several of the panels in its own collection.

Although Brooklyn's Near Eastern collections
are small, the impressive scale of its Egyptian
galleries and the beauty of their treasures will draw
you in: Brooklyn has always treated Egyptian art
less as a matter of ethnographic interest than as a
matter of aesthetics – of art itself. Hence, while the
origins of many of the objects in the collection are
sometimes sketchier than at the Met, the sheer
beauty of the pieces on show makes up for this. The
museum does have strengths in particular
areas. One is the Pre-dynastic period, from which
comes its famous 'bird-woman', her arms arched
up as if in flight. Also notable is the head of a lion
(*c* 3150–3050 BC), which, in the typical style of this
early period, is distilled down to the essentials of
the creature's powerful form. Lions were a feature
of life in the desert at this time, and the Egyptians
came to associate them with kingship, creating
statues in their image to stand guard at temples.

Brooklyn also has strengths in the royal
sculpture of the 6th dynasty (*c* 2245–2157 BC):

Hedgehog
Middle Kingdom, Second
Intermediate Period
(Deir el Nawahid, Egypt),
c 1938–1700 BC
BROOKLYN MUSEUM
The symbolic significance of
the hedgehog suggested
courage – perhaps because
of his tendency to wield his
spikes when approached.
But he also had other uses:
his spines were ground into
powder and mixed with oil to
form a remedy for baldness.

of six known royal sculptures from this era, three are in Brooklyn. Particularly outstanding is the statue of Pepy II and his mother. Pepy succeeded to the throne aged only six, and a document from the Old Kingdom claims that he reigned for 94 years (though most experts suspect that 64 is more likely). This sculpture, made perhaps in the early part of his reign, shows him at child's size, sat on his mother's lap; the piece still retains the stiff formality typical of Egyptian art, but Pepy's position, with his legs off to the side, is unusual in eschewing the conventional frontality.

Another era in which Brooklyn is strong is the so-called Amarna period, which falls late in the 18th dynasty (c 1540–1292 BC). Its distinctively vivid style is visible in *The Wilbour Plaque* (c 1352–1336 BC) which depicts, in sinuous lines, the profiles of a king and queen. Arguments rage over their identity, with most maintaining that they represent Akhenaten and his chief wife Queen Nefertiti; all agree that the 'cap crown' worn by the queen, which was normally reserved for kings, reflects the status of royal women in Amarna. Particularly proud of this piece, Brooklyn has also acquired other plaques like it, one of which shows a kiss between Nefertiti and Merytaten, her eldest daughter. This type of kiss, rarely depicted in Egyptian art, might have suggested Nefertiti conferring on her daughter life, power and legitimacy as a ruler. The long, stylised 'arm' that comes down towards them, holding an ankh, probably emanated from a solar disc, which would have appeared in an adjoining block.

The museum is also strong in its holdings of art from the later period, when Greek and Roman influence is evident in Egyptian art. This is unmistakable in the *Aphrodite Anadyomene*, sculpted in the beautiful turquoise ceramic, faience. Although the sculpture has a Greek

precedent, it is a product of the Roman Imperial period (around AD 150) and represents the goddess Aphrodite in the process of arranging her hair. Less obviously Greco-Roman, but stranger and more startling, is the coffin for an ibis, the long-legged wading creature; made of gilded wood, silver and gold, it is enlivened with rock crystal eyes. Produced some time between the Macedonian period and the Ptolemaic period (c 332–330 BC), it points to the contemporary practice of mummifying ibises to give as votive offerings to the god Thoth, who was represented as an ibis-headed man. Greek authorities claim that, for the Egyptians, it was a capital offence to kill an ibis, but if that was true it did not apply to temple personnel, whose job it was to create these mummies.

Just as the quality of the objects in Brooklyn's collection makes them appealing, so too does their oddity. Look, for instance, at the imagery of animals. Particularly enchanting is a tiny frog that dates from the reign of Amunhotep III, in the 18th dynasty (c 1390–1352 BC). Egypt was inundated with them every year when the floodwaters of the Nile receded, so the creatures became symbols of regenerating life, and were possibly given to expectant mothers as amulets of protection.

Or take the hippopotamus, a common motif in Egyptian art, and represented at the Metropolitan in a glazed and painted faience figurine from the late 12th or 13th dynasties (c 1878–1627/1606 BC). The Egyptians hunted the hippo for food, its ivory, and also to keep down the numbers of what was regarded as a pest. But the superstitious people also saw the animal as a symbol of chaos, and although they often placed figurines depicting them in tombs, as remembrances of earthly pursuits, they sometimes broke off the legs – as in the example at the Met – just in case they came alive and injured the deceased.

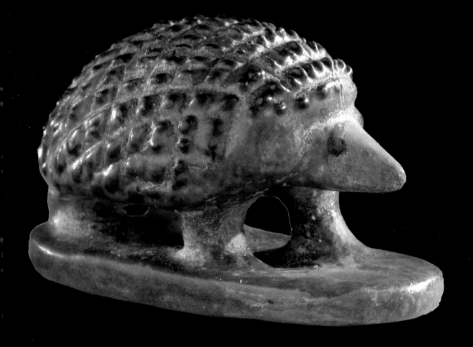

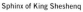

Sphinx of King Sheshenq
Third Intermediate period
(Egypt), *c* 945–718 BC
BROOKLYN MUSEUM
Although a sphinx is a union
of human and beast, it can
represent royalty as well as a
deity. On this creature's chest
are inscribed hieroglyphs
meaning 'good god', or
'perfect god', though
scholars are uncertain of the
exact identity of the king
represented.

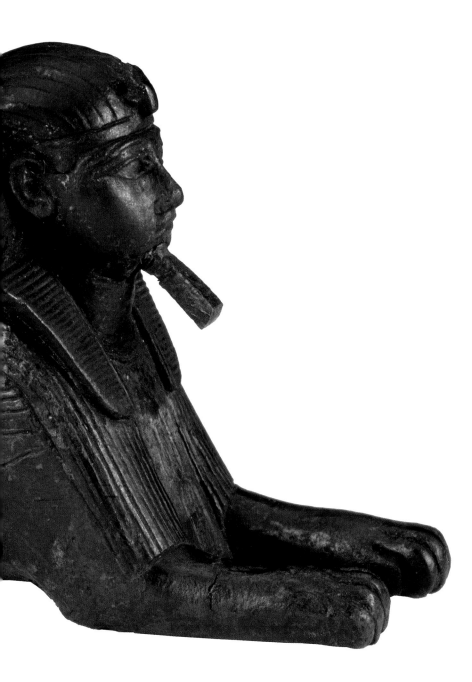

GREEK & ROMAN ART

A Roman sarcophagus was unearthed at Tarsus in southeast Turkey in 1863. Soon afterwards it was gifted to the **METROPOLITAN MUSEUM OF ART** in New York, and it required the strength of 16 buffalo to drag it to its port of departure. It was a foundation stone, of sorts, since it was the first object to be gifted to the museum, and it even served for a time as a donations box. That sarcophagus has now retired from its mendicant work, but one could say that it has passed on the task to its brethren in the Greek and Roman galleries, for the museum's collection of Classical art has always been one of its highlights, and since a dazzling renovation of its galleries was completed in 2007, it has become one of the most popular attractions at the museum.

The collection reveals the cultures of Greece and Rome in all their marvellous diversity, encompassing the formal and monumental (a hefty fragment of an Ionic column from the temple of Artemis at Sardis) to the minute and bizarre (a pair of eyes, replete with bronze eyelashes, which once lent colour to a Greek statue). Separate rooms focus on all the major periods in the development of Greek art, and they culminate in a light-filled courtyard where we see how Rome evolved its own forms, inspired by its humble admiration of the culture it conquered: as the Roman poet Horace put it, 'Captive Greece took her rude captor captive'. The design of the courtyard evokes the garden of a Roman villa and presents a modern democracy of the Roman gods, where Dionysus mingles with statues of muses and ordinary mortals. In the adjoining rooms you can enjoy the best collection of Roman painting outside Italy.

The Greek and Roman collections are magnificent, and yet they are just the backbone of the Metropolitan's collection of Classical art. It actually begins long before the Greeks, with the art of the prehistoric cultures that began to flourish in the eastern Mediterranean during the Neolithic period (c 6000–3200 BC). It also takes in the art of the Etruscans, who dominated northern and central Italy in the centuries before the rise of Rome, and whose culture blends indigenous Italic elements with the influence of Greece (do not miss the stunning chariot, embossed with scenes from the life of Achilles).

In an entirely different sequence of galleries, found on the second floor, you can explore the Classical art of ancient Cyprus, a country that absorbed the influence of all three powerful civilisations it bordered – the Near East, Egypt and Greece – and yet managed to maintain its own distinctive style. Cyprus may seem peripheral after the triumphs of Greece and Rome, but the Met has the best collection of the country's ancient art outside its borders.

Statuette of seated harp player
Cycladic, c 2800–2700 BC
METROPOLITAN MUSEUM
Although carved in the characteristic Cycladic medium of marble, this figure is unusual for its period in being both male and engaged in activity (most similar figures are motionless). Little is known about the original purpose of such figures, though most derive from burial sites.

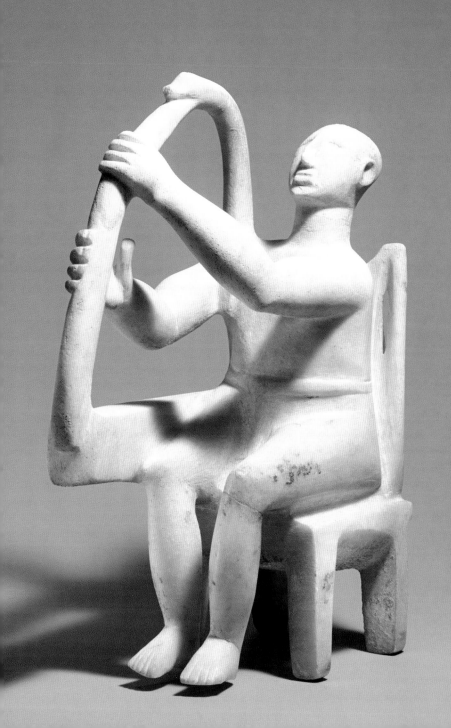

Marble stele (grave marker) of a youth and a little girl
Archaic, *c* 530 BC
This is the most complete example of a grave monument to have survived from the Archaic period. The youth, depicted as an athlete, has an oil flask hanging from his arm (for toning the body), and a pomegranate in his fingers (symbolic of both fruitfulness and death). The girl, perhaps his sister, holds a flower.

Visitors to New York who begin their tours of the city's galleries with the **MUSEUM OF MODERN ART (MoMA)** may get the strange sense of déjà vu when they arrive in the first rooms of the Metropolitan's Greek and Roman galleries, where the smooth, schematic forms of a female figure dating from around 2600–2400 BC are reminiscent of Alberto Giacometti (1901–66), or maybe Constantin Brancusi (1876–1957). They will see the harp player that dates from slightly earlier, his head realistically arched back as he pulls his strings; or the stirrup jar painted with the coiling tentacles of an octopus, from around 1200–1100 BC – and maybe they will think of Pablo Picasso (1881–1973).

The area around the eastern Mediterranean played host to three distinct cultures that flourished in the Neolithic and Bronze Ages, and all of them contributed to the formation of the Classical tradition as we know it today: the Cycladic, from the Cyclades Islands; Minoan, centred around the ancient palaces of Crete (and named after the legendary King Minos); and that of the Greek-speaking Mycenaeans.

Although the Metropolitan owns some marvellous examples from these prehistoric periods, we must wait until the fall of the Mycenaean culture in the 12th century BC, and the rise shortly thereafter of a new culture centred on the Attic region of the Greek mainland, before we gain such a rich insight into Greek culture itself. It was then that Greece began to consolidate some of its most important institutions – the city-states, and the Panhellenic sanctuaries at Delphi and Olympus. The era is referred to as the Geometric period (1050–700 BC), since its art shows a love of

rectilinear and curvilinear form – look at the sleek, schematic body of the horse statuette from the 8th century BC, or the decorative motifs which separate the different registers on painted pottery of the time. One only begins to notice a change in this style with the advent of the Archaic period (700–480 BC), when Greece began to absorb the influence of the older civilisations that survived on its borders. Sphinxes begin to appear: see, for example, the 6th-century grave stele.

Although we describe all the art of Greece and Rome, and its related cultures, as 'Classic', the phase of Greek art that is itself described as Classic is that which followed the Archaic. It began in the 5th century, after Athens repulsed Persian invaders, and when Pericles established the first democracy and presided over the construction of the Parthenon. During this time, Greek art attained new heights: see the complexity of the scenes depicted on some of the period's vases. The last phase of Greek art is that which we describe as Hellenistic, which followed the death of Alexander the Great, at the age of just 33, in 323 BC. Alexander left an extraordinary empire, but he also left no heir, and thus it fell to his generals, who split the empire into a series of smaller Greco-Macedonian dynasties. This phase is described as Hellenistic because it is diverse in style and form, and retains only the memory of the great Greek culture that preceded it.

The galleries that unfold this story contain all kinds of objects, but one could almost chart the whole development of Classical art by following the growing realism in the depiction of the human figure,

Terracotta calyx-krater
Attic/Greek, *c* 440–430 BC
From the 4th to the 6th centuries BC, Attic vase painters used both a 'black figure' and, employed here, a 'red figure' technique to decorate fine pottery. This krater, attributed to a painter of the Polygnotos Group, was used for mixing wine and water, and it depicts one of the feats of Theseus, founder of Athens, who killed a bull that was harassing Marathon.

for it was the great achievement of Classic art to perfect this form. If some of the female figures from the Cycladic period have the look of fertility symbols, and some of those on pottery of the Geometric period are little more than stick-figures, the great leap forward comes in the Archaic era, when the Greeks began to create life-size human figures inspired by those in Egyptian art. The *kouraos* (youth) was the prototype for all that was to come, and the museum owns one that is among the earliest marble statues of a human figure to have been carved in Attica; it once marked the grave of a young Athenian aristocrat.

One can see another major development in the *Diadoumenos*, a statue depicting a young athlete: the museum's figure is a Roman copy of the Greek original from *c* 440–430 BC, and portions of the statue are missing, but the detail and realism in the depiction of the human form are still clearly new for the period. There is also a sense of serenity and emotional restraint that is characteristic of the Classic phase. This was lost when the era gave way to the Hellenistic period, and sculptors became interested in new sculptural types which might convey different qualities of humanity: the marble statue of an old woman (AD 14–68), a copy of a Greek work from the 2nd century BC, is bowed with age, her robes only emphasising the aged body underneath.

There is little sense of interruption between these examples of Greek art and the Roman that emerged in its wake: this is not surprising, as at different times the Romans emulated the emotionalism of Hellenistic sculpture and the restraint of Classical. Of course Rome had its own styles – and since its empire was the largest and longest lasting of any of those in the ancient Mediterranean, these were various and changed frequently. But at the Metropolitan, more exciting than trying to unpack the history of Roman art is seeking out its highlights. The museum owns an

astonishing sequence of wall paintings from two Roman villas near Pompeii. Also noteworthy are the sarcophagi: far grander than the poor tomb that ended up as a donations box is the marble which depicts the *Triumph of Dionysus and the Four Seasons* (*c* AD 260–70), with 40 figures all carved in high relief. Dionysus, the god of wine, rides his panther in the centre, while the goat god Pan and his followers surround him.

To sober up, you should perhaps seek out the marble head that came from a monumental statue (*c* 325–70) of Constantine I, the emperor who converted to Christianity and thus brought an end to the religious culture that had given the Empire so much of its character. Huge though his image is, Constantine appears before us with his eyes cast not down, towards his subjects, but heavenward, towards his new saviour.

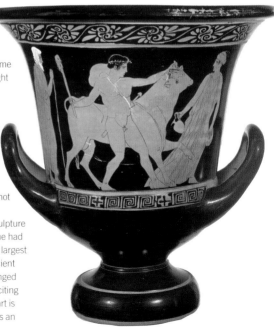

Wall painting on black ground: aedicule with small landscape from the imperial villa at Boscotrecase

Augustan, last decade of 1st century BC
This fresco comes from the summerhouse of Agrippa, a friend of the emperor Augustus, which overlooked the Bay of Naples. Despite the dark background, the decoration makes light-hearted play with architectural motifs. Candelabras and swans provide embellishment, and a tiny landscape floats at the centre.

New York City offers few reliefs from the frenetic urban experience it provides, but one of the most reviving tonics – and surely the strangest – is a visit to **THE CLOISTERS.** Situated overlooking the Hudson River, high above the bustle of north Manhattan in Fort Tryon Park, here you can breathe in the pungent air of a Medieval herb garden, step through the carved portals of Tuscan churches, and stroll the precincts of no fewer than five French monasteries, just as monks did centuries ago.

The centrepiece is a collection of architectural elements that were gathered by the American sculptor George Grey Barnard (1863–1938). While living in France in the years before the First World War, Barnard supplemented his income by trading in salvaged architecture; often Medieval elements which had found their way into private hands during the previous centuries. Later, he brought some of his favourite items back to the US and opened a public museum. Its contents were purchased by the **METROPOLITAN MUSEUM OF ART** in 1925 and a new building was constructed for the collection, which was renamed, and opened in 1938.

Today the Cloisters showcases some of the highlights of the museum's Medieval collection, though it focuses on the 12th to the 15th centuries, and the museum's main building, on Fifth Avenue, has broader and more numerous displays. The Cloisters' architectural reconstructions are not always perfect: in some cases the knowledge of the exact dimensions of the original structures has been lost. To the untutored eye, however, they appear seamless, and with little more than the sound of footsteps and fountains echoing around the museum convey a striking sense of peace.

New York's other essential venue for Medieval art, further south in midtown, on Madison Avenue, is the **MORGAN LIBRARY & MUSEUM,** the creation of the 19th-century financier and collector John Pierpont Morgan. Standing in his beloved West Room, where he received the statesmen and the business leaders of his day, one would have to conclude that Morgan's tastes were more early Renaissance than Medieval: paintings by Hans Memling (c 1430–94) and Sandro Botticelli (1445–1510) adorn the walls. But when he began to assemble his library, his nephew wisely advised him to search out older manuscripts, and by the time Morgan died he had the largest private collection of manuscripts in the world.

Unfortunately, due to the fragility of the objects, only a fraction of the collection's treasures are ever on view at any one time, but you can be sure of seeing one of its three copies of the *Gutenberg Bible* (the first book printed from movable type), and new displays were recently opened to show a rotating selection of its permanent collection. Look out for everything from ancient Mesopotamian seals to children's books to the largest archive of materials relating to the life and work of the Victorian entertainers Gilbert and Sullivan.

If the religious qualities of Medieval art attract you, it might be worth visiting the **MUSEUM OF BIBLICAL ART (MoBiA)** at Broadway and 61st Street. Though it does not have a permanent collection, it does offer impressive temporary exhibitions of art related to the Bible and its cultural legacy in Jewish and Christian traditions.

The Virgin Mary and Five Standing Saints above Predella Panels
(detail) Boppord-am-Rhein, Germany, 1440–46
THE CLOISTERS

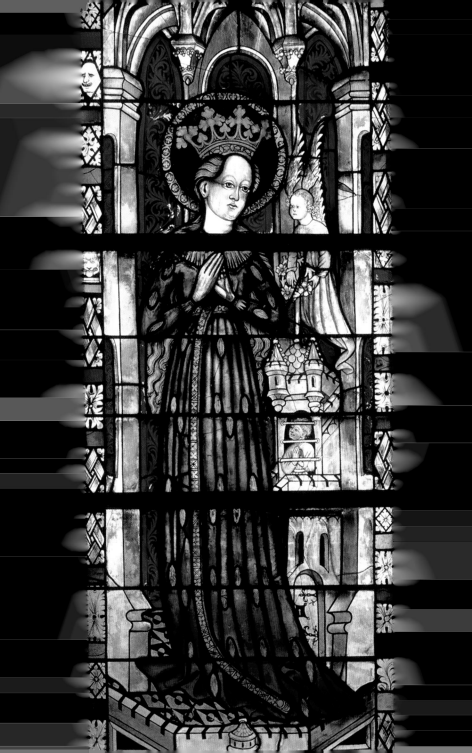

Visitors from Europe are sometimes amused by the Cloisters: nothing would seem more typical of the New World's attitude to the distant past than this fantastic museum on a hill, erected in the 1930s in faux-Medieval style, and filled with imported fragments of the Old World. But the Medieval art it houses is part of a larger collection that few museums in Europe can beat; one which leads you from the fall of the Classical civilisations of the Mediterranean, through the rise and fall of the Byzantine Empire, the onrush of the Barbarian invasions, and the flowering of the Gothic.

Christian art by no means replaced the Classical culture that preceded it; it evolved gradually, and in dialogue with the Classics, throughout the Middle Ages. One example is a sarcophagus lid from the late 3rd to the early 4th century, which is in the collection of the Metropolitan. Funerary sculpture was among the first Christian art, and this tomb depicts the earliest known example of the Last Judgement theme in Christian art, showing the parable in Matthew's Gospel in which Christ sorts the sheep from the goats. The subject may be Christian, but the ornament that surrounds it is Roman in style.

When Constantine, the first Christian ruler of the Roman Empire, moved his seat of power to the old city of Byzantium and renamed it Constantinople (now Istanbul), this coexistence of Classical and Christian continued. When the Antioch Chalice (6th century) was discovered, early in the last century, some claimed that its ornamented silver shell housed the simpler beaker

Fragment of a floor mosaic with a personification of Ktisis
Byzantine, first half of the 6th century
The Byzantine period is noted for the quality of its mosaics, and this example shows the Greek figure Ktisis, who personified the generous act of donation. She holds a measuring instrument for the Roman foot, while the figure in the background holds a cornucopia, a symbol of abundance.

Crucified Christ
French, c 1260–80
The crucified Christ was central to the Medieval period's often morbid imagery; Paris even had a guild dedicated to the production of such images. During a time when the human figure was often stylised in art, this example is remarkable for the accuracy of its anatomy, which increases its emotional impact.

that was the Holy Grail. Scholars now suspect that the object was merely an oil lamp – but its beauty has not changed. Alongside this, Byzantine culture produced fine carvings, including the Diptych of the Consul Justinian (521), which comprises two ivory panels that were commissioned by Justinian to celebrate his appointment as consul for the East, six years before he became emperor. Plainly but elegantly carved, the diptych was given to a member of the Senate.

While Constantinople prospered under its new imperial patronage, Rome declined and was harassed by barbarian tribes. Originally, the word 'barbarian' referred to anyone who did not speak Greek: it did not simply denote lack of cultural sophistication, as it does today. Such notions ought to be extinguished entirely by the exquisite metalwork of the Vermand Treasure (350–400), a group of decorated silver mounts for spear shafts and a belt buckle, which were influenced by techniques from regions along the Rhine and Danube. They were found in a military tomb in northern France.

The collection at the Cloisters begins around the 8th century when Charlemagne, King of the Franks, was crowned by the Pope as Emperor of the West. Thus begins the century of the Carolingian empire, and another revival of the Classical style. The period is particularly renowned for its ivory carving, and one eloquent example is provided by the plaque with a seated Saint John the Evangelist (early 9th century), which was probably made in Charlemagne's court school. Once again, Christian and Classical

blend: the saint holds out a book inscribed with the first words of his gospel: 'In the beginning was the Word,' but he sits under a Classical arch, and the folds of his tunic recall those of earlier Classical art.

Work such as this prefigures the revivalist aspects of the Romanesque period, which spans from 1050 to 1200. One can see the restrained aspects of that style in the Cuxa Cloister, which, built around 1130–40, originally derives from the Benedictine monastery of Saint-Michel-de-Cuxa, in the French Pyrénées. This might be compared with the later, more ornate decoration of the Cloister of Saint-Guilhem-le-Désert (finished prior to 1206, but with 14th-century additions).

To sample the heights of Gothic art, and the romantic spirit of royal courts in the period, see the Unicorn Tapestries (c 1495–1505). Many mysteries surround them, but scholars believe they were probably produced in the southern Netherlands, and their tale of the hunt and capture of a unicorn is probably an allegory of the life and Passion of Christ.

The Virgin Mary and Five Standing Saints above Predella Panels
German (Boppard-am-Rhein), 1440–46
Among the Cloisters' architectural elements is this sequence of stained-glass windows, originally from a Carmelite church south of Cologne. The glass was dispersed after the Napoleonic invasion. The Virgin is the figure in blue; others include the virgin saints, Saint Catherine, Saint Dorothy and Saint Barbara.

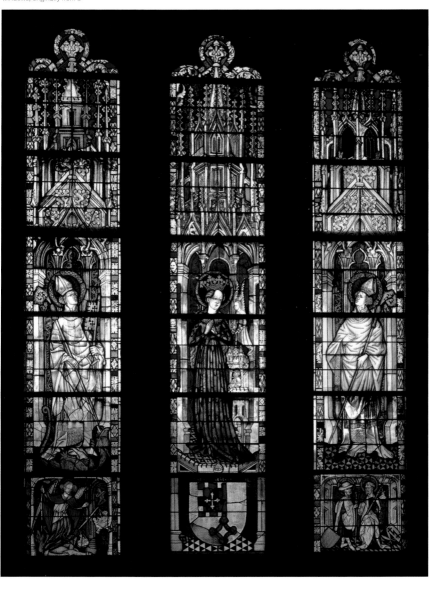

If you decide to tour the Metropolitan before visiting the **MORGAN LIBRARY,** you might already have a sense of Pierpont Morgan's taste, since 40 per cent of his collection – as many as 8,000 objects – came to the Metropolitan following his death. Nevertheless, the Morgan still has plenty to lure us, and, rather like the Cloisters, its setting is as much of an attraction as its collection. It was designed by Charles Follen McKim (1847–1909), of the firm McKim, Mead, and White, a leader of the American Renaissance movement of the late 19th century.

In addition to the rich decor of Pierpont Morgan's West Room lair, it also houses his multi-tiered library (sometimes called the East Room), which is shelved on inlaid walnut, crowned with ceiling paintings, and hung with a monumental 16th-century tapestry (cynics may enjoy its subject, the triumph of avarice). The Rotunda, which separates the East and West Rooms, is clad in marble and mosaic. It has recently been installed with displays of Americana, including such items as autographed letters by Thomas Jefferson and Abraham Lincoln, and copies of the Declaration of Independence (1776) and the Star-Spangled Banner (1816–17). The North Room has recently been opened to exhibit some of the collection's earliest objects, including Near Eastern seals, and artefacts from Egypt, Greece, Rome and the Middle Ages.

Although occasional visitors cannot hope to see the full range of the library's collection of illuminated manuscripts, a series of temporary exhibitions alongside the rotating displays drawn from the permanent collection ensure that you will always be able to get a taste of them. The manuscripts include such items as the Egyptian *Book of the Dead* (c 300 BC); a copy of the four

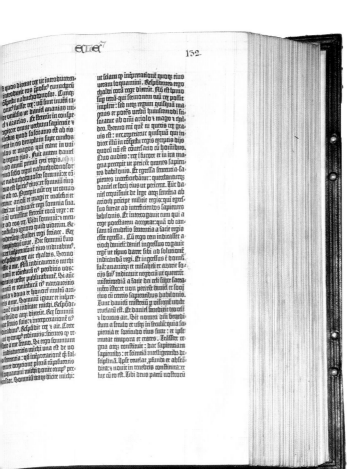

Gospels (c 860), produced by the influential Reims school and written in gold; and a *Book of Hours* (c 1460) by the great French painter Jean Fouquet (1420–81). Among the library's printed books is the *First Folio* (1623) of William Shakespeare's plays; Isaac Newton's *Principia* (1687); and an edition of *Aesop's Fables* (1666), with a text in English, French and Latin, and illustrations by Francis Barlow (c 1626–1704)

**Biblia Latina
(Gutenberg Bible)**
Mainz, Germany, 1455
MORGAN LIBRARY
This Bible gained its popular name from Johann Gutenberg, the Mainz goldsmith who invented the mechanical process that made printing possible. It is

thought that around 180 copies were originally printed, of which 48 survive. Although the process represented a huge technological advancement, the book's style echoes that of illuminated manuscripts of the period.

It is an unfortunate fact that Asian art is mostly bypassed by the great mass of public that sweeps through New York's museums. The crowds at the **METROPOLITAN MUSEUM OF ART** leave sated after spending their energies looking at Greek and Roman art or European painting. But the public's loss can be the adventurer's gain, for there can be some sweet moments of tranquillity in the Asian galleries. One display will lift you up into the carved dome of a 16th-century Jain meeting hall in Gujarat, India: it conjures the heavenly sphere that all Jains hope to eventually reach. Another will reveal the reception room of an early 18th-century Syrian home: here visitors used to recline on divans while soft light was filtered in through stained-glass windows. Or you might take a stroll in Astor Court, a garden modelled on a Chinese scholar's court: studded with craggy and mysterious rocks, and burbling with the sound of trickling water, it offers a perfect balance of light and dark, softness and hardness – of yin and yang – polarities which underlie so much Chinese thought and art. The court also happens to be the product of the first permanent cultural exchange between the US and the People's Republic of China.

New York is a surprisingly good place to see Asian art. The Metropolitan – which should be your first port of call – has a collection that spans China, Japan, Korea, South and Southeast Asia. It also has a separate department devoted to Islamic art, and boasts one of the most comprehensive permanent

exhibitions, anywhere in the world, of art in this field (its galleries have been recently refurbished and expanded).

The **BROOKLYN MUSEUM** also deserves your attention, and so too do the many smaller institutions around the city that are devoted to this region. The **ASIA SOCIETY MUSEUM**, located near the Metropolitan, on Park Avenue, is the home of the Mr and Mrs John D Rockefeller collection of Asian art, a small but impressive array of classical Chinese art. Closer to midtown is the **JAPAN SOCIETY**, which does not have its own collection but does host good temporary exhibitions. Further downtown is the **RUBIN MUSEUM OF ART**, which has the largest Western collection of religious art from the cultures of the Himalayas. On the fringes of thriving Chinatown is the **MUSEUM OF CHINESE IN AMERICA (MOCA)**, which in 2009 moved to new and expanded quarters designed by Maya Lin (1959–), the sculptor and architect famous for the Vietnam Memorial in Washington DC.

If, unlike most visitors who board the Staten Island ferry simply to cruise past the **STATUE OF LIBERTY** (1875–84), you decide you would actually like to see some of the island, you should venture to the **JACQUES MARCHAIS MUSEUM OF TIBETAN ART**. Constructed in the manner of a Himalayan monastery, when the 14th Dalai Lama, Tenzin Gyatso, visited in 1991 he was pleased to say that it felt just like being in Tibet.

Standing Ganesha
Pre-Angkor period
(Cambodia), 7th century
METROPOLITAN MUSEUM
Ganesha gained his elephant head after a quarrel with his father, Shiva, who cut off his original head and ordered the gods to replace it with that of the first animal they encountered. Ganesha controls obstacles, having the power to remove and create them, and he is worshipped before any great task is begun.

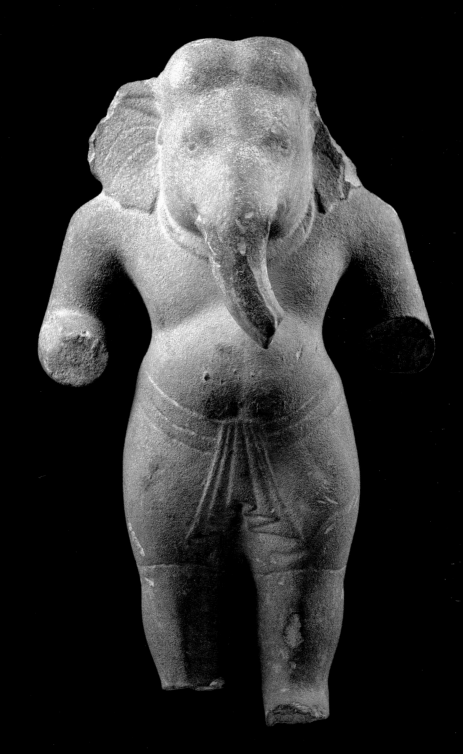

Bust of warrior
Kofun period, 5th–6th century
This is a *haniwa* (circle of clay), a funerary ornament common in early Japan. They evolved from simple clay cylinders to representations of houses and animals and, eventually, figures such as this. During the period it was created, the ruling elite were buried in enormous tombs covered with mounds of earth and surrounded by moats.

One of the earliest examples of South Asian art in the Metropolitan is a small bronze figure sitting on a wickerwork stool. He is bearded, his hair is tied high in a bun, and he wears a *yogapatta*, a cloth band intended to help support the legs while in the lotus position. He is Agni, the Vedic god of fire. It is believed that when the Ayrans migrated into the Indian subcontinent around 1500 BC, their beliefs blended with those of the indigenous peoples and gave birth to Vedism, a cult of fire sacrifice that had Agni at its helm.

Agni remains sacred to Hindus to this day, but his eminence has long been challenged by other creeds, the most significant of which arrived with the birth of Siddhartha Gautama, some time in the 6th century BC, probably in what is now Nepal. Gautama was a prince, but was prompted to leave his riches behind in search of peace and enlightenment. Finally, he concluded that peace could only come from finding a route between the extremes of worldly life and self-denial – by meditating on 'the middle way'. He came to be known as Buddha, the 'awakened one', and those to whom he taught his beliefs spread them so far and wide that Buddhism became the first global religion.

Buddhism is one of the central forces in Asian art, and one might almost construct a tour of the Metropolitan's collection by following its spread from India, through China, into Korea and finally to Japan. One of the earliest Indian Buddhas in the museum is the Standing Buddha, which dates back to the late 5th century; a smooth, serene, red-sandstone figure, apparently wearing a thin, rippling robe. The lobes of his ears are elongated (partly to

'Simonetti' carpet
Mamluk period (Egypt),
c 1500
Cairo began to be an
important centre for carpet
production in the late 15th
century, under the Mamluk
sultanate. This example is
typical of the period,
particularly in its palette, and
in the way the rosette and
star motifs are gradually
developed outwards into
octagons and then into
squares.

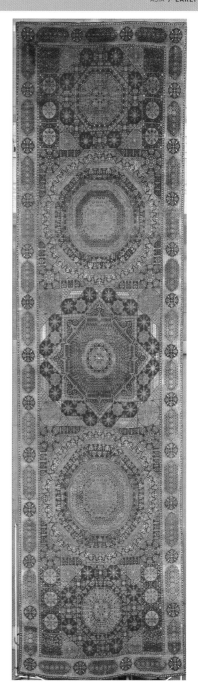

suggest that he is all-hearing); his body seems full
and rounded (it is full of the breath of God); and
while his lower arms are missing, the fragments
suggest that they were originally in the orthodox
position for imagery of the Buddha, with the right
raised to signify protection, the left open to suggest
charity.

The Metropolitan has a fabulous collection of
Chinese Buddhas, and numerous bodhisattvas
(those destined to attain buddhahood), including
a particularly early example from the 2nd or 3rd
century which forms a fascinating connection with
the Classical civilisations of the Near East. A head
of a bodhisattva derives from the area of modern-
day Afghanistan, which, during the period the
sculpture was made (4th to 5th century), was
controlled by a succession of rulers, some of whom
were inspired by Hellenistic and Roman art, and it
is easy to see the influence of these styles on the
sculpture. The rich curls of her hair alone are
enough to give her life, but the shining brown
garnets that serve as the pupils of her eyes make
her seem ever more present.

Of course, Buddhism shaped more than
simply the imagery of religious figures. It also made
its mark on ceramics – notably when it passed
through Korea, which was an important stopping
point on the religion's route to Japan. Search out
the 12th-century *kundika* bottle: these bottles
were originally used in Buddhist rituals to scatter
water for purification, though they were also used
in everyday life to store liquid; this example is
decorated with trees and water fowl. Western
scholars have not studied Korean art as thoroughly
as they have the work of the country's neighbours,
and the peninsula is sometimes dismissed as
having produced fewer works of outstanding value,
but the Metropolitan's collection, in particular the
celadons from the Kory dynasty (918–1392), of
which the *kundika* is an example, could persuade
you otherwise.

Asian artists have always been noted for the
fine design and craftsmanship of their ceramics,

Pendant in the form of a knotted dragon
Eastern Zhou dynasty (China), 770–256 BC
Jade has been a popular material in Asian jewellery, despite its hard and brittle qualities, which make it difficult to carve. It began to replace bone as a material for ritual objects in the Shang and Chou dynasties. This tour de force joins a dragon's head to a body resembling a rope.

and if you want to see more you should look for the Chinese green-glazed bowl, a 10th-century piece from the famous Yuëh kilns in the west of the country. Decorated with coiling dragons, it was probably reserved for the use of local princes.

Returning to the subject of the Buddha, scholars believe that tales of his life were important in encouraging narrative forms of art throughout Asia. It would certainly be a short step from those stories to the 13th-century Japanese handscroll depicting *The Miracles of Kannon*, a bodhisattva who saved the faithful from myriad disasters. But it is also plausible that this love of narrative sowed the seed of entirely new types of imagery. Take the 12th-century Chinese hanging scroll, *Emperor Ming-huang's Flight to Shu*: it depicts an incident from the life of an emperor who fell in love with a concubine, neglected his duties and ultimately had to flee when rebellion erupted. The imperial entourage is vividly captured, but it is dwarfed by the looming trees and mountains in the background, as if the artist considered the story to be merely a foil for the landscape. By the time we come to the work of Japanese artists such as Kitagawa Utamaro (*c* 1753–1806) in the late 18th and early 19th centuries, the memory of the Buddha seems long gone: one of the most influential printmakers of his time, Utamaro was entirely devoted to images of beautiful women.

If the life of Buddha significantly shaped East Asian art, the word of Muhammad became one of the fundamentals of Islamic art, and one can see some exquisite renderings of that at the Metropolitan. A fragment from one of the best early manuscripts of the Koran, an Egyptian or Iraqi volume from the 9th century, employs the elegantly elongated characters of Kufic script. The other fundamental category in Islamic art is the so-called 'arabesque'; all kinds of objects make use of this intricate decoration, which weaves together sinuous tendrils and foliage. A page from a 12th-century Iranian Koran sees the characters soar vertically over a rolling field of arabesques. The Metropolitan's collection also contains many carpets, which have always been a popular art form in Islamic societies, and examples of these are lavished with similar decoration.

One is certainly more likely to see arabesques than human figures in the galleries, since Muhammad's iconoclasm has made many Muslims uncomfortable with realistic, sculptural representations of living creatures. Look at the 12th-century Iranian incense burner: although it takes a feline form, rather than attempt to describe the animal's fur, the artist has shied away from realism and used its torso as an opportunity for elaborate ornament.

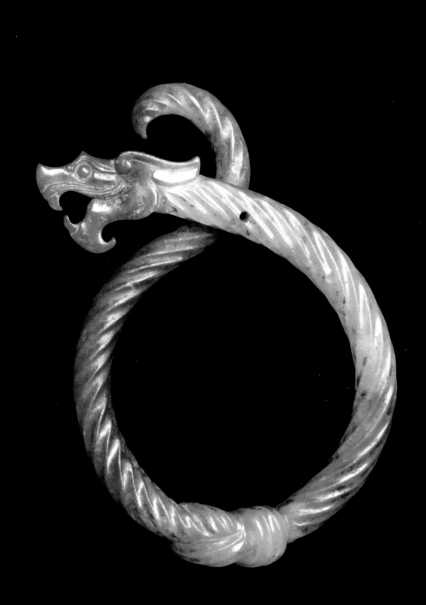

Asian art is remarkable for the longevity of some of its traditions, and the **BROOKLYN MUSEUM** can be a good place to appreciate this. Look at *Infinity II (Shinsho)*, the porcelain sculpture made in 1994 by Kyoto artist Fukami Sueharu (1947–): its form may be a sleek and entirely non-functional abstraction, poised between conceptual art and product design, yet its pale hue is inspired by the long tradition of green-glaze ceramics in East Asian art. Seeing works such as this, however, can tempt us to seize on certain aspects of Asian art – stylistic tics and recurrent motifs – and think of them as somehow essential and timeless. It is a reasonable mistake to make yet Asian art is a complex field, and one fed from multiple streams.

Brooklyn's 18th-century *Shrine with an Image of a Bodhisattva* is a fabulously eclectic fusion: it is categorised as cloisonné, a metal artefact that has been decorated by a technique in which coloured glass paste is applied in *cloisons* (French for 'partitions') constructed from metal wires. The figure sheltered in the Brooklyn work is Tibetan in origin, but the canopy-like structure that covers it may be Indian; the lions at the corner are Chinese, and the form of the shrine echoes the baldachino by Giovanni Lorenzo Bernini (1598–1680) for St Peter's in Rome (apparently, Jesuit missionaries introduced European engravings to China in the 17th and 18th centuries – just as they also, no doubt, brought home examples of Chinese art which inspired some European chinoiserie).

The Brooklyn Museum is such a marvellous place to see Asian art that it seems unkind to give it second billing to the Metropolitan; indeed its holdings of Korean artefacts trump those in Manhattan, and it was one of the first American museums to focus on Korean contemporary art. If you make the journey to see the Korean collections, then you must also see the celadon ewer (early 12th century), another extraordinary example of work from the Kory dynasty: it resembles an English teapot, but it is even more ornate than its cousins at the Metropolitan. Also important is the 14th-century hanging scroll *Amit'a Triad*. Kory dynasty Buddhist paintings typically blend dark hues and gold pigment, and few survive; this one depicts the Buddha Amit'a, who was believed to carry the souls of the pious deceased to paradise, accompanied by two bodhisattvas.

It would be optimistic to say that greater understanding has erased conflict between East and West, but the last century certainly has seen strides towards this, and some credit must go to institutions like the **ASIA SOCIETY MUSEUM**. Today it has a global and pan-Asian presence, and its home in New York has a sparkling, if small, collection. It has strengths in Chinese ceramics of the Song and Ming periods and Southeast Asian sculpture, as well as Indian bronzes from the Chola

Dish depicting a dragon amongst foliage
Jiajing era (China), 1522–66
Engulfed in blossoming plants is a dragon from whose mouth springs a *shou* character, signifying longevity.

The dragon originally had five claws on each foot to identify the emperor, but one was removed from each at a later date, prompting scholars to wonder whether the dish was subsequently used by someone outside of the imperial court.

Siddha Lakshmi with Kali
Basohli, Punjab Hills, India, *c* 1660–70
Lakshmi, goddess of prosperity and Vishnu's consort, sits on a lotus flower beside Kali, goddess of time.

The subject may relate to a popular theme within the Hindu sect of Shaivism – the introduction of the lotus flower. Enormous work has gone into the decoration of Lakshmi, who is ornamented with beetle wing-cases.

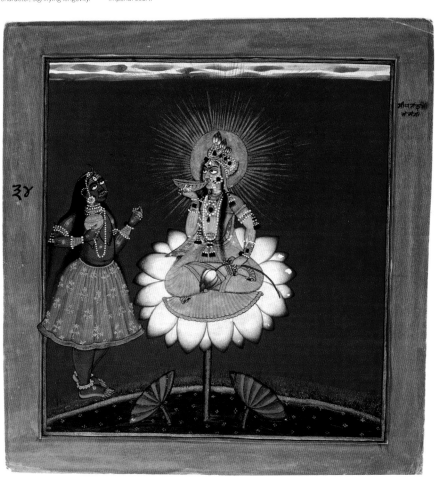

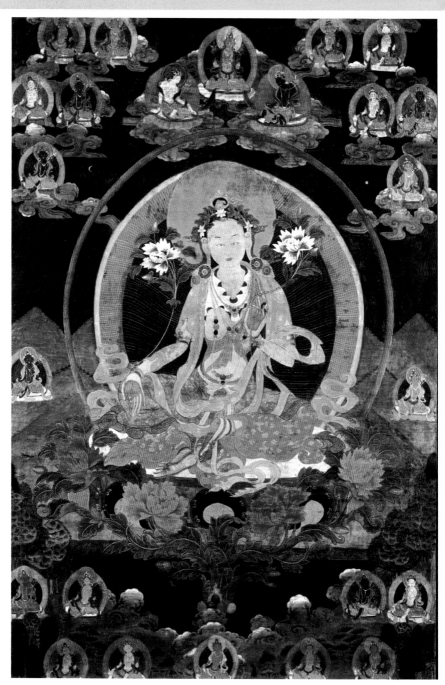

Green Tara
Tibet, 18th century
RUBIN MUSEUM
Tara, or Drolma, is the most popular female deity among Tibetan Buddhists, who resort to her for long life, healing and protection. Here

a form of the deity known as Green Tara – although she appears richly depicted in gold – is surrounded by her 21 forms, each one of which has specific activities and functions.

Bottle
Northern Song period (north China), late 11th– early 12th century
ASIA SOCIETY MUSEUM
This vessel is sometimes referred to as a 'truncated *meiping* bottle' as it

resembles the lower half of a bottle for plum wine. Judging by its flaring lip, this item was probably also used for pouring wine. Its bold decoration is typical of other examples of this stoneware called Cizhou ware.

period (880–1279). In recognition of the increasing prominence of Asian art, the society has also recently begun collecting examples of contemporary art by Asians and Asian Americans. So if you enjoy contrasting old and new, you might also seek out *Li Tai Po* (1987), by the pioneering Korean new-media artist Nam June Paik (1932– 2006). It represents a lumbering robot made from antique televisions – a fearful vision of how our domestic appliances might master us.

Far narrower in its geographical perspective is the **RUBIN MUSEUM OF ART,** a relatively new addition to New York's museum landscape, which focuses on art from the Himalayas. The sheer scale of this mountain range, spanning from Afghanistan to Burma, and the barrier it erects between South Asia and the rest of the continent, has encouraged the generation of distinct traditions. The collection moves from the 2nd up to the 20th century and focuses on scroll paintings and sculptures, but it also holds other artefacts such as masks, textiles and illuminated manuscripts.

The Asian art museum with the strangest history is surely the **JACQUES MARCHAIS MUSEUM OF TIBETAN ART**, on Staten Island. It was built by an eccentric Cincinnati-born woman who was named Edna Coblentz, but who decorated herself with various different titles before settling on Jacques Marchais. After starting to study and collect Tibetan art in the early 1930s, she hatched a dream of building a museum, and subsequently designed it herself in the manner of a small Himalayan monastery, setting it on a hillside

overlooking New York Bay. The logotype of the Asia Society is actually inspired by a pair of 18th-century Nepalese leogryphs that were donated by the museum (leogryphs – fusions of lions and griffins – are typical of the fierce creatures that traditionally stand guard at the entrances to Buddhist temples). If you go out to Staten Island, you will find 1,200 pieces of Buddhist art from Tibet, Mongolia and northern China. And if you like Brooklyn's *Shrine with an Image of a Bodhisattva*, you should enjoy the Jacques Marchais, as it has a good collection of 18th-century cloisonné, including a complete altar set and incense burners.

If any more evidence were needed of the diversity of the Asian experience, one might try visiting the **MOCA**. Founded in 1980 to preserve the history and culture of people of Chinese descent in the US, its collection includes some 60,000 objects ranging from letters to textiles to theatrical costumes to precious artefacts. The museum has quarters on Centre Street, and here, in addition to a temporary exhibition, often of items on loan, you can find a permanent exhibition which narrates the history of Asian Americans, and which draws mainly on materials from the museum's own archives. The archives have some fascinating highlights: the collection of the Chinese Musical and Theatrical Association brings to life the Cantonese opera clubs which have flourished in America's Chinatowns since the 1930s; and a recent acquisition reveals the life of the pioneering Chinese-American woman aviator Hazel Ying Lee.

AFRICA, OCEANIA & THE AMERICAS

It is said that when Picasso was midway through his work on *Demoiselles d'Avignon* (1907), the seminal masterpiece that is now one of the lodestars of the **MUSEUM OF MODERN ART (MoMA)**, he made a trip to Paris' Musée d'Ethnographie du Trocadéro. Here he looked at the African masks – maybe something like the feather-crowned and shaggy-bearded Senufo facemask (19th–mid-20th century) in the **METROPOLITAN MUSEUM OF ART**. Inspired, he returned to his studio and gave some of the picture's figures their severe and geometric features. Picasso had been seduced by the fantasy of primitive art.

Imperial Europe liked to consider its colonial subjects unsophisticated in their development, and even figures such as Picasso, Paul Gauguin (1848–1903) and Henri Matisse (1869–1954) were happy to see the region's art as similarly stunted – as 'primitive'. It allowed them to conjure with notions of the exotic, the natural and unspoilt, with suggestions of liberation and lost origin. And such was the poor understanding of the predominantly tribal art of Africa, Oceania and the Pre-Columbian Americas that there was not much to contradict them.

Much has changed, thankfully, and scholars now understand that tribal art is sophisticated both in design and execution. But this appreciation was slow in coming – not so long ago New York had an institution called the Museum of Primitive Art. The museum sprang from the collection of Nelson A Rockefeller and, when it closed, he donated its contents to the Metropolitan Museum, giving it

what is now the core of its collections of African, Oceanic and American art. Today the collections are housed in a wing dedicated to the memory of Rockefeller's son, Michael, who was a devoted collector of tribal art, and who went missing during an expedition to New Guinea in 1961.

The Metropolitan should be your first stop in search of art from these regions, but there are many other venues besides. The **BROOKLYN MUSEUM** has the largest collection of African art in any American museum and, thanks to the contact between the US and Latin America, and the States' own Native American heritage, New York also has a number of institutions devoted to both Pre-Columbian art (art predating the Spanish invasions of the early 16th century), as well as post-Conquest, Latin American art. An outpost of the **NATIONAL MUSEUM OF THE AMERICAN INDIAN (NMAI)** resides in the old Custom House, close to Wall Street. Further uptown is **EL MUSEO DEL BARRIO,** a major centre for Latino, Latin American and Caribbean art, with a sizable collection. Nearby on Park Avenue is the **AMERICAS SOCIETY**, which holds temporary exhibitions, and further north, newly installed at the crown of Museum Mile, is the **MUSEUM FOR AFRICAN ART**, which offers a small collection of around 500 objects, ranging from the 16th century to the present day. In West Harlem is the **HISPANIC SOCIETY OF AMERICA MUSEUM AND LIBRARY**, whose world-renowned collection of Spanish, Portuguese and Latin American art is one of the largest outside Spain.

Basalt figure
Hawaii, 9th–11th century
METROPOLITAN MUSEUM
The puckered basalt face of this figure was found on Necker Island, a barren outcrop 300 miles (482 kilometres) from the core of the Hawaiian Islands. Archaeologists assume that it played some part in a traditional pilgrimage to the island. Many similar figures have been found and they are thought to represent deities.

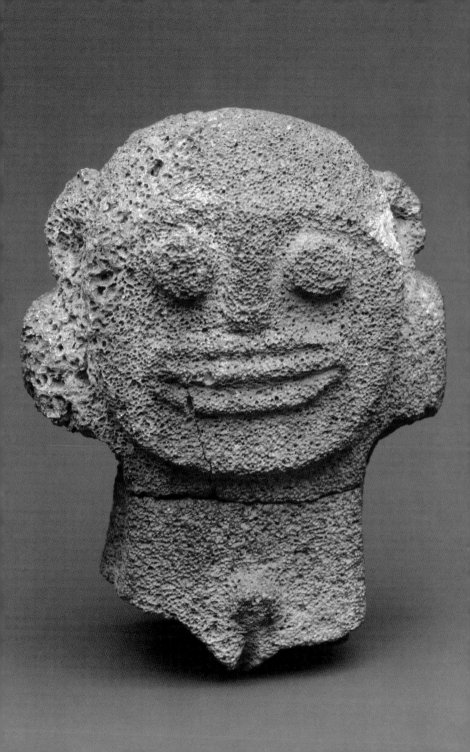

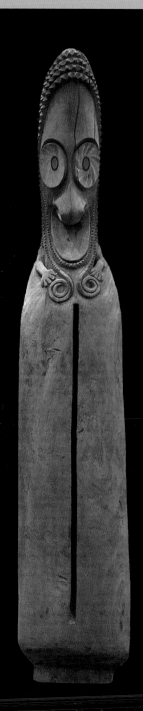

Slit gong
Vanuatuan, mid- to late 1960s
The slit gongs from Vanuatu are among the largest musical instruments in the world. Carved from the trunks of breadfruit trees, and hit with club-like tools to create a deep sound, they are played at ceremonial events and were once used to communicate between villages.

Although the notion of primitive art is now dismissed, we should perhaps have some sympathy for artists like Picasso who were so fascinated by tribal art, for it contains a fascinating paradox. Because much of it was made using perishable materials, such as wood, it rarely endured, hence much of what now sits in our museums is no older than the 19th century. The Metropolitan's Kwoma ceiling, a sequence of painted panels from a ceremonial house in New Guinea, was made in the early 1970s. So tribal art was, for Picasso, a 'contemporary' art, and yet it deserves to be considered an ancient art, too, because most of the cultures that produced it, certainly in Africa and Oceania, changed little over the centuries.

It may seem strange, and slightly condescending, to have art from such far-flung cultures united together in the same department. Are not these cultures very different? The urban civilisations of Pre-Columbian Meso-America and South America were highly complex, and the kingdom of Benin, in present-day Nigeria, once had a royal court that sprang from a dynasty of rulers dating back to the 14th century (the Metropolitan owns a particularly good selection of its treasures). But most of the traditional art from these regions was made by tribespeople who were hunter-gatherers; it was made from similar materials and, crucially, it tends to pay tribute to ancestors rather than a ruling class. This encourages similarities: try comparing the ancestor figure from New Guinea (mid–late 19th century) with the mask with a female figure created by the Mossi of Burkina Faso (19th–20th century). Figures such as the New Guinea sculpture played a vital part in feasts during which ancestors were honoured: they served as the dwelling places of the ancestors' spirits. The mask, meanwhile, was used at the funeral of an old woman. Although the ancestors have died, both cultures represent them in their physical prime.

Seated figure
Djenné-Jeno, Mali, 13th century
This figure comes from Djenné-Jeno, the oldest known city in sub-Saharan Africa, which emerged in the 9th century and was abandoned by 1400. It may represent a mythic figure, an ancestor or a guardian. Its pose may indicate mourning, as it echoes practices still found in the region today.

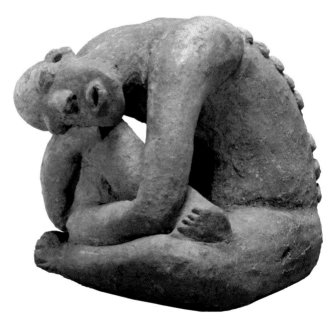

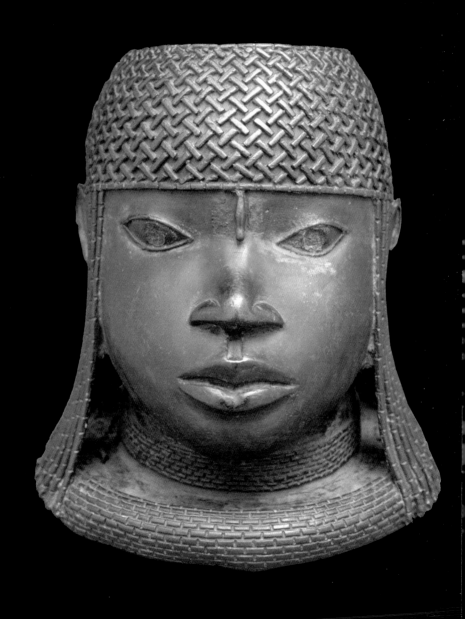

Head of an oba
Benin, Nigeria, 16th
century
The rituals of succession in
the royal court of the Benin
Kingdom involved the
creation of portraits
representing the recently
deceased oba, or king.
Although associated with a
particular individual, the
sculptural conventions stress
instead the role of kingship,
and the head itself, which
was revered as the centre of
power and authority.

Bearing in mind how different the societies
that produced these objects were from our own,
we would do well to put away any preconceptions
gleaned from our understanding of Western art.
It would be wrong, for instance, to think that the
figures that appear in Oceanic art are necessarily
'representational' in the Western sense of depicting
something that is not present. The Asmat memorial
poles (late 1950s) were intended to help summon
a real presence. The Asmat believed that only the
very young and very old died naturally; all other
deaths were somehow inflicted by an enemy, and
the spirits of those dead lingered, causing trouble
in the village until their deaths were avenged with
those of the enemy. Periodically, poles would be
carved, a feast would be held – often along with a
head-hunting raid on the enemy – and through this
the spirits of the lingering dead represented on the
poles would be liberated. The poles were finally left
to rot in groves of palms (on which the people relied
for food), their supernatural power pouring
nourishment into the surroundings.

Scholars feel confident in making assertions
about the antiquity of traditions in tribal art only
when they find an older object with which they can
compare more recent work. Rarely are those
objects wooden: the Mayan seated figure from the
6th century is a particularly unusual survivor in
a region where the damp climate quickly erodes
wood. Generally such survivors are made of stone
or metal, and they mark the beginnings of the
Metropolitan's collection; but remnants of so long
ago do not always find contemporary cousins,
nor do they easily yield their secrets. Look at the
zoomorphic figure from Papua New Guinea:
it probably represents the echidna, or spiny
anteater, but archaeologists are uncertain of its
significance and they can only speculate that
it dates back to 1500 BC.

Sometimes these stone survivors are poor
indicators of the character of the contemporary
wooden objects simply because the different
materials allowed the artists to produce different
effects. Look, for instance, at the fine detail the
artist has managed to carve on the soft wood of the
Mayan figure, or at the rounded and tangled limbs
that have been facilitated by the clay medium of
the 13th-century seated figure from Mali. Scholars
speculate that the Malian figure may relate to
mourning rituals (does the head, leaning heavily
on the figure's knee, suggest sorrow?); but, once
again, its exact significance is probably lost forever.

When we come to the civilisations of Pre-
Columbian America, we tend to be on slightly
firmer ground. The time span is still huge: complex
and often urban cultures flourished in Central and
South America for 3,000 years before the arrival of
Spanish invaders, and the number and disparity of
the cultures is still significant. Meso-America, the
area of the ancient Americas now occupied by
Mexico and Guatemala, was home to the Olmecs
and the Maya long before the emergence of the
Aztecs in the 14th century, and Peru hosted the
Chavín long before the Incas in the 12th century.

But many of these cultures worked in the
durable materials of stone, ceramic and gold
(the Metropolitan's collection of gold artefacts
from this region is noteworthy). The Olmecs, for
instance, were particularly accomplished sculptors:
a pale 'whiteware' bowl dating to the end of the
first millennium BC has an exquisitely smooth,
balanced, fluted outline; a 'baby' figure from
the same period displays remarkable realism.
Sometimes, when you think you can finally discern
the new from the old, you can still be confounded.
The Peruvian *kero* carved in the form of a head
resembles many of the beakers that were produced
in the Pre-Columbian era, and this one represents
the Anti, forest-dwellers from the eastern Andes,
yet it dates from the 17th to the 18th century, and
if you look on the back you will see a procession
of figures in Spanish dress. New World and Old
have met.

If your visit to the Metropolitan Museum has piqued your interest in the arts of ancient America, New York has numerous other museums which will bring that story up to the present day and shed light on art both north and south of the Rio Grande. The **BROOKLYN MUSEUM** should be the next stop on your trail. Its vast collection of African art covers around a hundred cultures: look out for the figure sculpture, the Berber jewellery, facemasks and Ethiopian processional crosses. Its collections of art from across the Americas is also comprehensive: at the turn of the last century one of its curators embarked on several expeditions across the US, amassing more than 9,000 examples of Native American art. He was succeeded by a curator with interests that ranged from ancient America to the Spanish colonial period.

It is fitting, somehow, that one of the earlier objects in Brooklyn's collection of Pre-Columbian art is also a perfect reminder not only of what so attracted the Old World to the New (gold), but what has continued to fix the attention of the urban West on some of the remoter corners of South America (drugs). The Colombian lime container (*c* 500–1000) may only be an alloy of copper and gold, but it shines like the more precious metal, and in other parts of the continent the deposits of the mineral were rich enough to attract the attention of the Spanish monarchs. Containers such as these were used to store the lime that was consumed while chewing coca leaves to enhance the stimulant.

You might imagine that the **NMAI** addresses a narrower field than Brooklyn's collection, however it aims to encompass the art of all the indigenous peoples in the Western hemisphere. Its holdings thus reach all the way from Canada, through the civilisations of Meso-America, and down into the native cultures of South America. But do not expect to find it all in the Custom House: NMAI is part of the Smithsonian Institution, and its other major outpost is in Washington DC; moreover, its collection is so vast – numbering some 825,000

Hat
Wari (Peru), 1100–1470
BROOKLYN MUSEUM
Square hats are typical of the Wari culture of Southern Peru, as are the motifs that decorate this piece – combinations of feline heads and geometric designs. This example is unusual in its use of feathers, though the Wari valued tropical birds highly for their plumage.

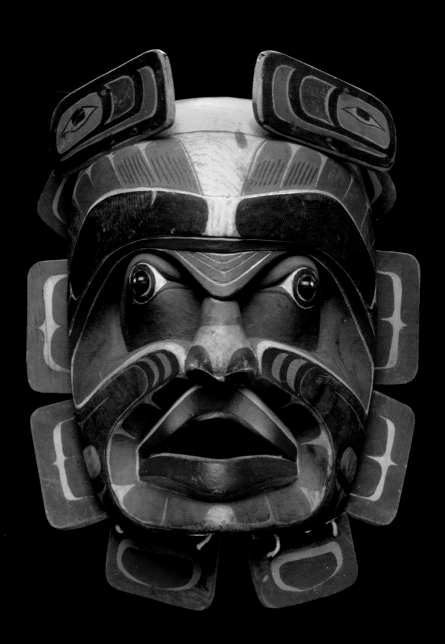

objects – that it must be stored in Maryland. The museum's historical exhibitions, however, all draw on these collections (look out also for temporary shows which explore contemporary art by Native Americans), and, since autumn 2010, new galleries showcase its permanent collection.

It was during the Late Pleistocene era, some 12,000 years ago, when glaciation had caused sea levels to drop, that a land bridge between Siberia and Alaska opened the way to the first significant migration into North America. The NMAI owns what are called 'points' – arrowheads, or cutting implements – dating back to this period. Indeed, half of the artefacts in the museum are archaeological in character, though a great many objects also give a rich impression of the diversity of tribal life, and some have a tale attached. Take the ceremonial pipe tomahawk, which was presented by the British army to Tecumseh, the Shawnee war chief, for his support against the Americans during the War of 1812. Tecumseh remained true to the spirit of his gift: when the odds became too much for the British at the Battle of the Thames, the British fled the field while Tecumseh and his men stood and fought.

An interest in Pre-Columbian art should not be the only reason to visit the **HISPANIC SOCIETY OF AMERICA**, since its holdings range from artefacts of ancient Spain, through relics of the Roman and Islamic eras, right up to the 20th century. It is particularly strong on work from the Spanish Golden Age (see Chapter 9), but the story it unfolds of Spain's arrival in the New World is fascinating. The museum owns a copy of Juan Vespucci's *Map of the World*, from 1526, which shows just how little Europe knew of the Americas at that time: while Africa's contours are relatively accurately described, the Americas form a bizarre curve, their Western coast vague and uncertain. One of the New World's chief attractions for the Spanish is described in an anonymous, naively styled watercolour of the silver mine at Potosí (*c* 1585), a city in Bolivia which until 1800 was home to one of the world's richest mines.

If you find these reminders of colonial plunder depressing, you might look at the bishop's featherwork mitre (*c* 1559–66): *amantecayotl*, or feather mosaics, were a highly prized art in Pre-Conquest Mexico, and the Spanish liked them so much they began to have them made for

Xi'xa'niyus (Bob Harris)
Kumukwamł (Chief of the Undersea mask), *c* 1900
NMAI
This mask, by Kwakwaka'wakw artist Xi'xa'niyus (Bob Harris) (*c* 1870–1935), represents Kumugwe' (Wealthy) – the Chief of the Undersea. He is believed to live under the ocean guarded by monsters, the doorway of his house being a monster's mouth. Certain ancestors were able to enter his house, and were permitted to marry one of his daughters and receive his riches as dowry.

Power figure (*nkisi nkondi*)
Congo, 19th century
BROOKLYN MUSEUM
Power figures were carved
with a cavity in their
abdomen to hold magical
ingredients; these were
activated by being breathed
on, and the cavity then
closed with a mirror. The
nails and blades may have
been driven into the figure to
drive out an evil force. Its
pose shows us he is ready to
defend his owner from
enemies.

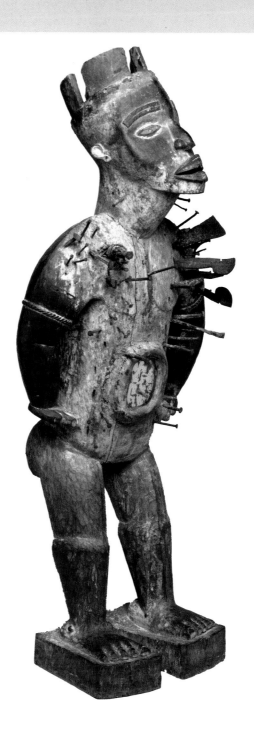

Peace medal
Kansas, 1845
NMAI
In the 19th century, the US
government bestowed
numerous medals on Native
American leaders who made
terms with them. On one side
of this example is the bust of
President James Polk, and
on the other are two shaking
hands and the motto 'Peace
and Friendship'.

European purposes, with imagery based on Old World prints.

Moving on to **EL MUSEO DEL BARRIO**, there is a much greater focus on contemporary art – mainly by New York-based Latino artists, and particularly Puerto Ricans – but it too has a Pre-Columbian story to tell. The culture of the Taíno people may be less celebrated than that of the Aztecs and Incas, but it dominated the Caribbean between 1200 and 1500. The museum's collection starts with objects such as a quartz amulet depicting twinned figures: twins were an important motif in Taíno art, since spirits were often thought of as pairs, personifying sun and rain, or sun and moon. Curators are unsure of the object's date; it may have been made at any time during the Taino period. But they are certain of the origins of the museum's copy of a remarkable book by a Spanish Dominican friar named Bartolomé de las Casas. *A Relation of the First Voyages and Discoveries Made by the Spaniards in America* was published in Seville in 1552 (the museum owns a slightly later English edition) and is remarkable for its time in documenting the brutal treatment of the indigenous people by the Spanish invaders.

To complete this picture of Taíno culture, the museum's collection of graphic art contains a poster, designed by Eduardo Vera Cortés (1926–2006), for a documentary film about the Taínos made in the early 1970s, a period during which Puerto Rican artists were particularly inspired by Taino heritage.

THE
WESTERN
TRADITION

America's most powerful art collectors today look back perhaps only a century or so for all that is most revered in their culture. Picasso and Andy Warhol (1928–87) are their idols – at least if auction results are any guide. Yet their predecessors in the 19th century looked back a lot further – to Italy, and the Italian Renaissance in particular, as the conduit through which the best of their civilisation had come down to them. So when American industry achieved enormous advances after the Civil War, and searched around for a style that would trumpet its newfound confidence, architecture answered with the American Renaissance Movement. The Great Hall and the facade of the Metropolitan Museum, and the building that houses the Brooklyn Museum, all bear its stamp. The architect's initial plans for the Frick Collection even conceived it as an Italian palazzo.

But in looking back, Americans were only joining a much larger tradition of reverence for Italy, and the Classical, that dates back much further. It is significant, in this regard, that when the **METROPOLITAN MUSEUM OF ART**'s great collection of Italian art finally starts to thin, it does so in the 18th century, when we come upon pictures like *Ancient Rome* and *Modern Rome* (both 1757) by Giovanni Paolo Panini (1691–1765). Italy's glories had passed, tourists were arriving on the Grand Tour and artists were starting to specialise in picturesque views of monuments and ruins. Indeed, like contemporary citybreak travellers buying postcards, some Grand Tourists wanted reminders of it all, and artists like Panini devised ingenious new compositions to satisfy their hunger. Borrowing from the Flemish tradition of picture-gallery scenes, Panini hangs fantastical, cavernous spaces with, in *Ancient Rome*, paintings of monuments and ruins (the Pantheon, the Colosseum) and, in *Modern Rome*, paintings of Renaissance and Baroque additions (Bernini's fountain at Piazza Navona).

The Metropolitan Museum must be your first port of call for Italian art in New York, particularly since it is now the home of one of America's most extraordinary private art collections, assembled by investment banker Robert Lehman. The collection includes some outstanding work from the Renaissance, and today it is housed in its own suite of galleries which echo Lehman's former New York townhouse. (It is a far cry from a Renaissance palazzo, however, and if you want to see how real Italian patrons once appreciated art, you might instead seek out an intriguing period room elsewhere in the museum, the Studiolo (*c* 1478–82), a study-cum-gallery from the Ducal Palace of Gubbio.)

Following the Metropolitan, a stroll down to the **FRICK COLLECTION** is essential: there you will find Henry Clay Frick's typically brief but brilliant selections. The **BROOKLYN MUSEUM** also has a notable collection, with some good examples of the Sienese school, and pictures by Giovanni Bellini (*c* 1430–1516) and Jacopo Tintoretto (1518–94), though the collection is not of the same quality as those in Manhattan.

MASTER OF THE OSSERVANZA
Saint Anthony the Abbot Tempted by a Heap of Gold, *c* 1435
METROPOLITAN MUSEUM
Although the Sienese were renowned for the humanity and formality of their Early Renaissance art, this piece by the Osservanza Master (the artist's identity being uncertain) is remarkable for its eerie mood. More peculiar still, the titular heap of gold has been scraped away, leaving the saint recoiling from an animal.

Andrea DELLA ROBBIA
Tondo: Prudence, c 1475
Renaissance sculptors did not confine themselves to making the freestanding bronzes we think so prestigious today. Della Robbia (1435–1525) also produced highly coloured terracotta reliefs such as this, using a technique developed by his uncle, Luca (1400–82). This represents the Christian virtue of Prudence, surrounded by fruit which might represent the four seasons.

When Duccio (1255–1319) produced his *Madonna and Child*, around 1300, Medieval piety still directed the focus of Italian art, and Byzantine religious art still influenced its style. The gold leaf that furnishes the background of Duccio's composition is typical of Byzantine icon painting, as is the intimate posing of the figures; the damage to the bottom of the picture's frame is from candles that were burned in private devotion before this image of God. But some things in this picture are new, and different: the figures seem more real and substantial than they had done before, and the painted parapet that appears at the base of the picture thrusts awkwardly forward, trying – for the first time – to reach out from the painted world into the real. It heralded the onset of the Renaissance.

Duccio's art matured in the surroundings of Siena, which at the time was the most prosperous Tuscan city outside Florence. It produced many of the first innovators in Renaissance art, several of whom are represented in the collection: Giovanni di Paolo (c 1403–83), whose *Creation of the World and the Expulsion from Paradise* (1445) contains a strange circular symbol representing the universe; Simone Martini (c 1284–1344), who is represented by all three parts of an altarpiece commissioned by Siena's civic government; and Sassetta (c 1392–1450), whose charming *Journey of the Magi* (c 1435) shows the Magi on their way to Bethlehem, their guiding star placed mysteriously and inventively low in the foreground of the picture.

Arguably, though, it was Florence that was the true wellspring of the Renaissance. It was here that the Medici banking empire emerged in the late 14th century, and Giotto (1267–1337), who was regarded by all Renaissance artists as a father figure, spent many years there. Giotto is represented by *The Epiphany* (c 1320), which uses the simplest architectonic depiction of a stable to lend a new sense of space and volume to the picture. It was also in Florence that scientific perspective was developed: one can see a famous and exemplary use of this in *The Annunciation* (c 1485) by another leading Florentine, Botticelli. Advances such as these could not be confined to the city walls: it is believed that, through the sculptor Donatello (1386–1466), Florentine ideas reached Padua, and hence the eyes of painter Andrea Mantegna (1430–1506); his *Adoration of the Shepherds* (c 1450) shows what he was capable of when he was only in his early twenties.

Southern Italy was slower than the north in taking up Renaissance ideas. The influence of the Gothic style clung on longer there, as one might surmise from looking at *Christ Crowned with Thorns* (c 1470), by Antonello da Messina (c 1430–79), an artist who was influenced by the many Flemish portraits he saw while growing up in Naples. Some in Rome sought to change this in the early 16th century; hence Pope Julius II lured artists such as Michelangelo (1475–1564) and Raphael (1483–1520) to work on projects in the Vatican. Michelangelo's *Studies for the Libyan Sibyl* (1508–12) shows one of the female seers who adorns the Sistine Chapel ceiling.

Nevertheless, despite the Pope's noble efforts, Florence remained dominant throughout the High Renaissance. Leonardo da Vinci (1452–1519) and Michelangelo had both trained in Florence. Leonardo's *Head of the Virgin* (1508–12), a fully developed preparatory drawing for his *Virgin and Child with Saint Anne* (c 1510), which hangs in the Louvre in Paris, points to the importance of line and drawing in the Florentine style. Raphael also passed through the city between 1504 and 1508, and although his altarpiece, *Madonna and Child Enthroned with Saints* (c 1504), is mostly reminiscent of his early years in Perugia, the boldly modelled figures point towards the development of his Florentine phase. Even after all three men had left Florence, other talented artists remained there to pioneer new styles, transforming the calm grandeur of the High Renaissance into the overripe contortions of Mannerism. *Portrait of a Young Man* (1530–40) by Bronzino (1503–72) is jewelled with the kinds of jokes that entertained this later period,

Domenico GHIRLANDAIO
Francesco Sassetti and His Son Teodoro, c 1488
Francesco Sassetti was a manager of the Medici banking empire, and when the bank's fortunes declined

he decided to leave home to attend the emergency. Intriguingly, it is thought that this picture by Ghirlandaio (1449–94) marks an affirmation of his wish that his family be provided for.

Michelangelo Merisi da CARAVAGGIO
The Musicians, c 1595
Figures playing musical instruments often symbolise stages of love, and although this picture is an allegory of

music, Cupid appears in the background. It is interesting to compare this salute to pleasure with more moralising treatments of the theme by Vermeer, also at the Metropolitan.

such as the way the grotesque heads in the furniture rhyme with the similar forms in the man's breeches.

Venice, meanwhile, also nurtured its own distinctive style of High Renaissance art, becoming particularly renowned for its artists' use of colour. The formal composition of Bellini's *Madonna and Child* (c 1480–5) may recall an older time, but the rich colour points forwards to this new phase; so too does the atmospheric landscape that peaks out beyond the traditional 'cloth of honour' which was often depicted behind the throne of the Virgin and Child. Bellini's most talented pupil was Titian (c 1490–1576), whose invention and virtuosity are apparent in pictures from throughout his long career, for example in his *Portrait of a Man* (c 1515), which was once attributed to Titian's other great teacher and collaborator, Giorgione (1477–1510), and also in his *Venus and the Lute Player* (c 1565–70), which may expound Neoplatonic ideas about whether beauty is better apprehended through sight or sound; note how Titian creates a dramatic contrast, even greater than that in the Bellini, between the rich, sequestered foreground and the landscape background.

This dynasty of talents was continued by Paolo Veronese (1528–88) who learned from Titian and Albrecht Dürer (1471–1528). His *Boy with a Greyhound* (possibly 1570s) may have originally hung to the side of a door, since the unusual backdrop – part wall, part landscape – seems to call for such a border to complete its suggestive spatial illusionism.

If you want to see the wonders Venetian glassmakers were capable of in this period you

should look at the pilgrim flask (c 1500–25), which also highlights the influence of the Islamic world on this famous gateway between East and West.

If Rome was held back by the political instability in southern Italy throughout the 16th century, in the following century it finally pushed itself into the forefront as a leader of the Baroque. The Carracci brothers Annibale (1560–1609) and Agostino (1557–1602), and their cousin Ludovico (1555–1619), were crucial in introducing the innovations that moved Italian painting out of

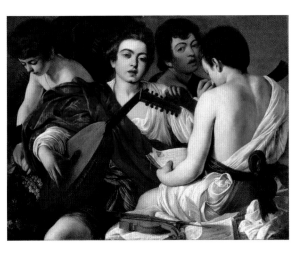

Mannerism and into the Baroque. They first emerged in Bologna, but Annibale's work in Rome had the most profound effect in spreading their ideas. The connection of the Baroque to the Catholic Counter-Reformation is readily apparent in the confidence and grandeur of his *Coronation of the Virgin* (after 1595).

Another key figure in the Roman Baroque was the sculptor and architect Giovanni Lorenzo Bernini. He learned much from his father, Pietro (1562–1629), whose work is represented by

Antonio CANOVA
Perseus with the Head of
Medusa, 1804–6
This Perseus, by Canova
(1757–1822), is a close
replica of one from the
Vatican and reminds us how
Italians returned to antiquity
long after the Renaissance.
It borrows from the *Apollo*
Belvedere, a sculpture from
Classical antiquity which had
stood in the Vatican, but
which it replaced after
Napoleon had the *Apollo*
transported to Paris.

Figures of Flora and Priapus (1616), but it was quickly apparent that the son would excel his father: *Bacchanal* (1616) shows his abilities when he was only about 18. Bernini's influence is also apparent in portrait busts by Giovanni Battista Foggini (1652–1725): *Grand Duke Cosimo III de' Medici* (c 1676–82) dates from just after Foggini had returned to his native Florence from Rome, and it is fully charged with Baroque energy.

Amid all this ebullience, Rome also fostered realists, foremost among them Michelangelo Merisi da Caravaggio (1571–1610), who is represented by *The Musicians* (c 1595) and *The Denial of St Peter* (1610). The latter was painted in the final months of the painter's life and, in his characteristic manner, it translates the biblical incident into a compressed moment of human drama. More proto-Romantic in spirit, but similar in his sense of drama, was another southern Italian painter, Salvator Rosa (1615–73), whose *Dream of Aeneas* (c 1663–6) shows the hero exhausted by the banks of the River Tiber, the river god above assuring him that his travels are over and that he has reached his goal, the founding of Rome.

If one reads the tradition of Italian art from the Renaissance to the Rococo as a long dialogue about reality and artifice, then the last exchange occurs in Venice. Reality has its say in pictures by Canaletto (1697–1768), like *Piazza San Marco* (late 1720s), and by Francesco Guardi (1712–93), such as *The Antechamber of the Sala del Maggior Consiglio* (c 1765), which reveals a room in the Palazzo Ducale, Venice's seat of power. But the accent on artifice is much stronger. Look for the period bedroom from the Sagredo Palace, Venice (c 1718), a frothy confection in stucco and carved wood that writhes with *amorini,* Cupid's winged helpers. And seek out pictures by

Giovanni Battista Tiepolo (1696–1770), who has the last magnificent word on artifice. The painter may not be as beloved by the public as some of his peers, but scholars have always esteemed him, and the Metropolitan owns several of his masterpieces. *The Capture of Carthage* (1725–9) shows his early style; *Glorification of the Barbaro Family* (c 1750), like several of his compositions, was produced as a design to decorate the ceiling of a palazzo in Venice; and *Allegory of the Planets and Continents* (1752) is an oil sketch produced when he was at his most confident: Apollo sets forth on his daily voyage across the sky, while celestial figures line the circling clouds.

Andrea del SARTO
The Holy Family with the
Infant Saint John the
Baptist, c 1530
Florence came under the
influence of the fervent
religious and political leader
Girolamo Savonarola in the
late 15th century. This later
picture by del Sarto (1486–
1530) may take heed of one
of his ideas, that Florence
should replace St John the
Baptist as its patron saint
with Christ.

SEE ALSO

PIERO della Francesca
St John the Evangelist,
c 1454–69
FRICK COLLECTION
Scholars are uncertain as to whether the figure in this altarpiece panel represents the Evangelist, since he

bears no identifying attribute, but the style is typical Piero – the figure standing in calm thought against a blue sky, the architectural surrounds straining to lend him the substance of a real individual.

Paolo VERONESE
Allegory of Wisdom and Strength, *c* 1580
FRICK COLLECTION
Veronese has been described as a finer decorator than he is a persuader, and one might

ask if the rich splendour of his Venetian Baroque style is really appropriate for this moral subject. Wisdom looks heavenward for guidance; Hercules look to the jewels – worldly strength – scattered on the ground.

Italian art was not Henry Clay Frick's first love, but when he started to buy he did so judiciously and, despite the concision of its collection, the **FRICK COLLECTION** offers the same full sweep across the history of Italian art as the Metropolitan. The story begins just as early, too, with Duccio's *Temptation of Christ on the Mountain* (1308–11), one of a series of panels illustrating the life of Christ that originally formed part of the artist's *Maestà*, a vast double-sided altarpiece for Siena's cathedral. This fragment shows Christ banishing the winged, black devil; he looms over both the mountain he stands on and the doll's-house kingdoms that the devil has conjured to tempt him.

The Frick also manages to fill out gaps in the Metropolitan's coverage of the Early Renaissance, offering four pictures by Piero della Francesca, two of which, *St John the Evangelist* (*c* 1454–69) and *The Crucifixion* (date unknown), may originally have been part of the same altarpiece in a Tuscan church. Another highlight is Bellini's sizable panel *St Francis in the Desert* (*c* 1480), which may show the saint in the Apennines on the retreat during which he received the stigmata (the miraculous appearance of the wounds of Christ's crucifixion). The landscape is dotted with strange details that, to informed contemporaries, would have resonated with Franciscan ideas. Moving on into the 16th century, the collection also offers portraits by Titian and Bronzino, and mythologies by Veronese, such as *Allegory of Wisdom and Strength* (*c* 1580).

Although the Frick recently constructed a new gallery devoted to sculpture, many of those in its collection still stand among its paintings, which seems fitting when one realises that the sculptures were often produced by polymaths who excelled in all the arts. Antonio del Pollaiuolo (*c* 1432–98), for instance, was adept as a painter, sculptor and goldsmith, and the collection offers three pieces that are associated with him. His *Hercules* (date unknown) shows us the legendary founder of Florence; the attribution and dating of *Hercules in Repose*, and *David*, are also uncertain, but the

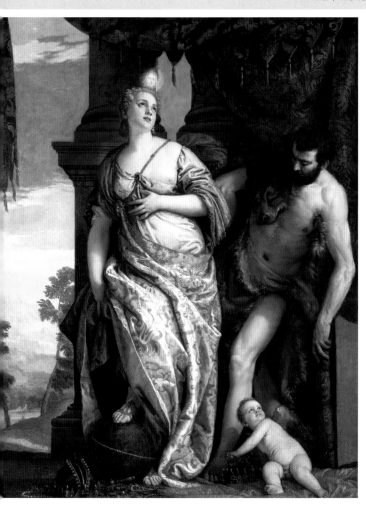

David may be a later work given that the biblical figure eventually replaced Hercules as the favourite hero of Renaissance Florentines. Another interesting sculpture with uncertain authorship and dating is *Samson and Two Philistines*: it is probably a copy of one of Michelangelo's models, most likely for a marble which he hoped would accompany his *David* (1501–4) in Florence's Piazza Signoria.

Most of the Frick's bronzes are freestanding figures, but the collection has one particularly striking relief by Vecchietta (1410–80), a Sienese artist influenced by Donatello. His *Resurrection* (1472), which may originally have served as the door to a tabernacle, shows Christ hovering above his tomb, surrounded by angels, while Roman soldiers slumber beneath. Further into the realm of decorative art is *Lamp* (date unknown) by Andrea Riccio (1470–1532), which draws on the artist's considerable Classical learning to create just the kind of ornate, boot-shaped object from which one would expect a genie to leap. See also a pair of cassoni with reliefs of Apollo (16th century), two ornately carved chests that traditionally held valuables in a Renaissance home. Although the chests exploit the warmth and lustre of walnut, their form recalls the marble sarcophagi of Roman times.

She has been standing in New York Bay for so long, and so many have come to know her, that one can forget that the **STATUE OF LIBERTY** (1875–84) is a work of French art. Gifted to the American people by the French government, and dedicated in 1886, she commemorates the liberty and friendship of the two nations and was the work of French academic sculptor Frédéric-Auguste Bartholdi (1834–1904), who personally selected the site on Bedloe's Island.

Of course, French art in Bartholdi's style, a grand, austere Classicism, fell out of favour with the rise of modern art; the work of his contemporaries is now held up to exemplify all that was wrong with academic art. And the traditions that European art academies upheld in their 19th-century heyday – fine technique, study of the human figure, and themes drawn from Western myth and history – hold few attractions for our artists today. But historians and critics have been looking on this work with more interest in recent years, and New York is lucky to have the **DAHESH MUSEUM OF ART**, the only institution in the US that is devoted to the academic tradition in the 19th and 20th centuries.

The Dahesh represents the tradition as it evolved right across Europe, but it has particularly strong holdings of French art. It grew out of the collection of Dr Salim Moussa Achi, a Lebanese writer, philosopher and connoisseur who wrote under the name of Dr Dahesh, Dahesh being an Arabic word meaning 'wonderful' or 'inspiring wonder'. His collection was brought from Beirut to the US in 1976, and formally opened to the public as a museum in 1995. It not only provides a venue for the permanent collection, which runs to more than 3,000 objects including paintings, prints and watercolours by the likes of William-Adolphe Bouguereau (1825–1905), Alexandre Cabanel (1823–89) and Jean-Léon Gérôme (1824–1904), but also regularly stages temporary exhibitions.

As in most areas of art, though, the collections of the **METROPOLITAN MUSEUM OF ART** excel all others in the city for the breadth, depth and quality of its holdings of French art. Its galleries will take you from the work of unidentified court painters of the 15th century through to, and beyond, the work of moderns like Picasso and Matisse (for a fuller treatment of art after 1860, see Chapters 12–23 which cover modern art.

If you find yourself drawn to the work from the 18th and 19th centuries, take a short walk south down Fifth Avenue to the **FRICK COLLECTION**, which has a particularly good group of pictures by the Rococo painters François Boucher (1703–70) and Jean-Honoré Fragonard (1732–1806). All are laid out in exquisite galleries furnished with European decorative art. If you are weary after a day on your feet, the Frick's Garden Court is modelled on a Roman atrium and offers a serene, enclosed refuge with statuary and a bubbling fountain.

Frédéric-Auguste BARTHOLDI
Statue of Liberty, 1875–84
It is said that Bartholdi settled on Bedloe's Island for the site of his monument as soon as he sailed into New York Harbour. The statue has a skeleton constructed by Alexandre Gustave Eiffel (1832–1923), who built the Eiffel Tower (1887–9), and a copper skin that moves independently of the skeleton, meaning *Liberty* has little to fear from the harbour winds.

Nicolas POUSSIN
The Rape of the Sabine Women, c 1637
Poussin followed Plutarch's account of this incident from Classical legend, in which Romulus, the founder of

Rome (here seen on the podium to the left), invited the Sabine tribe to a religious celebration with the intention of detaining their women, as wives were lacking in his new city.

The story of art in France from the 15th to the 17th centuries could almost be told as the story of the struggle between the styles of the north and the south: a rivalry between the clarity, calm and sinuous lines of Netherlandish artists and the warm colour and muscular vigour of the Italians. It was not until the close of this period that the country's artists began to evolve their own native tradition.

Initially, it was locality rather than nation that exerted the most powerful influence: small centres of production represented the engines of activity in the late 15th century. Avignon was one of these, and *The Pértussis Altarpiece* (1480) features a landscape view of the city in the background; in the foreground, Saints John the Baptist and Francis venerate the cross.

Jacques-Louis DAVID
The Death of Socrates
(overleaf) 1787
Inspired by Plato's dialogue
the *Phaedo*, the scene
depicts Socrates on a prison
bed after being condemned
to death for criticising
Athenian society. Exhibited in
the prestigious Paris Salon in
1787, the picture served to
rally the Revolutionary
bourgeoisie, urging them,
like Socrates, to be prepared
to die for their cause.

Although Avignon is in the south of the country,
the picture was clearly shaped by the crisp
simplicity of design found in northern art. And one
can see this again in Jean Clouet's (c 1485–
1540/1) likeness of *Guillaume Budé* (c 1536),
the scholar and humanist who established the
library that was to become the nucleus of France's
Bibliothèque Nationale.

However, Clouet is perhaps not the most
representative figure of French art in this period,
because although he rose to be chief painter to
Francis I, it was under the patronage of this king
that the nation began to open up to Italian
influence. The style of the Fontainebleau School, as
it became known, after the court of French kings, is
infused with the elegance, contortion and opulence
of Italian Mannerism. *The Nymph of Fontainebleau*
(late 16th century), by an unknown French painter,
is derived from a decorative composition by
another artist that originally hung in Francis' gallery
at Fontainebleau. It details the myth of the
discovery of this favourite residence of the French
kings, according to which a dog named Bléau
came upon a clear spring in the middle of the forest
during a royal hunt. In the original composition, the
spring was represented by a nymph leaning on an
urn from which waters flow; here, the nymph has
become Diana, the goddess of hunting.

The battle between northern and southern
styles sometimes resulted in some strange fusions.
Georges de la Tour (1593–1652), one of the most
original French Baroque painters, exemplifies
these, as although he may never have gone to
Rome he absorbed the manner of the Italian
Caravaggio from his Dutch followers. *The Penitent
Magdalen* (1638–43) is one of a series of pictures
he painted of the Magdalen, and it depicts her at
the moment of her conversion. It is a characterful
example of the artist's use of pronounced
chiaroscuro, the light from the candle throwing
harsh shadows across the scene and illuminating
the skull, a bleak memento mori, that lies on
her lap.

The painter who would come to most
powerfully represent Italian influence in French
painting was Nicolas Poussin (1594–1665). Venice
and Titian shaped his early style most significantly;
later, Raphael and the Antique came to dominate.
Scholars have spilt much ink over the meanings of
his *Blind Orion Searching for the Rising Sun*
(1658), but essentially the picture shows a scene

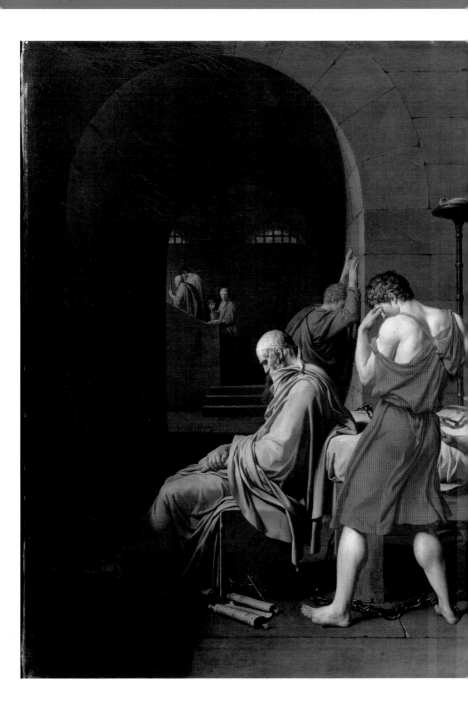

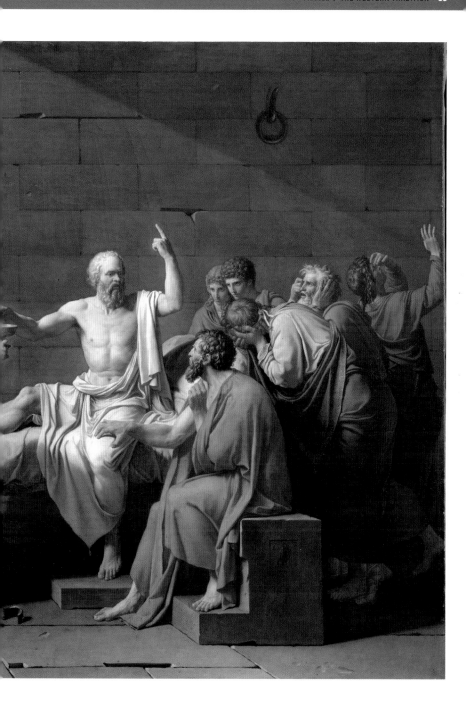

François **BOUCHER**
The Toilet of Venus, 1751

The Marquise de Pompadour, mistress of Louis XV, is thought to have commissioned this picture to hang in the bathroom of Bellevue, her château near Paris. The flowers remember her role as patron of gardeners, and the pearls allude to her birth from the sea. She is surrounded by winged *putti* and doves, her traditional attributes.

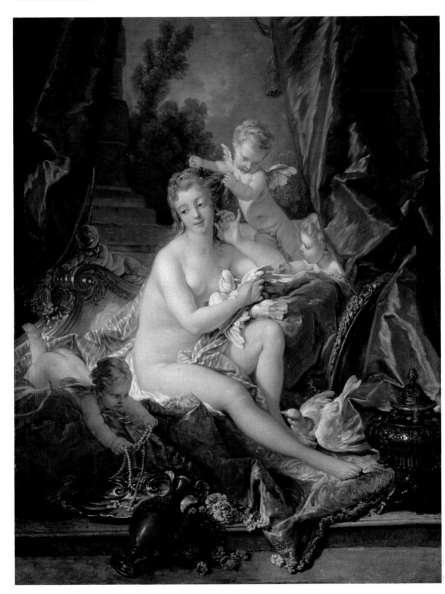

from Classical legend in which the giant hunter, Orion, blinded by the King of Chios for ravishing his daughter, attempts to find the rising sun. An oracle has told him that this will restore his sight; his guide, Cedalion, stands on his shoulder, urging him on.

Poussin soon came to represent the pinnacle of achievement for French artists, at a time when the country's academic tradition was taking shape, but he would have to share that acclaim with Claude (1604–82), his one-time sketching companion, whose work crystallised the ideal landscape for many far beyond France. Again, the Metropolitan boasts several fine pictures by Claude: in *The Trojan Women Setting Fire to Their Fleet* (c 1643), the artist employs a scene from Virgil's *Aeneid* as the basis for a grandly dramatic seascape and richly various light effects.

Although artists like Poussin contributed to the establishment of an enduring hierarchy among art's genres, with history painting at the top and still life at the bottom, the next century demonstrated that talents could flout that hierarchy and still find success. In the realm of portraiture, grandeur survived a little longer, as we can see in the work of painters such as Hyacinthe Rigaud (1659–1743) and Nicolas de Largillierre (1656–1746), and in the work of sculptors such as Jean-Baptiste Lemoyne (1680–1767). Lemoyne was Louis XV's favourite sculptor, and he created many portraits of the king; most were destroyed during the Revolution, but the Metropolitan has a bust from 1757, when the king was 47. Throughout the Rococo, however, decoration and warm sentiment were valued over grandeur and sobriety, and informality became the keynote of the splendid portraits by Jean-Marc Nattier (1685–1766). His *Madame Marsollier and Her Daughter* (1749) shows the daughter of a court official; Madame Marsollier was popularly known as 'La Duchesse de Velours', since she was the wife of a rich textile merchant who had purchased an aristocratic title.

Lighter still in mood is the work of Jean-Antoine Watteau (1684–1721), and his *Mezzetin*, from 1717–19, introduces us to a stock character from the Italian theatrical tradition of *Commedia dell'arte*, an amorous valet who sings his hopeless serenade while a statue of a woman stands in the distance with her back to him. Similar in its marvellous whimsy is a terracotta model for a balloon movement by Clodion (1738–1814). Clodion fashioned it in 1783, to commemorate the invention of the hot-air balloon. Aeolus, the god of wind, blows on one side of the balloon; Fame trumpets its progress on the other; and *putti* (the angelic infants that are so often seen making mischief in Renaissance art) see to the fire that will raise it into the skies. Sadly, the model was never made into a full-scale monument.

Not all 18th-century artists maintained this mood of diverting frivolity, and for some the influence of 17th-century Dutch art served to sober them up. Jean-Siméon Chardin (1699–1779) is best known as a painter of still lifes, and works like *The Silver Tureen* (1729) offer a strong example of this. But he could also paint moralistic genre scenes: *Soap Bubbles* (c 1734) seems entirely diverting, yet it is intended to carry a reminder of the fragility of life, and is based on several older Dutch examples. Jean-Baptiste Greuze (1725–1805) is another interestingly contradictory figure – sometimes light, sometimes sombre. He too was influenced by the sober themes and styles of earlier Dutch painters, and one can see this exemplified in *Broken Eggs* (1756), in which a young man shows his dismay at the life of a woman of easy virtue. If you examine the figure of the little boy on the right, you can see that he has just put down his bow and arrow to attempt to piece together the broken eggs: he was a reminder of the danger of playing with Cupid's darts.

By the end of the 18th century, when French painters celebrated great individuals, they championed them not as nobles destined to rule but as ordinary people made great by their talent.

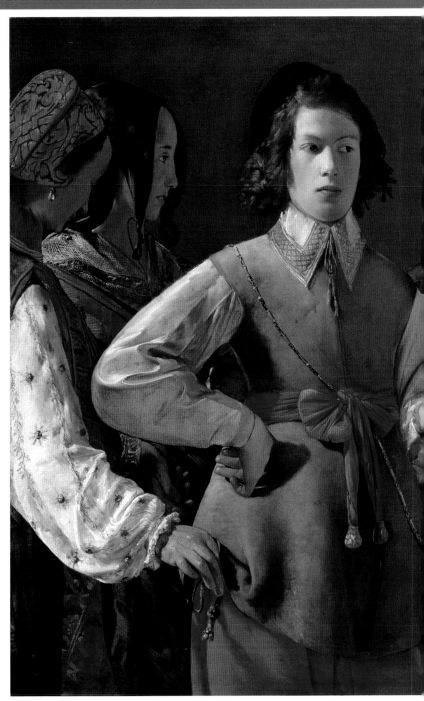

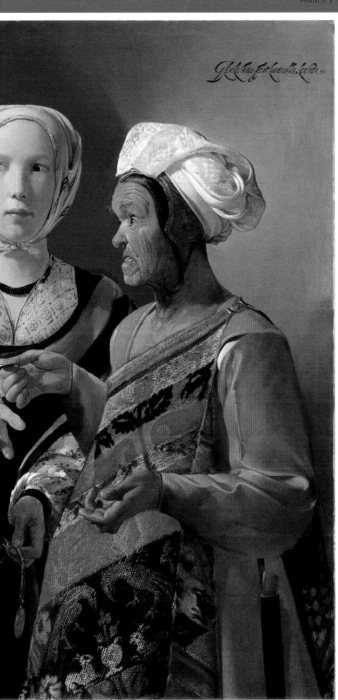

Georges de la TOUR
The Fortune Teller, c 1630

This is an unusual example of De la Tour's painting, as he is more often known for dramatically shadowy scenes. But its frieze-like composition and its theme – trickery – are still reminiscent of Caravaggio, from whom the Frenchman learned a lot. Even in daylight, it suggests, the innocent can be blind.

Honoré DAUMIER
The Third-Class Carriage,
c 1862–4
The spread of rail transport across France supplied subjects for Daumier (1808–79) for over two decades. There was change to document, undoubtedly, but there was also the comedy that derived from the mixing of different types and classes. Here one of the greatest satirists in French art looks at how the poor travelled.

The work of sculptor Jean-Antoine Houdon (1741–1828) is typical: he produced more than 150 busts of the great men of his age; his *Bust of Diderot*, the writer of the *Encyclopaedia*, from 1733, shows a man who is, above all, a human being. Jacques-Louis David (1748–1825) also painted some marvellous portraits of the period's leading lights, such as that of the scientist *Antoine-Laurent Lavoisier and His Wife* (1789).

With the exile of Napoleon and the restoration of the Bourbon monarchy, the austerity of David's manner gave way to a lighter Classicism. Artists like Jean-Auguste-Dominique Ingres (1780–1867) began to lavish their considerable skill on the wealthy bourgeoisie; his portrait of *Joseph-Antoine Moltedo*, from 1810–15, depicts a prominent industrialist who, at the time of the portrait, was director of the Roman post office (hence we can see the Colosseum and the Appian Way in the background). More Romantic in his Classicism was the sculptor Antoine-Louis Barye (1795–1875), who was renowned for his imagery of writhing animals: *Theseus Fighting the Centaur Bianor* (1846–8) remembers the battle of the Lapiths and Centaurs in Ovid's *Metamorphoses*. Meanwhile, other artists found fuel for their

Gustave COURBET
Young Women from the Village, 1852

Set in the hills around his native town of Ornans, Courbet (1819–77) submitted this landscape to the Salon of 1852 where critics reviled it. They might have liked the anecdotal scene of a young woman giving money or food to a poor cowherd, but were disturbed by the discordant scaling and perspective.

Romanticism by lending fresh impetus to an older grand manner. *The Abduction of Rebecca* (1846), by Eugène Delacroix (1798–1863), almost recalls Baroque art: it depicts a scene from Walter Scott's *Ivanhoe*, in which the beautiful Rebecca is abducted by two Saracen slaves at the behest of their master, Templar Bois-Guilbert.

Towards the end of the 19th century, French artists began to look to nature. Following the French defeat at the hands of Prussia in 1870, nationalism, realism and historicism came together in pictures like *Joan of Arc*, from 1879, by Jules Bastien-Lepage (1848–84), in which the Medieval French heroine is re-imagined as a contemporary French peasant experiencing visions in her garden. Artists like Jean-Baptiste-Camille Corot (1796–1875) found inspiration in the landscape around Fontainebleau, beginning the interest in *plein air* painting that would eventually lead to Impressionism.

Jean-Auguste-Dominique
INGRES
*The Comtesse
d'Haussonville,* 1845
FRICK COLLECTION
The artist was in his sixties
when he painted this picture
of the young Louise,
Princesse de Broglie, the
granddaughter of Madame
de Staël who, by her own
admission, was 'destined to
beguile, to attract, to seduce'.
He captures her as if
surprised, her evening wrap
and opera glasses discarded.

Chief among the attractions of the **FRICK COLLECTION** have to be the period rooms devoted to Boucher and Fragonard. The former was originally the sitting room of Mrs Frick, and it is designed around a suite of eight paintings that Boucher produced in the early 1750s for the Marquise de Pompadour, one of the mistresses of Louis XV. They are grouped around the theme of *The Arts and the Sciences*, and feature delightful scenes of children haplessly playing at great endeavours.

The Fragonard room also features a coherent suite of pictures: *The Progress of Love* was produced in the early 1770s for another mistress of Louis XV, the Comtesse du Barry, and in four stages it tells the story of a happy love affair. When Henry Clay Frick acquired it, he was so pleased that he spent another $5 million on furnishing the interior to contain the series. Curiously, however, when the Comtesse received the same series, she promptly returned it to the artist: some have speculated that the red-coated lover was so good a likeness of Louis XV that it might have caused embarrassment.

The marble portrait bust of *Louis XV as a Child of Six* (1716), by Antoine Coysevox (1640–1720), may show the king at too young an age for us to make that assessment ourselves, but it is still a fabulously vivid image of the boy only a year after he had succeeded to the throne.

Aside from these insights into French noble life in the 18th century, you should also look out in the Frick for works by Watteau, Chardin, David and Jean-François Millet (1814–75) and, in particular, Poussin's *The Sermon on the Mount* (1656) and Corot's *The Boatman of Mortefontaine* (1865–70).

In many respects the work in the **DAHESH MUSEUM** represents the culmination of the tradition of French art as it evolved through the Renaissance, Baroque and Rococo. Like that tradition, it encompasses the grandly ambitious and the frivolously diverting. Cabanel's *Death of Moses* (1851) represents the higher aspirations of the tradition of French art: the painting established the artist's reputation when it won second prize at the Salon in 1852, and it blends the muscularity of Michelangelo with the high colour of Raphael. *Andromeda Chained to a Rock* (1874) by Henri Pierre Picou (1824–95) may also sound very erudite, but Picou's version of the Classical tale, in which the warrior Perseus rescues Andromeda, is transparently a vehicle for sensual eroticism, as the goddess' naked body shines in the light.

The audience for French art in the mid-19th century had greatly expanded beyond the confines of the monarchy, clergy and nobility, and the newly wealthy middle-class sought new subjects. They were particularly fond of the work of *animaliers* like Constant Troyon (1810–65), still-life painters like Blaise Alexandre Desgoffe (1830–1901), and landscapists like Jules Breton (1827–1906), all of whom are represented in the Dahesh Museum. Under this new patronage, the history painting that rendered the great deeds of great men began to take on a more romantic and anecdotal tone. As France's empire expanded overseas, they also developed a taste for Orientalist pictures: *Portrait of Leconte de Floris in an Egyptian Army Uniform* (1840), by François-Léon Benouville (1821–59), commemorates one of the officers who was sent as an envoy to thank Pasha Muhammed Ali for the Obelisk of Ramesses II that was installed in the Place de la Concorde in Paris in 1836.

François **BOUCHER**
Madame Boucher, 1743
FRICK COLLECTION

After some years modelling
as goddesses and nymphs,
Marie-Jeanne Buseau, the
wife of the great court
painter, got to be herself in
this charming portrait. She
was 27 when it was painted,
and mother to Boucher's
three children. Some have
called it 'Boucher's untidy
Venus' because of her
relaxed pose and disordered
belongings.

GERMANY & THE LOW COUNTRIES

It was the Dutch East India Company that sponsored Englishman Henry Hudson on his 1609 expedition in search of the Northwest Passage. He sailed into New York Bay on 3 September, explored the river that would later bear his name, and sent back reports that encouraged the Dutch to fund several more expeditions. They formed a colony named New Netherland in 1614 and, in 1626, Peter Minuit bought Manhattan from the local Native Americans for a sum equivalent to $24. Ever since – and through wave upon wave of immigration from many other parts of the world – New Yorkers have maintained a special affection for the Dutch, and that affection has often translated into a taste for the nation's art. They have looked to the Golden Age of Dutch art, the 17th century, for the commercial qualities they like to see in themselves – commercial vigour, moral rectitude, and scorn for the pomp of monarchies.

In fact, New York offers art from across Northern Europe in the period between the early 16th and the mid-19th centuries. Coverage of Swiss and German art ranges from the Italianate production of Dürer to the Romanticism of Caspar David Friedrich (1774–1840) and Arnold Böcklin (1827–1901). The coverage of the Low Countries (today's Belgium and Holland) is similarly broad; it begins with the crystalline clarity of Early Netherlandish religious art by Jan van Eyck (1390–1441), but it is focused above all on the so-called Golden Age of Dutch art.

Purchases in this area represented the **METROPOLITAN MUSEUM OF ART**'s first significant attempt to assemble a comprehensive picture of a national school. Good Dutch paintings were abundantly available on the art market in Paris and Brussels when the museum's vice president made a purchasing trip there in 1871. In the decades following this, further purchases and gifts added up to create a fabulous bounty at New York's premier museum: five paintings by Vermeer (making him better represented here than in any other museum in the world, only 36 pictures being accepted as extant by the artist); 11 by Frans Hals (1581–1666); 20 by Rembrandt (1606–69), though here arguments over authenticity rage; and, in addition, some 200 more by figures ranging from Jan Steen (1626–79) to Meindert Hobbema (1638–1709).

A stroll down Fifth Avenue to the **FRICK COLLECTION** will enrich your experience: here are another three by Vermeer, two by Hals, and perhaps three by Rembrandt – again, though, a row over authenticity clouds the most famous and enigmatic of these, *The Polish Rider* (c 1655) – see page 103. If you would like to segue from the Netherlands to the New Netherland (the first name the Dutch gave to New York) you might look for some of the city's intriguing period rooms: the Metropolitan has the New York Dutch Room (1751), from a house built in the Bethlehem area of the city, and the **BROOKLYN MUSEUM**, where you can also be guaranteed to see a handful of good Dutch pictures, has no fewer than two small houses owned by the same family, the Schencks. Jan Martense Schenck built the earliest in the late 16th century, on the south shore of Long Island, and his grandson, Nicholas Schenck, built another a century later, in what is today the Canarsie section of Brooklyn.

Albrecht DÜRER
Adam and Eve, 1504
METROPOLITAN MUSEUM
This most Italianate engraving shows the influence of the Renaissance interest in human proportion. The figure of Adam may be based on the *Apollo Belvedere*, a famous Classical statue that had recently been excavated In contrast to this touch of modernity, the four animals in the scene allude to the Medieval notion of the four temperaments.

Quentin MASSYS
The Adoration of the Magi,
1526
Massys (1465–1530) was an
eclectic artist who borrowed
liberally from north and
south. The rich clutter in this
scene reflects the style of
Antwerp Mannerism, and
many of the costumes and
decorative objects similarly
reflect contemporary style.
But the extraordinary
expressions on the figures'
faces may have been
inspired by Leonardo's prints.

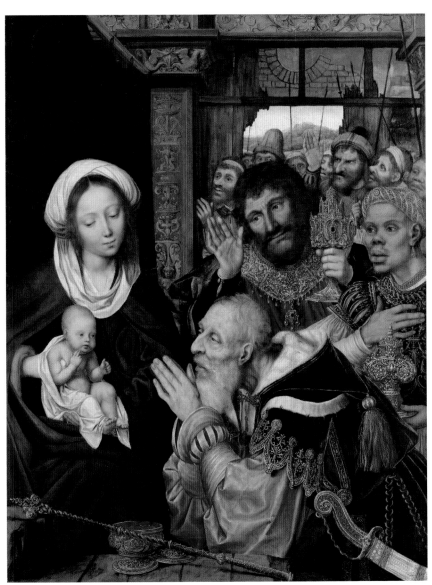

Gerrit DOU
An Evening School,
early 1660s
Dou (1613–75) was
Rembrandt's first pupil and
went on to a major career of
his own. He was strongly
influenced by his master, and
the contrast of light and
shadow in this late picture,
and the appreciation for
texture and materials, is
reminiscent of the older
man's style. Aptly, it also
celebrates the virtue of
teaching.

Contemporaries observing the Italian
Renaissance were wont to dismiss all that
came before it as crude and untutored, and time
passed before audiences changed their attitudes.
North of the Alps, however, scholars were never so
dismissive of their forebears, because there the
Gothic tradition had encouraged extraordinary
inventiveness. This is not to say that northerners
were unmoved by the advent of the Renaissance in
Italy, but, with superb Gothic art and architecture
throughout the region, and none of the rich, ruined
evidence of the Classical past that inspired the
Italians, the northern Renaissance took a different
shape to that in the south. Look, for instance, at
The Crucifixion and *The Last Judgement*, both
painted around 1425–30, early on in the career
of Van Eyck. Many of the pictures' figures –
particularly those at the base of *The Crucifixion* –
are observed with a new realism.

Similarly, *The Annunciation* (*c* 1450), which
has been attributed to another Flemish innovator,
Petrus Christus (*c* 1410–72/3), takes place at the
doorway to a garden that is observed with care and
attention to nature. Yet all of these pictures are still
steeped in the religiosity of the Middle Ages, and
seek none of the harmony that the Italians
cherished. If we look at Christus' *Portrait of a
Carthusian* (1446) we see the same sincere
religiosity filtered through eyes newly attentive to
the weight and texture of earthly life: look at the
detailed observation of the monk's beard – there
is even a fly sitting on the painted frame of the
picture.

Artists in Germany reacted differently to the
new ideas coming from the south, and were more
likely to absorb them. Dürer made two visits to
Venice, in 1494–5 and 1505–7, and what he
learned would be decisive for German art
throughout the 16th century. His *Virgin and Child
with Saint Anne* (1519) owes much to Bellini, its
warm, rounded figures being far different from the
linear, stylised types that populate most Gothic art.
The influence of the Classical tradition is even more
apparent in the work of Lucas Cranach the Elder
(1472–1553) who worked in the court of the
electors of Saxony. He enjoyed painting Classical
subjects, particularly *The Judgment of Paris*
(*c* 1528), but the example of the latter in the
Metropolitan nods to German Medieval treatments
of the subject, with the goddesses accompanied by
Mercury dressed in a costume associated with the
Nordic god Wotan. Cranach continued to paint
many religious subjects, such as *The Martyrdom of
Saint Barbara* (*c* 1510), which shows the saint's
beheading by her father, Dioscurus, after she
refused to abandon her Christian faith.

Germany does not figure strongly in New York's
art collections, and while there may be many
reasons for this, one is undoubtedly the fact that
the region's art declined with the advent of the
Reformation. Protestantism discouraged Catholic
traditions of religious art, and nothing powerful
emerged to replace them. This is not to say that art
perished with the arrival of Martin Luther; indeed,
Cranach served as something like his official
portraitist, and the Metropolitan owns a small
engraving by him of *Martin Luther as an
Augustinian
Monk,*

Peter Paul RUBENS
The Holy Family with Saints Francis and Anne and the Infant Saint John the Baptist, early 1630s
Perhaps it was Rubens' mature appreciation of family life which brought warmth to his later religious pictures. By this stage in his career he had a team of assistants, and although he seems to have personally repositioned several of the figures, his helpers certainly worked on passages of this picture.

Johannes VERMEER
A Maid Asleep, 1656–7
Like many of Vermeer's genre scenes, this likely has some moral import. The maid shirks her duties while a displaced chair, a large glass, and the open door point to the recent presence of a companion – a lover, perhaps. This picture was once owned by a Delft collector who had as many a 21 pictures by the artist.

produced in 1520, the year that Luther published his *95 Theses.* It also owns a fine, crisp oil portrait of him, though this was likely produced by Cranach's workshop rather than the man himself. What did flourish under Protestantism was portraiture, and fine examples of that can be seen in the work of Hans Holbein the Younger (*c* 1497–1543). His portraits of *Dierick Berck* (1536) and *A Member of the Wedigh Family* (1532) show the prosperous German merchants who traded from London in the period, where Holbein himself earned considerable income from his attachment to the court of Henry VIII.

Of course, the Reformation had consequences far beyond culture, and further north, in the Low Countries, it became a defining issue in the formation of a new nation-state. The Dukes of Burgundy had controlled the region from the late 14th to the late 15th century; subsequently, power shifted to the Spanish Habsburgs, and their Catholicism soon clashed with the Protestantism of the increasingly prosperous merchant class of the northern Netherlands. War settled the matter and, in 1579, the north bound together as the United Provinces while the south remained controlled by the Habsburgs.

Antwerp was the liveliest centre of production in the south, and its art is largely associated with the Italianate Baroque of the Counter-Reformation. But the city also fostered talents who benefitted from the spread of Protestantism, and one such was Pieter Bruegel the Elder (1525–69) who introduced important innovations in landscape. Previously, landscape had languished in the distance of religious subjects or it had served allegorical ends, but the suppression of religious subject matter in some Protestant lands encouraged it to come into its own. The Metropolitan owns Bruegel's *The Harvesters* (1565), the only canvas in America from the artist's famous six-part series depicting different times of the year. This scene shows peasants pausing to rest under a pear tree while others continue to cut and stack a field of wheat.

An interesting sign of the significance of Bruegel is *The Feast of Acheloüs* (*c* 1615), an unusual collaboration between his son, Jan Brueghel the Elder (1568–1625), who maintained his father's style, and the young Peter Paul Rubens (1577–1640). It is thought that Rubens designed the figures while Brueghel created the landscape and still-life elements. The scene shows a tale from Ovid's *Metamorphoses*, in which Theseus and his companions are entertained by the river god Acheloüs. More Italianate in influence – indeed, inspired directly by Titian –

is Rubens' *Venus and Adonis*, from the mid- or late 1630s. More Flemish, and endearingly homely, is a portrait Rubens produced of his own family during this period, including his second wife Helena Fourment and their son Peter Paul; Rubens married Fourment in 1630, when he was 53 and she 16. The diversity of Rubens' production – never mind its bounty – is testament to his talent, but in the realm of portraiture he was bettered by the man who, when only in his teens, was his chief assistant – Anthony van Dyck (1599–1641).

With justice, one might regard Van Dyck as an English artist – so much of his best work was produced there in the 1630s, and so great was his influence on subsequent generations of English artists like Thomas Gainsborough (1727–88). But Van Dyck always regarded Antwerp as home, and he yearned to return so that he might usurp Rubens' reputation on his own ground. *Self-Portrait* (1620–1), produced when Van Dyck was around 21, shows his precocious talent; it was probably painted shortly after he left his apprenticeship with Rubens. *James Stuart, Duke of Richmond and Lennox* (c 1634–5) exemplifies the grandeur with which he flattered his English subjects.

Now compare a portrait like *James Stewart* with one by Hals, perhaps his likeness of Harlem brewer *Nicolaes Pietersz Duyst van Voorhout* (1636–8).

Finally you can appreciate what has attracted Americans to the Dutch: Van Dyck flattered the court, Hals paid tribute to the city. The courtier would never have done justice to the subject of Hals' *Merrymakers at Shrovetide* (c 1616–17): one of the artist's earliest pictures, it shows stock characters from popular theatre crowding over a woman who, in fact, may be a man in drag. Food sits on the table before her, but the number of buried sexual references suggests that her companions have more on their mind.

The newly independent Dutch were often shown making merry in contemporary pictures; however, a keenly religious people, they always viewed such scenes within the moral framework of virtue and vice. Steen's *Dissolute Household* (1663–4) shows how standards can slide when such considerations are cast aside: the maid pours

Caspar David **FRIEDRICH**
Two Men Contemplating the Moon, c 1825–30
Three versions exist of this famous scene which probably shows Friedrich on the right, alongside his friend August Heinrich. Both wear the Old German dress which had become a symbol of opposition to the conservative policies that were adopted in the aftermath of the Napoleonic Wars.

wine for the lady of the house while flirting with her husband; the Bible is reduced to a footstool. The import behind such pictures is obvious, though scholars have had to work harder to tease out the meanings of pictures by Vermeer. *Woman with a Lute* (c 1662–3) shows a young woman gazing distractedly out of a window while she tunes her instrument; educated viewers may have understood her action as a reference to the virtue of temperance. *Young Woman with a Water Pitcher* (c 1662) balances symbols of worldliness (the map and jewellery box) with those of spirituality (the water providing an assurance of purity).

In comparison to artists like Vermeer and Steen, Rembrandt can seem Italianate. In fact he never saw the south, but he admired the work of those who had. The influence of Titian is evident in several of the Metropolitan's pictures, including *Flora* (early 1650s) and his portrait of his companion of the 1650s, *Hendrickje Stoffels* (1660). One might also detect a suppressed wanderlust in his early *Man in Oriental Costume* (1632), though pictures such as this (another, more mature, example is *Aristotle with a Bust of Homer*, from 1653) were the product of Rembrandt fantasising in the confines of his studio, toying with props and costumes.

As he grew older, Rembrandt grew less interested in such artifice and began to appreciate that the studio could also be a place of retreat where the masks we don in everyday life could be set aside, where honesty could prevail. This, at least, is how scholars have traditionally interpreted his many self-portraits – as a definitely modern searching of the doubtful soul. The Metropolitan's *Self-Portrait* of 1660 shows him entering his last decade, with lines of anxiety gathering on his forehead.

Hans **HOLBEIN the Younger**
Sir Thomas More, 1527
FRICK COLLECTION
Thomas More was a
humanist scholar, essayist,
diplomat, leading
parliamentarian, Privy
Councillor and Lord
Chancellor. Here, in 1527, he
seems at the height of his
power, wearing a chain that
signifies his service to Henry
VIII. But in 1532 he would
resign in protest at the king's
divorce; in 1543 he was
beheaded.

what misled Vasari. In terms of materials, the most important piece from this era in the Frick is actually *The Deposition* (c 1495–1500) by Gerard David (c 1460–1523). It is one of the earliest Northern European paintings executed in oil on canvas rather than on panel (artists of this period more often used a water-based medium such as tempera when they were working on a fabric support).

Inevitably, the Frick Collection recapitulates much the same history of Northern European art as one finds in the Metropolitan. Some of the stresses are slightly different, however. For instance, even though the collection can only offer a work associated with Rubens (rather

If Italy could claim to be the wellspring for most of the significant developments associated with the Renaissance, its artists did at least defer to northerners on the matter of technique. Vasari, the great Italian biographer, credited Van Eyck with the invention of oil painting. In fact, his praise went too far, as the artist only made refinements to what was already known. However, if you look at the dazzling skills on show in his pictures at the **FRICK COLLECTION** – such as *Virgin and Child, with Saints and Donor* (c 1441–3) – you can appreciate

than one certainly by his own hand), the importance of the Flemish artist is more apparent here. His technique shines through Hals' *Portrait of an Elderly Man* (c 1627–30). Van Dyck had not long left the master's studio when he painted the portraits of the celebrated Flemish painter *Frans Snyders* and his wife *Margareta Snyders* (both c 1620); his influence is clear both in the brushwork and backdrop. (Incidentally, the Frick is a good venue to appreciate the European – as opposed to the English – Van Dyck, since the

REMBRANDT van Rijn
The Polish Rider, c 1655
FRICK COLLECTION
Speculations have ranged widely: is he an ancestor of the Polish family that owned the picture in the 18th century, a Polish theologian, the Prodigal Son or the Old Testament David? No one is sure, and since no other equestrian portraits by Rembrandt exist, many also doubt that it is by the Dutchman's hand.

collection contains some of his portraits of Italian nobles.)

The Frick also offers views of the beginning and end of Rembrandt's career: there is a portrait of *Nicolaes Ruts* dating from 1631, only six years after the artist's earliest known work, and a great, late *Self-Portrait* (1658): painted when the artist was 52 and had suffered bankruptcy and illness, it is also painted in certainty of his unbroken human dignity. There is also the legendary and mysterious *Polish Rider*: all manner of identities have been suggested for the enigmatic rider, and recently an influential panel of Rembrandt scholars also cast doubt on its authenticity.

An intriguing pair of pictures by Hobbema at the Frick demonstrate the degree to which even masterful landscapists of the 17th century relied on stock formulas. His *Village with Water Mill among Trees* and *Village Among Trees* (both *c* 1665) are uncannily similar, with the same aging tree leaning over much the same charming farmhouse. There is also a trio of Vermeers that provide amusing counterparts to those at the Metropolitan, for if the latter show young lovers apart, two of the Frick's paintings show them together. The girl tuning her lute at the Metropolitan has put aside her music to entertain her man in the Frick's *Girl Interrupted at Her Music* (*c* 1658–9), and the slumbering, abandoned maid at the Metropolitan (see page 99) could almost be the livelier, smiling soul in *Officer and Laughing Girl* (*c* 1657).

But the last painting that Henry Clay Frick purchased strikes the same note of anxiety as those at the Metropolitan, and this time it is the lady of the house who is to suffer disappointment: in *Mistress and Maid* (1666–7), the maid emerges out of the darkness to hand her mistress a folded note; the lady turns her head just out of our sight, but the pen dropped on her letter, and the hand raised to her chin, say all that needs saying.

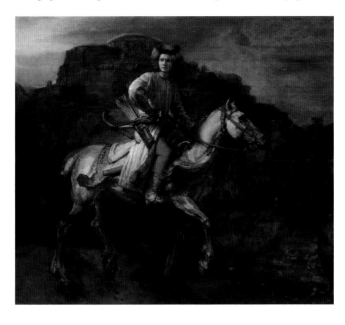

It may have been the chance purchase in a London bookshop of George Borrow's *The Zincali, An Account of the Gypsies in Spain* (1841) that inspired AM Huntington's lifelong enthusiasm for Hispanic culture. Judging by the character of the man, though, there could easily have been others seeds, and those could have led him elsewhere entirely. But whatever excited this young man's passion, it was certain to yield something great, for Huntington was one who followed inspirations to their end and beyond, and he had the funds to do so.

Archer Milton Huntington was the only son of the railroad and shipping magnate Collis Potter Huntington. His father would have liked him to assume the family business, but early on he decided that scholarship and collecting would be his occupation. He wanted to open a museum dedicated to Hispanic culture – to that of Spain, Portugal and Latin America – and soon enough he founded the **HISPANIC SOCIETY OF AMERICA MUSEUM AND LIBRARY**, which opened in a Beaux Arts building on Audubon Terrace in West Harlem in 1908.

Huntington had the precincts studded with public sculpture: there is an equestrian sculpture of the Spanish Medieval hero *El Cid* (1927), by his wife, Anna Hyatt Huntington (1876–1973); and bas-reliefs along the north wall of the museum, including portrayals of Don Quixote on Rozinante, and Boabil, the last Moorish king of Granada. Today the museum has one of the largest collections of Hispanic art outside of the Iberian Peninsula.

A visit to the **METROPOLITAN MUSEUM OF ART** and the **FRICK COLLECTION** should certainly be on your itinerary if you want to see some of the finest works from the so-called Golden Age of Spanish culture, the 17th century. In both museums you will find paintings by Diego Velázquez (1599–1660) and El Greco (1541–1614) – born in Crete, he was known as 'the Greek', but spent the second half of his life in Spain – and both also contain work by Francisco de Goya (1746–1828) from the late 18th and early 19th centuries.

But beyond examples by these luminaries, the Frick and the Metropolitan are somewhat thin in Spanish art, and one has to visit the Hispanic Society for a truly rich panorama. There you will find artefacts dating back to the second millennium BC, through to pictures from the 1950s. It is also dotted throughout with curiosities to divert you. There are copies of the first edition of Cervantes' *Don Quixote* (1605). There is a copy of the *Tercero cathecismo*, a book printed in three languages, which contains a series of sermons by the Jesuit theologian and historian José de Acosta. Priests used it on their missions of conversion. There is also a letter in Latin from English monarch Elizabeth I to Philip II, dated 20 January 1559. At this stage they were cordially discussing the exchange of ambassadors; soon they would be at war.

EL GRECO
The Holy Family,
mid-1580s
HISPANIC SOCIETY OF AMERICA
This is El Greco's earliest known treatment of the Holy Family, and is considered his finest. Saint Joseph acquired new importance in the Counter-Reformation, hence his prominence here, though in other versions of the subject El Greco portrayed him as an older man, reflecting debate over Joseph's age at the time of his marriage to Mary.

ANONYMOUS
The Family of Philip II of Spain, 1583–5
The style of this picture is typical of Renaissance court portraiture in Spain. It is eerie, in that slightly stiff and formal manner that naive art sometimes achieves. The king is attended by two older daughters who look identical, while the young, future Philip III looks merely like an adult depicted at the wrong scale.

Francisco de GOYA
The Duchess of Alba, 1797
The duchess was 35 when Goya painted this portrait. Her husband had died the year before, and here she is depicted still in mourning. The painting remained in Goya's possession until his death, though whether this was because it reminded him of a romantic attachment, or because the duchess refused the picture, we do not know.

The art of the Spanish Renaissance sometimes seems a peculiar stew, with a little of Italy and a little of the Netherlands. Martín Gómez the Elder (1526–62), for instance, who created the Hispanic Society's *Altarpiece of the Two Saint Johns* (*c* 1550), was influenced by one of Leonardo's followers. You can sense this in the soft brushwork, yet his style has elements of the north as well – look at the overall composition, the colour, and the styling of the figures. It was not until the 17th century, when Spain became the dominant power in Europe, that the nation's art began to find its own identity. But unlike Dutch artists of the same period who, after they gained independence from Spain, devoted so much of their art to celebrating nationhood, Spaniards proclaimed their allegiance to the Counter-Reformation church.

Seventeenth-century Spanish art is religious art, for the most part. In this regard, the subject matter of the pictures by El Greco is entirely typical: there are portrayals of *Saint Luke* (*c* 1590), *The Holy Family* (*c* 1580–5), *St Jerome* (*c* 1600) and a *Pietà* (*c* 1575). However, the intense Italian Mannerism of El Greco's style is an anomaly of the period; it was more common to find religiosity coexisting with a new naturalism. For instance, *St Rufina* (*c* 1635), by Francisco de Zurburán (1598–

1664), depicts one of the two patron saints of Seville in a newly realistic way (though she is attired in an unusual, anachronistic costume); she carries lumps of clay with her book (presumably a Bible) and these remind us of her time working in a pottery. Still life and portraiture were the only other genres that thrived in this period, and the Hispanic Society has several examples of the latter, including Velázquez's *Gaspar de Guzmán, conde-duque de Olivares* (*c* 1625–6), which shows the first minister to Philip IV (it is worth comparing this with the artist's equestrian portrait of the same man in the Metropolitan).

By the time we come to the 18th century, Spain was in decline, with its fortunes fading abroad and corruption taking hold at home. Goya is the great critic of this period, yet he still prospered as a portraitist, flattering his sitters with evocations of power and cultured ease. There is a light, crisp quality in his portrait of the nobleman and military officer *Manuel de Lapeña, marqués de Bondad Real* (1799). But more than respectful admiration may have motivated his portrait of the *Duchess of Alba* (1797): he spent several months on the estate of this famously charismatic beauty, and here she wears two rings, one reading 'Alba', the other 'Goya', and she also points to words in the sand that read *'solo Goya'* ('only Goya').

Moving into the 19th and early 20th centuries, one can get a sense of Spain's disappointment at how far it had fallen by looking at *The Victim of the Fiesta* (1910) by Ignacio Zuloaga y Zabaleta (1870–1945). The country had recently lost the Spanish-American war, and was searching its soul: here an aging picador slumps on a weakling nag as the sky blackens behind him.

Francisco de **ZURBURÁN**
The Young Virgin, c 1632–3
METROPOLITAN MUSEUM
It was once believed that, as
a child, the Virgin lived in the
Temple of Jerusalem, where
she prayed and sewed

vestments. This portrayal is
typical of the Sevillian artist's
style, which has been
described as monastic,
combining images of
devotion with exquisitely
observed detail.

The **METROPOLITAN MUSEUM** has some
excellent late-15th-century pictures,
particularly by Juan de Flandres (c 1460–1519),
but the name that stands out in its collection is El
Greco, not least because the collection includes
one of his most famous pictures, *View of Toledo*
(c 1597–9). This landscape view of the town where
the artist spent nearly 40 years is one of the

reasons why the Spanish feel justified in claiming
him as one of their own. But debate continues to
rage over the origins of his distinctive style: Greeks
point to the influence of Byzantine traditions and
icon painting, which one can perhaps see in the
concentrated focus of *Christ Carrying the Cross*
(c 1580); Italians, meanwhile, insist on the
importance of his time in Rome and Venice, and

Diego **VELÁZQUEZ**
King Philip IV of Spain,
1644
FRICK COLLECTION
The king had just completed
a successful siege against
the French in Catalonia when
he posed for this portrait in a
dilapidated makeshift studio.
Philip, an ardent supporter of
the arts, though a weak ruler,
wears the silver and rose
costume he wore during the
campaign.

the example of Tintoretto, which one can see in
The Miracle of Christ Healing the Blind (*c* 1570).
Others have explained the feverish imagery of
pictures like *The Vision of St John* (1608–14) with
talk of mental instability and an astigmatism.

Turning to Velázquez, the undisputed master of
the period, it is more tempting to see him as
defining authentic Spanish style. He also learned
much from Italy: from Caravaggio, in early pictures
such as *The Supper at Emmaus* (1622–3), and,
later, from Titian and Rubens, as is evident in the
equestrian portrait of *Don Gaspar de Guzmán*
(*c* 1635). But before we imagine that Spain was
stylistically dependent on Italy, we should
remember that in many respects the Baroque was
a Spanish invention; the mixture of religious
devotion and naturalistic depiction throughout the
period's art was distinctively Spanish.
Jusepe de Ribera (1591–1652) learned
from Italians such as Caravaggio, but he also
matured into an inspirational talent. *The
Holy Family with Saints Anne and Catherine
of Alexandria* (1648) shows Catherine
without her conventional attributes
('principally the wheel – the origin of the
Catherine wheel' – upon which she was
tortured); Saint Anne, meanwhile, appears
as a humble old woman carrying a basket
of fruit.

Moving into the late 18th century we
come again to Goya. His tone is naturalistic,
something he might have imbibed from
Spanish art throughout the 17th century;
and, in tune with his troubled times, his
concerns are often ethical. The
shortcomings of Spanish society prompted
him to produce a series of etchings, *The
Caprices*, including famous images such as
The Sleep of Reason Produces Monsters
(1799), and, later, the Spanish War of
Independence encouraged him to return to
the medium to create another series, *The
Disasters of War* (1810–23). Yet, almost

despite himself, Goya managed to climb the ranks:
his service to the family of the aristocratic lady
depicted in *Condesa de Altamira and Her
Daughter, Maria Agustina* (1787–8) helped him
to become court painter to Charles IV.

Moving on to the **FRICK COLLECTION**, we
can round out our survey of Goya by seeing *Don
Pedro, Duque de Osuna* (*c* 1790s), another
example of the skill that elevated his reputation with
the powerful. *The Forge* (*c* 1815–20), meanwhile,
demonstrates his feeling for the poor. The collection
also has superb examples of Velázquez's
portraiture, including a picture of the monarch he
served for many years, *King Philip IV* (1644); and
of El Greco's religiosity, including *Purification of the
Temple* (*c* 1600), one of the many versions of the
subject that he produced throughout his career.

Surveying, as this guide does, all of Europe's national schools alongside each other, we are forced to be unkind to England. Were we looking exclusively at early English art, we might feel justified in rounding out our coverage by taking in the work of foreign artists such as Hans Holbein the Younger, Anthony van Dyck and Peter Lely (1618–80). All spent a large part of their careers in England, the country could claim to have nurtured their best talents, and native artists learned much from their presence. Holbein was court painter to Henry VIII, Van Dyck served Charles I, and Lely Charles II. A trip to the **FRICK COLLECTION** will introduce you to Holbein's *Sir Thomas More* (1527), who was one of Henry VIII's key ministers – until he displeased him and was beheaded – and, among several excellent portraits by Van Dyck, to *James, Seventh Earl of Derby, His Lady and Child* (*c* 1632–41), a Royalist who, during the Civil War, was also executed for his beliefs.

A visit to the **METROPOLITAN MUSEUM OF ART** will demonstrate that when Holbein was not painting Henry VIII's court, he made a good living painting German merchants who were based in London. The same museum also owns a fine portrait, by Lely, of *Mary Capel, Later Duchess of Beaufort, and Her Sister Elizabeth, Countess of Carnarvon* (1650s), offspring of another powerful Royalist family.

Yet there is no escaping the fact that Holbein was German, Van Dyck was Flemish, and Lely – born Pieter van der Faes – was Dutch. Indeed, for much of its history, English art was dominated by foreign talent. It was only in the 18th century, with

the emergence of figures such as William Hogarth (1697–1764), Joshua Reynolds (1723–92) and Gainsborough that something approaching an authentic national school began to stake its claim (and then we might better describe it as 'British' art, since it was only in this period that the people of England, Scotland, Wales and Northern Ireland began to uneasily unite).

It is the abundance and quality of English work from the 18th century in New York's collections that persuades us not to relegate coverage of the nation's art to a sidebar. The Metropolitan also boasts three exquisite, mid-18th-century interiors which remind us of the settings in which so many of these pictures were seen: the tapestry room from Croome Court in Worcestershire, designed by Robert Adam (1728–92) and fitted with tapestries from the Royal Gobelins Manufactory in Paris; the dining room from Kirtlington Park in Oxfordshire, with ornate Rococo stuccowork; and the dining room from Lansdowne House in London, another Adam interior (but more restrained and Neoclassical in tone) which was a regular resort of the period's most powerful politicians.

If, when you have taken all this in, you would like to extend your study into the 19th century, a visit to the **DAHESH MUSEUM OF ART** is recommended. It is an interesting place to see this traffic between native and foreign, home and abroad, expressed in a new way, in a sequence of academic paintings that leap from scenes of English countryside and figures from English literature to fantastic scenes from the distant reaches of the nation's colonies.

William HOGARTH
The Wedding of Stephen Beckingham and Mary Cox,
1729
METROPOLITAN MUSEUM
Hogarth is better known for his satirical prints than his paintings. Interestingly,

scholars have noted that the interior depicted in this image does not match that of the church in which Beckingham a lawyer, was married; they have surmised that it may have been executed by someone other than Hogarth

Nicholas **HILLIARD**
Portrait of a Young Man,
Probably Robert Devereux,
Second Earl of Essex, 1588
Hilliard was one of the finest
miniaturists of the
Elizabethan age, and this
portrait shows a soldier and
courtier who at one time was
a favourite of the queen.
Here he is aged 22; he
would be executed in
1601 after he began
scheming to remove
Elizabeth's counsellors.

I t is true that if we deny ourselves a glimpse of
the great foreign artists who shaped English
production in the 16th and 17th centuries, the
story of the nation's art in this period – the story at
least as it is told in New York's museums – is
patchy. But it does not disappear entirely; a fresh
story emerges, and one different in tone from the
grand manner of Van Dyck and Lely. Miniature
painting was particularly popular in England in
the 16th century. This, too, was introduced by
a foreigner: Lucas Horenbout (1490–1544) is
thought to have imported the medium from
Flanders, and to have taught Holbein; Holbein's
Margaret More, Wife of William Roper (1535–6)
demonstrates the skill he learned in working on a
scale smaller than 2 inches (5 centimetres) in
diameter.

However, miniature painting also attracted
talented indigenous artists like Nicholas Hilliard (*c*
1547–1619), whose training as a goldsmith no
doubt helped in this most decorative of art forms.
Even when artists were working on larger scales, as
does Robert Peake the Elder (*c* 1551–1619) in his
portrait of *Henry Frederick, Prince of Wales, and*
Sir John Harington (1603), they strove for a jewel-
like surface of bright colours and clean lines which
shows the influence of miniatures.

If Peake's *Henry Frederick* is crisp, it is also
stiff, and more than anyone it was Van Dyck who
was responsible for introducing freshness and
informality into English painting at this time. He is
also responsible for helping to make portraiture the
most popular genre well into the 18th century. The
nation's artists often bemoaned the lack of good
history painting – the most revered genre – but
patrons continued to demand flattering likenesses,

and so artists had to conform. Gainsborough
revived Van Dyck's swagger for his portrayals of
personalities such as *Mrs Grace Dalrymple Elliott*
(1778). Reynolds, meanwhile, used lessons
learned in Italy to bring grandeur to his subjects,
though he also helped pioneer a more informal
group-portrait form, the conversation piece, a
marvellous example of which is *The Honorable*
Henry Fane with Inigo Jones and Charles Blair
(1761–6). Tapping into the new enthusiasm for
sport, George Stubbs (1724–1806) proved that
horses could be as significant as their masters.
A Favourite Hunter of John Frederick Sackville,
Later Third Duke of Dorset (1768) is from his
greatest period.

There is far more English decorative art than
there is sculpture in New York's collections, but if
you want to see work by one of the better 18th-
century sculptors, seek out *John Barnard* (1744)
by the Flemish-born John Michael Rysbrack
(1694–1770). Barnard, a bishop's son, may have
died as a boy, which would explain the grave
features of this portrait bust.

Coverage of 19th-century English art includes
the Romantics John Constable (1776–1837) and
JMW Turner (1775–1851), but since those artists
are also on view at the **FRICK COLLECTION**, it
might be worth seeking out pictures from later in
the century. In particular, works by the Pre-
Raphaelites such as John Everett Millais (1829–96)
and Dante Gabriel Rossetti (1828–82). One who is
also closely associated with that group is Edward
Burne-Jones (1833–98), and his *Love Song*
(1868–77) remembers a scene from Sir Thomas
Malory's 15th-century rendition of Arthurian
legend, *Morte d'Arthur*.

Sir Thomas LAWRENCE
Julia, Lady Peel, 1827
FRICK COLLECTION
Lawrence (1769–1830) had
achieved extraordinary
renown as a portraitist by the
time he painted this likeness
of the wife of the British

statesman Sir Robert Peel.
The composition was
probably inspired by Rubens'
portrait of Susanna
Fourment, the sister of the
painter's second wife, a
famous portrait that Peel
owned.

resort for strolling near the artist's London residence on Pall Mall (though one contemporary critic reported that he painted it partly from dolls and a model of the park).

Looking further abroad, Reynolds' portrait of *General John Burgoyne* (1766) introduces the British commander who surrendered to American forces at Saratoga; a painting from around 1805–8, by Reynolds' sometime pupil Henry Raeburn (1756–1823), shows James Cruikshank, who made his fortune in sugar plantations in the West Indies; and *Lady Hamilton as 'Nature'* (1782), by George Romney (1734–1802), shows the young woman who would later be Lord Nelson's lover.

Moving into the 19th century, Turner was an indefatigable traveller, and *Harbour of Dieppe* (*c* 1826) and *Cologne: The Arrival of the Packet-Boat: Evening* (1826) provide reminders of how experience of different locales shaped his work. Both represent Northern European ports, and yet they are bathed in a rich light more reminiscent of Venice; one contemporary critic described the picture of Dieppe as a 'splendid piece of falsehood'. There are also two pictures by Constable, an artist entirely associated with the local English scene. His *White Horse* (1819) depicts the animal being carried over the ferry at Flatford Lock on the River Stour in

If the Metropolitan's collection can show you some of the curious byways of English art, the **FRICK COLLECTION** concentrates on the mainstream masterworks of the 18th and 19th centuries. The evocation of social life in the age of Jane Austen is particularly effective. Gainsborough's portrait of *The Hon Frances Duncombe* (*c* 1777) remembers a woman whose husband suffered such losses that he ended up in debtors' prison, despite the fortune his wife brought him. The same artist's scene of *The Mall in St James' Park* (1783) shows a popular

JMW TURNER
Mortlake Terrace: Early Summer Morning, 1826
FRICK COLLECTION
Turner's skill in topographical drawing is evident in this scene of his estate at Mortlake, to the west of London. In reality, the region's skies are not always so bright, but Turner so loved a rich yellow light that he bathed the scene in it. He also painted a companion picture of the view from a ground-floor window.

Suffolk, a scene the artist knew well since his father owned the nearby mill. His *Salisbury Cathedral: From the Bishop's Garden* (1826) shows the bishop himself on the path in the foreground, standing by his wife and pointing with his cane to the church he so loved.

Pictures by Constable and Turner were in the vanguard of the 19th century, but the collection of the **DAHESH MUSEUM** surveys more conventional taste, and while such academic art has long been dismissed, it is currently having a deserved revival. It is interesting, for instance, to compare Constable's earthy realism with the sentimental but finely observed treatment that is *Little Langdale, Westmoreland* (1870) by Sidney Percy (1821–86). Today's critics are also more interested in the

period's Orientalising scenes of far-flung places, and these are represented by, among others, the fantasy of life in ancient Egypt of Edwin Longsden Long (1829–91), *Love's Labour Lost* (1885).

Classical art of the period is represented by an oil sketch by Frederic Leighton (1830–96), and a mythological scene by Frederick Richard Pickersgill (1820–1900) – a somewhat brazen excuse for the copious nudes. Reminding one of Britain's perennial worry about its place in art's pantheon, *The Plays of William Shakespeare* (1849) by John Gilbert (1817–97) shows characters from many of the author's plays, all arrayed in a setting borrowed from Raphael's Vatican Stanzas. If England did not have the Italian Renaissance, it at least had Shakespeare.

Before you search out any American art in New York, go to the **METROPOLITAN MUSEUM OF ART** and stand in the Wentworth Room (c 1695–1700). One of the earliest of no fewer than 20 period rooms that are housed in the museum's American Wing, it is a wood-panelled interior from a house in Portsmouth, New Hampshire. It is one of the largest domestic interiors to survive from the Colonial period, and unusual, too, in the refinement of its carved panels. But this is no European palace, not even the saloon of an English country mansion: this is a house with modest dimensions, and it was settings such as these that determined the modest aspirations of most early American artists.

The first concern of settlers in the New World was to recover the living conditions they had left back home, so, inevitably, there were more opportunities for craftsmen before there were openings for painters and sculptors. Even when Colonial society began to acquire some prosperity, in the mid-18th century, American patrons remained different from their equals in Europe: they were commercial people, keenly aware of living on the edges of a vast frontier, and they had no need of the pomp of European court painting. They preferred documents: portraits, genre scenes of everyday life and, later, they admired landscape.

This is not to say that early American artists lacked talent: John Singleton Copley (1738–1815), the nation's first great painter, produced an exquisite sequence of portraits of Boston's kingpins

in the 1760s. But even while figures like Copley emerged, many still patronised the likes of Rufus Hathaway (1770–1822), whose *Lady with Her Pets* (1790), also in the Metropolitan, exemplifies the untutored and charmingly eccentric style of the many itinerant artists who made a living travelling about the Northeast in the period. An artist who dreamt of great things was advised to make for Europe, and many did; Copley left in 1771, never to return.

If you want to see the cream of American artistic talent, the best venue is undoubtedly the Metropolitan, whose American Wing (recently emerged from a four-year renovation) contains an almost unrivalled collection of painting, sculpture and decorative art. If you want a gallery that reveals some of the history of New York City and the surrounding region, you should visit the **NEW-YORK HISTORICAL SOCIETY**, which is at the opposite side of Central Park from the Metropolitan. If you prefer oddities like Hathaway to the suave facility of his academy-trained peers, visit the **AMERICAN FOLK ART MUSEUM**. The **BROOKLYN MUSEUM** has some good American paintings, which are hung alongside its displays of the country's decorative art. If you want to proceed into the 20th century you should visit the **WHITNEY MUSEUM OF AMERICAN ART**, which usually has on view a good selection from its sizable permanent collection (though we will visit that collection in detail in Chapters 12–23 on modern art).

John Singleton **COPLEY**
Daniel Crommelin Verplanck, 1771
METROPOLITAN MUSEUM
Verplanck was only nine when this portrait was painted; he would later marry the daughter of the president of Columbia College and, later, become a Congressman. The backdrop probably shows the family estate at Fishkill-on-Hudson. The picture's lively elegance is typical of that which has made Copley known as America's first great painter.

Wentworth Room
Portsmouth, New
Hampshire, *c* 1695–1700
The Wentworth room comes
from the New Hampshire
home of John Wentworth, a
merchant and sea captain
who served as the state's

lieutenant governor in the
early 18th century. One of the
largest domestic interiors that
survives from the early
Colonial period, it was likely
used for both sleeping and
entertaining.

When does the history of American art begin?
This is a question that has exercised
generations of art historians and brought forth a
multitude of answers, because commentators love
to search for the wellsprings of the American
character, and to isolate its first expression in art.
Some used to speak of a 'Pilgrim style' to refer to
furnishings of the earliest Colonial period, but, of
course, there was really no such thing, only the
styles the settlers had learned back home and
imported to the New World.

If there was anything like an authentic national
style in the painting of those early days, it was
found in humbler types of portraiture. The portrait
of the young girl *Catherina Elmendorf* (1752), by an
unknown painter from upstate New York, reveals its
characteristics: rigid posing, bold colour, sharp
detail. More ambitious artists emulated English
examples, and they did so for a remarkably long
time – even when relations between the two
countries were souring. Glance at *The American
School* (1765) by Matthew Pratt (1734–1805) and
you might imagine that you are seeing an early
American academy, a fount of native talent. In fact
you are looking at the London school founded by
the self-taught American painter Benjamin West

(1738–1820), a school that attracted many Americans like Pratt. The awkward formality of the picture might be explained by Pratt's early life as a sign painter, but the composition also owes much to an 18th-century English portrait format, the conversation piece.

Ambitious American artists clearly gained from travel abroad and some, like Copley and West, never returned. Departure did not always bring dividends. Copley, though self-taught, established a good career as a portraitist to Boston's merchants at a time when prosperity gave them confidence to want to parade in high style. He obliged them with portraits such as that of *Mrs Jerathmael Bowers* (*c* 1763), the wife of a wealthy Massachusetts Quaker who herself had a substantial fortune. He departed for England in 1774, and his style changed greatly, though many still prefer his work in the years before he left.

Copley's successor as America's leading portraitist was Gilbert Stuart (1755–1828). He owed much of his education to Britain, but his greatest successes were achieved at home with his portraits of George Washington. He produced countless replicas of them – even though Washington's wife, Martha, believed they were a poor likeness of the man. The version in the Metropolitan, from 1795, is one of the best and earliest replicas, prompting some to wonder if the president actually sat for it.

Despite the call for portraiture, sculpture did not flourish in America until the mid-19th century, with artists such as Hiram Powers (1805–73); a good example of his Neoclassical style is the allegorical nude marble *California* (1850–5), which was inspired by the Gold Rush of 1849. Prior to this, the best commissions in the US went to foreign sculptors such as Houdon, whose bust, *Benjamin Franklin* (1778), was the first of a series he produced commemorating prominent Americans.

The events of the American War of Independence (1775–83) excited some to talk of recording its events in history paintings, but patrons' steady desire for portraits prevented any major developments. The only famous history painting from this period, *Washington Crossing the Delaware* (1851), was painted by Emanuel Gottlieb Leutze (1816–68), a German-born painter, and mostly in his Düsseldorf studio. It remembers Washington's important surprise attack on English and Hessian soldiers, which took place hours after Christmas Day, 1776. Perhaps the distance at which Leutze painted the picture explains its historical errors, such as the inclusion of an American flag that was not introduced until six months after the events.

It was the landscape genre that ultimately came to carry the import and stature of history painting in America. Many important developments were pioneered by the English-born painter Thomas Cole (1801–48): *View from Mount Holyoke, Northampton, Massachusetts, After a Thunderstorm (The Oxbow)* (1836) shows the vast scales he liked to evoke, and his skilful blend of atmosphere and detail. But in the hands of his American peers, his innovations soon gave birth to what could be viewed as the first self-consciously American art movement, the Hudson River School, named after the region that inspired so many of its talents. The Metropolitan is particularly well-stocked with examples of the movement's work: *The Beeches* (1845), by Asher B Durand (1796–1886), shows the influence of Constable and Claude, though this is marred by sentiment; *Heart of the Andes* (1859) shows the handiwork of one of Cole's pupils, Frederic Edwin Church (1826–1900), and also suggests how the popularity of this landscape mode encouraged artists to search further afield for subjects.

The events of the American Civil War of 1861–5 might once again have spurred the emergence of some great history painting in America, but by then the newspapers offered more effective – or, at least, more democratic – mouthpieces. The photographs of the battlefields by Matthew B Brady (1822–96)

Martin Johnson HEADE
Approaching Thunder Storm, 1859
Heade (1819–1904) was part of a new generation, called the Luminists, who arose in the wake of the Hudson River School.

Fascinated by light, they stripped their compositions down to a few motifs and minimised traces of their brush strokes, producing evocations of stillness which were perfect for this scene of calm before the storm.

Henrietta JOHNSTON
Mrs Pierre Bacot (Marianne Fleur Du Gue), *c* 1708–10
Johnston (1674–1729) is the first artist from the South of which something is known. She produced this pastel just after she arrived in Charleston, South Carolina, from Ireland. She is thought to have supplemented her family's income by selling portraits such as this for a few dollars each.

are justly celebrated, and Winslow Homer (1836–1910) preceded a fascinating career painting life on the coast of Maine by covering the war as an artist-correspondent for *Harper's Weekly*. He painted *Prisoners from the Front* (1866) a year after the war had ended, but it well remembers the atmosphere of the battlefield with its realistic portrayal of a gang of Confederate troops standing before a Union officer. The picture launched Homer's career, though he went on to produce very different work, such as the image of crashing waves in *Northeaster* (1895).

It is with painters like Homer that the realist – and patriotic – thread in American art begins to show itself clearly. Some have located that strain as early as the mid-18th century, in Copley's attention to texture and detail, but it comes to the fore in painters like Thomas Eakins (1844–1916). His sober, almost dour, pictures – and his handling of the nude – put him at odds with some of his more conservative peers. *Max Schmitt in a Single Scull* (1871) shows the painter's boyhood friend on the Schuylkill River in Philadelphia; *The Thinker* (1900), a portrait of the painter's brother-in-law, Louis Kenton, shows the typically introverted mood of his portraits.

Charles PARSONS
Central Park, Winter: The
Skating Pond, 1862
Parsons (1821–1910) may
have authored this scene,
but its style is really that of
the famous New York print
publisher Currier & Ives,

which produced some 4,300
scenes of America and
American life in the mid- and
late 19th century. The prints
were hand-coloured and sold
on street corners and in
stores throughout the country
and abroad.

Pewterer's banner
New York, 1788
NEW-YORK HISTORICAL SOCIETY
This banner was carried by
New York's Society of
Pewterers in a procession of
1788 to celebrate the
ratification of the US

Constitution. It includes an
American flag featuring only
13 stars, the society's arms,
which include two men
standing above a banner
reading 'Solid and Pure', and
a scene inside a pewterer's
shop.

Today, New York has a multitude of museums catering to every audience, but in the early 19th century few souls were interested either in preserving the city's or the nation's heritage. So, when a handful of business and government leaders got together to form the **NEW-YORK HISTORICAL SOCIETY,** in 1804, they imagined it as a repository for all kinds of materials.

Among the 60,000 objects in the society's collection today you will find materials relating to

everything from the slave trade to the terrorist attacks of 9/11. There is also an impressive collection of American art that evokes much of the flavour of New York life in times past. *Streetscape of Old Manhattan* (c 1797) by Francis Guy (1760–1820) shows the intersection of Wall Street and Walker Street around 1800. At their crossing is the Tontine Coffee House, a venue where stockbrokers often met in the period and, one might imagine, where the founders of the Historical Society might also have met to thrash out their plans.

The society also contains some paintings by important pioneers of American art. The English painter John Wollaston (1710–75) was among the country's first successful portraitists, flattering his clients with a Georgian Rococo style he had mastered back home. His portraits of *William Walton* and *Cornelia Beekman Walton* (c 1750) record a couple whose recent marriage bound together two of New York's most powerful families.

The collection also reveals some of the odder personalities in the city's history, including the woman with strangely masculine features who sits before us in a cerulean dress in an early 18th-century portrait. It was once fancifully argued that she might be Edward Hyde, Lord Cornbury, the Governor of New York and New Jersey between 1702 and 1708. He was infamous for cross-dressing: one observer once joked that Cornbury explained himself by saying that since he represented a woman (Queen Anne), he ought in all respects to represent her as faithfully as he could. Sadly, research has refuted the story, and the identity of the sitter remains a mystery, as does that of the artist.

More conventional social life was the focus of much of the work of Eastman Johnson (1824–1906). His career was launched with *Old Kentucky Home* (1859), a scene of African-American life in the Old South just before the Civil War. The Neoclassical sculpture *Dying Indian Chief Contemplating the Progress of American*

F BARTOLI
*Ki-On-Twong-Ky (also
known as Cornplanter),*
1796
NEW-YORK HISTORICAL SOCIETY
This Native American chief
met with members of the US
Congress in 1786 and
established peaceful
relations between the tribe
and the new republic. Little is
known of the artist, F Bartoli
(active c 1783–96), though
he exhibited at the Royal
Academy in London before
arriving in America.

**Miniature figureheads:
mermaid and woman with
trumpet**
Probably Salem,
Massachusetts, late
19th century
AMERICAN FOLK ART MUSEUM

Ships' figureheads were
among the first sculptures
made in America, though
these miniatures, found in a
house in Salem, may simply
have been produced as a gift.
Their angling is also more

commonly associated with the
figures produced for ocean
clippers after the 1840s.

430 of the original drawings for *The Birds of America*, which he published between 1827 and 1838, were purchased directly from the artist's widow and reveal many species which are now rare or even extinct in America.

A walk south into midtown will take you to the **AMERICAN FOLK ART MUSEUM** at West 53rd Street. It might seem incongruous to find it next door to the Museum of Modern Art (MoMA), but actually it is rather fitting, since the study of folk art is a recent phenomenon, encouraged by modern artists' rejection of academic values. It deserves this

Civilisation (1856), by Thomas Crawford (1813–57), shows a freestanding version of the relief sculpture that eventually made it on to the tympanum above the entrance to the Senate wing of the US Capitol.

Moving on to the natural world, the collection is particularly strong in work by Durand. His *Solitary Oak* (1844) has light pouring down on the pastoral landscape, proclaiming the redemptive power of the American landscape at a time when industrialisation was starting to transform it. More important still is the society's collection of material related to John James Audubon (1785–1851), America's greatest naturalist-illustrator;

prominence, too, because rather than retaining a narrow definition of folk art, associating it with the art of tight-knit, traditional peasant communities, Americans employ a broader definition, viewing material created by artists outside of the academic mainstream as a kind of folk art. This opens the field to a great deal of work created in the Colonial period and beyond; the museum even collects work by present-day artists who work outside the established art world; indeed, its collection of work by the Chicago-born recluse Henry Darger (1892–1973) is widely renowned.

Just how much invention can be encouraged by distance from the academy is suggested by one

Henry **DARGER**
Untitled (Flag of
Glandelinia), mid-20th
century
AMERICAN FOLK ART MUSEUM
Darger is famous for his epic
war story, illustrated in some
300 watercolour and collage

paintings, at the centre of
which are the seven 'Vivian
girls' who set out to rescue
children abducted by the
Glandelinians. The tale was
influenced in part by
Darger's interest in the
American Civil War.

of the earliest pieces in the collection, a low chest incorporating a drawer (*c* 1690–1720) by an unidentified group of craftsmen in Connecticut. Its painted decorative scheme of tulips, trailing vines, crowns and thistles ultimately derives from Mannerism, which first arose in Italian courts in the early 16th century, but the scheme has become something genuinely new on its long journey, via England, down into the homes of the American middle-class. Such work is the stuff of a new, grassroots tradition, but not one that remains entirely unaffected by developments in higher art: there is a whitework quilt that is embroidered with a similar floral decoration, a tree-of-life motif (1796) yet its all-white colour reflects the prestigious Neoclassicism of the period.

The museum's 18th- and 19th-century collections are dominated by material from New England and the Mid-Atlantic states, and consequently from mainly Anglo communities. Curators are trying to redress this imbalance by acquiring work from other peoples: Dutch New Yorkers, Latinos from the Southwest and African-Americans. This is important, as folk art often reflects feelings of national belonging: one weathervane dating from around 1800 takes the shape of the bald eagle that became the national symbol of the US in 1782. But it can also express division, even unintentionally, as does the grim, mid-19th century *Game of Chance: Slaves and Auctioneer*. A box-like contraption by an unknown craftsman, it has an auctioneer standing over a sequence of boxes containing slaves who occasionally pop out like a jack-in-the-box.

Painting takes its place at the American Folk Art Museum right alongside all the other objects. *Child Holding Doll and Shoe* (*c* 1845), probably by George G Hartwell (1815–1901), is an example of the popularity of posthumous portraits in the mid-19th century. The departing ship, scattered roses and withered tree evoke the loss; the shoe the child holds may suggest her age at death – between infancy and toddlerhood.

Folk art declined in the late 19th century, as industrialisation removed the need for craftsmen. It continued as a vehicle of self-expression, but artists moved closer to the fine-art formats of painting and sculpture. It also moved into the cities: *Empire State Building* (*c* 1931) was created from interlocking pieces of wood (no glue), supposedly by an ironworker who was employed in the construction of the original building. The art also occasionally became strange and apocalyptic: *Church and State* (1970–1), by William A Blayney (1917–86), a mechanic turned Pentecostal minister, is an allegorical painting inspired by the Book of Revelations.

MODERN ART

MODERN PIONEERS OF THE LATE 19TH CENTURY

The **METROPOLITAN MUSEUM OF ART** has collected the art of our time – just as it has collected the art of the past – ever since its foundation in 1870. Perhaps, in those early days, curators spoke of such work as 'contemporary' just as we do today. But their understanding of the difference between so-called 'Old Masters', 'moderns' and 'contemporaries' was undoubtedly different. These terms are always in flux – as art history redraws boundaries and institutions change – and old understandings of their relative merits can seem strange to us today. There was even a time when the **MUSEUM OF MODERN ART (MoMA)** – far more dedicated, as its name suggests, to fostering the new – believed that if the new works it collected stood the test of time, they ought to leave their galleries and travel up Fifth Avenue to the Metropolitan, to enter history, as it were. Works which failed to make that grade would be dispersed elsewhere. The museum would be like a torpedo, casting off the old like spent fuel as it travelled into the future.

That policy is long dead, but a stroll around New York's museums today might suggest that there is still no settled agreement as to how to gather and display artwork from the modern age. The collections of both the **GUGGENHEIM MUSEUM** and MoMA only come into focus with the Post-Impressionists, yet art historians will tell you that the modern was born in the 1860s, with Édouard Manet (1832–83). The Metropolitan is the best place to see his work, and yet in theory its Department of Modern Art oversees only work after 1900; and in practice you will likely find the Modern Art galleries beginning a little later, with Cubism, while the galleries of 19th-century painting spill over into the 20th century to show us the last years of Post-Impressionism.

The Metropolitan's presentation of 19th-century art is very refreshing and includes some of the paintings covered in Chapter 7 on French art (examples of Realism, and the Barbizon School work of painters such as Corot). However here you will also find Manet, the Impressionists, and their followers and successors, which are covered in this chapter. The same applies to the collections of 19th-century sculpture, which at the Metropolitan are gathered in one gallery, effectively showing the continuities between *animaliers* like Barye (also addressed in Chapter 7), and moderns such as Auguste Rodin (1840–1917), included here. Where the Metropolitan's 19th-century galleries conclude is roughly where we conclude, and to find the work covered in the next chapter, covering the years 1900 to 1914, you should search the galleries of Modern Art.

Vincent **VAN GOGH**
L'Arlésienne: Madame Joseph-Michel Ginoux, 1888–9
METROPOLITAN MUSEUM
Both Van Gogh and Gauguin painted portraits of this Arles café owner. Van Gogh produced two versions: the first he executed quickly, and later used as the basis for this second, more careful portrait, which he gave to the sitter.

Auguste RODIN
The Burghers of Calais,
1884–95
It is believed that when
Edward III was putting Calais
to siege in the 14th century,
he offered to spare the town

if six of its leaders should
surrender themselves. The
king ordered their
beheading, but they were
saved by the intercession of
his queen.

Edgar DEGAS
At the Milliner's, 1882
Here Degas' interests in
modern life, and the act of
looking, come together in one
picture. The American
Impressionist Mary Cassatt
(1844–1926) posed for the

woman trying on the hat –
she said that she
occasionally replaced his
models when they '[couldn't
seem to get his idea'. This
pastel was shown in the last
Impressionist exhibition, in
1886.

If you do go to the galleries of 19th- and early 20th-century art at the Metropolitan Museum, and start looking for works by Manet, you might find *The Spanish Singer* (1860) and begin to wonder why the painter deserves the status he enjoys as art's first modern. *The Spanish Singer* does not depict the city life that so attracted the Impressionists, and which made them so undeniably modern. Instead it was inspired by the Old Masters: many of the pictures by Manet in the Metropolitan are derived from this early phase in his career when he was fascinated by artists such as Velázquez and Rubens. But this is no copy after Velázquez, nor slavish tribute to him; contemporaries who shared Manet's love of Spain (and many did in the Paris of the 1860s) would have noticed that it is a kind of pastiche. It was painted from a model dressed to look like a Spanish singer using only the props to hand: the hat and the jacket would resurface in *Mademoiselle V... in the Costume of an Espada* (1862), and in that picture the model (Victorine Muerent, after whom it is titled) stands

before a reproduction of a scene from a painting by Goya. Manet is making play with the conventions of his art, and with the old and the new, in a way artists had not done before.

There was a time when scholars focused on Manet's scenes of leisure, such as *Boating* (1874), and consequently regarded him as an Impressionist. Today, they acknowledge more Realism in him – more ties, in other words, to the artists among whom he hangs at the Metropolitan, such as Courbet. Manet's friend, Edgar Degas (1834–1917), is more easily described as an Impressionist, though he too had Realist tendencies: look at the dark palette and unflinching honesty of his *Homme nu couché* (c 1855). But Degas' fascination with movement, and with acts of looking and being looked at, sent him in new directions. *The Rehearsal of the Ballet Onstage* (1874), of which two versions hang in the museum, shows his interest in dancers. It arranges them in such an unconventional way as to include both figures performing and resting, as well as what looks like idle stagehands standing in for an audience.

Manet and Degas were slightly older than the other artists who, in their twenties during the 1860s, would come to be known as the Impressionists. What distinguished this emerging group was their abiding commitment to painting *en plein air* (in the open air, directly before the subject), something they believed had enhanced the work of Barbizon School painters such as Corot. In time, they would also work with a lighter palette, which enabled them to more accurately capture effects of shifting light, changing atmosphere, and movement. Look at *Jallais*

Hill, Pontoise (1867), by Camille Pissarro (1830–1903), and you will see a picture still influenced by the earthier hues of the Barbizon School. *Garden at Sainte-Adresse* (1867), by Claude Monet (1840–1926), meanwhile, shows innovations, the surface thick with flecks of saturated colour. Monet's *Parisians Enjoying the Parc Monceau* (1878) shows further advances into the classic Impressionism of the 1870s, with the canvas now becoming a field of colour, soft dabs and long strokes of paint both conjuring light and movement.

The Impressionists began to part ways in the late 1870s. Exhibitions of their work continued, but, individually, the artists started to explore new directions. Monet's style became more adventurous, and in the 1890s he embarked on his famous series paintings. *Poplars* (1891) is one of many pictures he produced showing trees on the

banks of the River Epte, near his house at Giverny. *Rouen Cathedral* (1894) and *The Houses of Parliament* (1903) show similar experiments on sites further afield. Pierre-Auguste Renoir (1841–1919), meanwhile, followed different inclinations. At the height of his Impressionism he was producing works such as *A Road in Louveciennes* (c 1870), which pushes the figures into the background in favour of capturing the overall atmosphere. But by the end of the decade he was retreating from that style and, in 1879, instead of sending *Madame Georges Charpentier and Her Children* (1878) to the fourth Impressionist exhibition, he chose to send it to the more conservative Salon. Later, he retreated yet further, into a sentimental style influenced by Raphael, and produced sweetly conventional portraits such as *By the Seashore* (1892).

Claude MONET
Garden at Sainte-Adresse,
1867
Although this picture seems typical of Monet's scenes of carefree leisure, it was painted during difficult years for the artist, when he had to live with his family due to a shortage of funds. The figures probably include his father, in one of the chairs, and, nearer the shore, his cousin and her father.

Paul Cézanne (1839–1906) was one of the most important figures to explore new directions beyond Impressionism. He had actually exhibited in the group's first exhibition, in 1874, but even pictures he made around that time, such as *Bathers* (1874–5), a somewhat Classical idyll, suggest his discomfort with the themes and approaches of his peers. Cézanne yearned to lend more structure and weight to Impressionist atmospherics. *The Card Players* (1890–2), one of several versions of the subject that he produced, may be reminiscent of earlier Realism, but it may also have been inspired by a 17th-century genre painting. A later picture, *Mont Sainte-Victoire and the Viaduct of the Arc River Valley* (1882–5) demonstrates his increasing preoccupation with structure – the landscape unfolding like a patchwork before us. *Still Life with a Ginger Jar and Eggplants* (1893–4) demonstrates his similar attention to the form and arrangement of objects from his studio, all the elements layered and overlapped in the most challenging way.

The other directions artists took in their departure from Impressionism included moves towards more subjective, symbolic or exotic content. Gauguin is typical in this respect. Upon leaving France and arriving in Tahiti, in 1891, his first major picture was *Ia Orana Maria (Hail Mary)*. Inspired by a bas-relief in a Javanese temple, it used Tahitian women as models, yet it is devoted to a Christian theme. Post-Impressionism was an eclectic phase, and artists entertained very different interests. Van Gogh (1853–90) admired the rustic imagery of Millet, and *Peasant Woman Cooking by a Fireplace* (1885) reminds us of his feeling for Dutch country life. It is painted in dark hues that the artist said reminded him of a 'good dusty potato, unpeeled, of course'. Nevertheless, Van Gogh was also a close friend of Gauguin, and was interested in the latter's innovative style. The pair spent over two months living together in a house in Arles, in the south of France, before Van Gogh suffered a breakdown. *La Berceuse* (1889),

Paul GAUGUIN
Still Life with Teapot and Fruit, 1896
Although the Post-Impressionists were an eclectic group with widely differing interests, many admired each other. Gauguin particularly admired Cézanne, and in this work he emulated a still life by the artist that he actually owned.

a portrait of Augustine Roulin, the wife of the town's postmaster, shares the linear decoration of some of Gauguin's work. At the same time Van Gogh also focused on landscapes which now seem the product only of his private battles: *Cypresses* (1889), which is alive with movement, was painted during his stay at an asylum in Saint-Rémy.

The other tangent artists took in the wake of Impressionism was towards a more technical attention to colour and its effects. Georges Seurat (1859–91) is most closely associated with this so-called Neo-Impressionism. *Circus Sideshow* (1887–8) echoes the Impressionists' interest in urban leisure, but its atmosphere is eerie and unsettling, and its surface of tiny dots was inspired by the artist's immersion in contemporary colour theory.

Henri de Toulouse-Lautrec (1864–1901) also deserves note, for while his work was shaped by his career as an illustrator – and in this respect stands slightly outside the mainstream of fine art in this period – his work absorbed the same influences (Japanese prints in particular) that inspired many of his peers, and his acerbic portrayal of Parisian nightlife provides a marvellous counterpoint to other, more romantic imaginings. *La Moulin Rouge: La Goulue* (1891) advertises the attractions of the famous dance hall and drinking garden, and it launched Lautrec's career as a poster artist. *The Englishmen at the Moulin Rouge* (1892) reveals what might have occurred on a regular night at that bar: a prostitute encouraging a potential client.

With so much good work by French masters on view at the Metropolitan, it is tempting to ignore American forays into Impressionism; particularly so given that the museum confines these works to the American Wing. This arrangement is awkward in the case of an artist like James Abbott McNeill Whistler (1834–1903) who was more at home in Europe than in America. His *Cremorne Gardens, No 2* (1870–80) offers a fresh perspective on the Impressionist interest in urban leisure, since rather than a Parisian locale, it depicts a London amusement park. *Harmony in Yellow and Gold: The Gold Girl – Connie Gilchrist* (c 1876–7) demonstrates his interest in colour harmony, while delivering a portrait of a London music-hall star.

Another American more European in background is John Singer Sargent (1856–1925). His greatest *succès de scandale*, *Madame X* (1883–4), was a portrait of Virginie Avegno, a Louisiana native, though she settled in Paris after her marriage to a French banker (the upset over

the picture was caused by her generous *décolletage*, something that seems innocent today). Sargent's portrait of *The Wyndham Sisters* (1899) reveals the talent for society portraiture which ensured that he never lacked for sitters.

Neither Whistler nor Sargent was a genuine Impressionist, but Mary Cassatt certainly was – and she was the only woman fully accepted by the group. *Mother and Child (The Oval Mirror)* (1889) is typical of her many domestic scenes of women

and children. *Woman Bathing* (1890–1), a print, is an interesting counterpoint to Degas' many voyeuristic pictures of women washing.

If you want to see Impressionism truly imported to American soil, you should look for work by Childe Hassam (1859–1935), such as *Winter in Union Square* (1889–90), though with the spire of Trinity Church poking up over the low buildings, and the trams and carriages in the foreground, you could easily mistake the scene for old Europe.

Paul SIGNAC
Evening Calm, Concarneau,
Opus 220 (Allegro
Maestoso), 1891

Signac (1863–1935) was a
close follower of Seurat's
Neo-Impressionism, and this
picture is informed by the
pair's notions of colour
harmony, hence the contrast
of yellows and blues. It
shows sardine boats (Signac
was a keen sailor), and is
one of five views of
Concarneau that the artists
produced that year.

Pierre-Auguste RENOIR
Woman with Parrot, 1871
GUGGENHEIM MUSEUM
This portrait depicts the
painter's friend Lise Tréhot,
who appeared in several of
his images, before she
eventually married another

man. The painting was
probably produced shortly
after Renoir's return from
service in the Franco-
Prussian War. It is strangely
genteel – given the erotic
subtext introduced by the
symbolic bird.

If you visit the Metropolitan to see a full panorama of Impressionism, you should visit the **GUGGENHEIM MUSEUM** to enrich your appreciation of its aftermath. The latter's holdings are an amalgam of several private collections, most of which are not usually on view (though selections from them generally furnish the temporary exhibitions). However, a significant proportion of the Thannhauser Collection is currently on long-term display, and it is rich in Post-Impressionists.

The Metropolitan does not possess a particularly late work by Cézanne, so it is helpful to see *Man with Crossed Arms* (*c* 1899), as well as his quarry scene, *Bibémus* (*c* 1894–5), in which the abstraction of his later years is starting to overtake the sensation of solidity in his earlier work. Van Gogh's *Mountains in Saint-Rémy* (1889) reveals another scene painted during the year he was being treated at the asylum; here the very rocks seem to be moulded into expressive forms. And Gauguin's *Haere Mai* and *In the Vanilla Grove, Man and Horse* (both 1891) capture a similar vision of enchanted nature, this time in Tahiti (they probably depict scenes near the village where he settled).

As the years passed, modern artists would be ever more interested in the margins of art – art from outside the academic tradition, and from outside Europe – and if you want a sense of how those tastes developed, you should conclude your tour with Henri Rousseau (1844–1910). Rousseau was known as 'Le Douanier', the customs man, by his many artist friends, as that was his day job for

much of his life. Only in his spare time did he produce strange visions such as *The Artillerymen* (*c* 1893–5), a group of 14 men – with identical handle-bar moustaches – posed around a cannon.

MoMA's coverage of Impressionism is similarly patchy, but if this is the period that interests you most, a visit to the museum is worthwhile if only for Monet's landmark *Water Lilies* (1914–26), his massive triptych which was inspired by the pond in his garden at Giverny. Among the works by Cézanne, look for the sturdy Classicism of *The Bather* (*c* 1885), and the increasing abstraction of *Pines and Rocks* (1897) and *Château Noir* (1903–4).

The museum has major pictures by Seurat, Van Gogh, including the legendary *Starry Night* (1889) and a portrait of *Joseph Roulin* (1889), husband of *La Berceuse* at the Metropolitan, and by Rousseau (*The Sleeping Gypsy,* from 1897, and *The Dream,* from 1910, are both landmarks). The collection also touches on the intriguing but lesser-known Post-Impressionist Édouard Vuillard (1868–1940), who painted many domestic scenes such as *Interior, Mother and Sister of the Artist* (1893) and the strangely dark and almost alarming *Dinnertime* (*c* 1889).

MoMA is also a good place to see sculpture: while the Metropolitan possesses only one of Rodin's studies for *Monument to Balzac* (1898), MoMA has a cast of the completed work. As if trying to bring the mood of *fin de siècle* Paris to American audiences, alongside the work of its artists the museum also offers one of the Art Nouveau entrance gates that Hector Guimard (1867–1942) designed for the city's Métro stations.

Paul CÉZANNE
The Bather, c 1885
MOMA

Cézanne once said that he wanted to create an art that was 'solid and durable like the art of museums'. This portrayal certainly acknowledges the tradition of the male nude, but its handling is influenced by Impressionism. The result is a figure that seems by turns substantial, weightless and unreal.

AVANT-GARDES: 1900–14

According to historians, centuries never end on time. Maybe they are early, like the British 17th century, which closed with the so-called Glorious Revolution of 1688. Or, maybe, like Europe's 20th century, they arrive late, with the First World War. Dates do not obey the rhythm of events, and history involves making deeper interpretations of those events – perhaps deciding what is truly of the past, and what is of the present. Hence history cuts across the centuries' neat decimals.

History also slices different ways depending on your perspective: politics may propose a rupture in 1914, but art has its own chronometer. Fauvism was, arguably, the last style of the 19th century – the movement that synthesised many of the strands of Post-Impressionism. What came after it, Cubism, represents a more significant departure, and one whose disturbing and radical abstraction seems more in keeping with the new century.

At the **METROPOLITAN MUSEUM OF ART,** this break stands out starkly, since the galleries presenting 19th-century pictures continue on until they have shown us early works by Matisse, André Derain (1880–1954) and other Fauves. At the **MUSEUM OF MODERN ART (MoMA)**, which should be your first stop for this period, the shape of the collection requires more ingenuity to articulate these developments: in one recent arrangement the painting that greeted us was Cézanne's *The Bather* (c 1885), and the impact and influence of this work becomes immediately apparent when one walks into the next gallery to find Picasso's *Demoiselles d'Avignon* (1907), and the beginnings of Cubism.

Modern art in the early years of the 20th century was pursued by artists not just in Paris, but also in Vienna, Milan, Berlin, Zurich, New York and elsewhere. Following it requires some mental gymnastics and, similarly, following the story in New York's galleries may require some energy. MoMA – since its foundation in 1929 the Vatican of modern art history – is essential. But it has gaps particularly in American art from this period, and for that you must go to the **WHITNEY MUSEUM O AMERICAN ART** and the Metropolitan Museum, which has a comprehensive collection spanning Europe and the US. The **GUGGENHEIM MUSEUM** does not exhibit its extensive permanent collection in quite the same way as other museums, but is also worth visiting, particularly as selections from the Thannhauser Collection are on ongoing display and contain major works from the early 20th century.

If you want a deeper exploration of art and design in Germany and Austria, a trip to the **NEUE GALERIE** is important. The brainchild of art dealer and exhibition organiser Serge Sabarsky, and entrepreneur, philanthropist and collector Ronald Lauder, the museum opened in 2001, and, although modestly sized, has a world-class collection. A few minutes spent over a Kaffee Crème in the gallery's Viennese-styled Café Sabarsky may be enough to transport you back a full century.

Gustav KLIMT
Portrait of Adele Bloch-Bauer I, c 1907
NEUE GALERIE
For this, his first portrait of Adele Bloch-Bauer, the wife of a Viennese banker (and the artist's lover), Klimt adorned her with precious materials and ancient artefacts, suggesting her wealth and power; but her stare and grasping hands also sugge that she is fragile. The picture marks the high tide Klimt's decorative abstracti

Constantin BRANCUSI
Mlle Pogany, 1913
Romanian-born Brancusi became successor to Rodin as the most modern important sculptor in Paris. He made several versions of this bust, which depicts Hungarian artist Margit Pogany (1879/80–1964), whom he met when she was a student in 1910. It is typical of the way in which he would strip forms down to their essentials.

We will examine Picasso's Cubism in more detail in the next chapter, but it would be wrong to suggest that he alone staked out the beginning and end of the style. Georges Braque (1882–1963) was his close partner. Indeed, their styles were so often alike in the years when they were conferring that curators have had trouble telling one artist's work from the other. *Road near L'Estaque* (1908) shows Braque's Fauvist colours muting and his surfaces hardening into geometrical planes; great works from his Analytical Cubist period include *Man with a Guitar* (1911–12). If the latter seems radical, arguably more innovative was *papier collé*, or pasted paper collage, which Braque began to explore in 1912. Analytical Cubism unsettled Western art's traditional illusionism, but this troubled it further, since it introduced elements that merely allude to the objects represented. For instance, *Still Life with Tenora* (1913) (the tenora being related to the clarinet) employs newspaper, wallpaper and wood-grained paper along with forms sketched in charcoal. The real and the unreal are blended in a radical visual puzzle.

Many were drawn to the experiments that Picasso and Braque undertook in this period, but not all pursued them with the same extreme abstraction. The artists associated with the group Section d'Or, around 1912–14, took the style in various directions. The Spaniard Juan Gris (1887–1927) retained more clarity in the description of objects; paintings such as *Still Life with Flowers* (1912) also made the grid that underpinned Analytical Cubist pictures much more emphatic, deploying it almost as a decorative feature.

In contrast, the early work of Fernand Léger (1881–1955) uses Cubism to stress dynamic movement: see works such as *Contrast of Forms* (1913) and *Exit the Ballets Russes* (1914). Meanwhile, the Czech-born painter František Kupka (1871–1957) took a more lyrical approach, producing pictures that to some suggested analogies with music. Look at the sunburst appearance of *Red and Blue Discs* (1911) or the more nocturnal hues of *The First Step* (1910–13). When the Russian-born painter Marc Chagall (1887–1985) arrived in Paris in 1912, his poetic manner quickly accommodated aspects of Cubism: *I and the Village* (1912) remembers the Hasidic community in which he was raised. *The Passage from the Virgin to the Bride* (1912), by Marcel Duchamp (1884–1968), seems almost satirical in the way it uses Cubist styling to imagine the body as a machine driven by desire. It prefigured a backlash against Cubism in the following years.

Before this backlash arrived, though, Cubism also won adherents among members of the Italian group known as the Futurists. At first, however, the Futurists cleaved to older styles. *The City Rises* (1910), by Umberto Boccioni (1882–1916), is typical of their contrary impulses towards the old and new: a horse occupies the foreground of the picture (rather than a car, or some other machine), and the flecked paint is reminiscent of Neo-Impressionism; but the whole composition is convulsed with the energy of the modern city. Gino Severini (1883–1966), who lived in

Kasimir **MALEVICH**
Woman With Pails: Dynamic
Arrangement, 1912–13
Malevich (1878–1935), a
leading Russian artist, began
as a painter of Post-
Impressionist landscapes,
but time in Paris turned his

eye to Cubism. *Woman With*
Pails shows how some artists
used the radically modern
style to depict much older
patterns of life, hence
emphasising the contrasts
that modernity produced.

Odilon REDON
Papillons (Butterflies),
1910
Redon (1840–1916)
maintained his earlier
Romanticism even into the
later years of his life, when he
painted *Butterflies*. He
sometimes found inspiration
in natural beauty, though his
work could also be fantastic
and border on abstraction, as
in MoMA's *Roger and
Angelica* (1910), his pastel
scene from the 16th-century
romance *Orlando Furioso*.

Paris, was more powerfully shaped by Cubism: one can see this in *Dynamic Hieroglyphic of the Bal Tabarin* (1912), a choppy and disorientating scene from a nightclub. Severini's example encouraged others such as Giacomo Balla (1871–1958), who evolved from the Neo-Impressionism of *Street Light* (*c* 1910–11) to the whirling, rhythmic evocation of movement in *Swifts: Paths of Movement and Dynamic Sequences* (1913).

If the Italians delighted in man's mastery of nature, many in Germany were less sanguine. The Expressionists echoed a widespread dismay at modern humanity's increasingly discordant relationship with the world, its lost feelings of authenticity and spirituality. They responded by delving into the expressive and Symbolist currents in late 19th-century art, distorting their forms and enriching their palettes. Ernst Ludwig Kirchner (1880–1938) was among those who joined the first Expressionist group, Dresden's Die Brücke. His *Street, Berlin* (1913) deploys grating hues and sharply angular forms in its depiction of prostitutes

parading before passing men. Meanwhile, in Munich, a similar group, Der Blaue Reiter, was formed from the talents of Wassily Kandinsky (1866–1944), Franz Marc (1880–1916), Auguste Macke (1887–1914) and others. Kandinsky strongly believed that art must have a spiritual purpose, and he followed this purpose by evolving a highly influential form of lyrical abstraction. His series of four *Panels for Edwin R Campbell* (1914), founder of the Chevrolet Motor Company, retains suggestions of landscape, but it is a landscape shaken and fragmented by a bursting rainbow of colour. Kandinsky believed in a close relationship between colour and music, and his abstraction, which he described as 'non-objective painting', is guided by a desire to excite rich sensations rather than to directly depict the world.

By this time, Europe was on its path to war. Some, like

Karl SCHMIDT-ROTTLUFF
Pharisees, 1912
Schmidt-Rottluff (1884–1976) was a founder member of the Dresden-based Die Brücke. This piece demonstrates his love of rich colour, but also his interest in religious subject matter. His graphic style lent itself to the woodcut technique, which was revived by the Expressionists, and MoMA's collection contains a number of his prints.

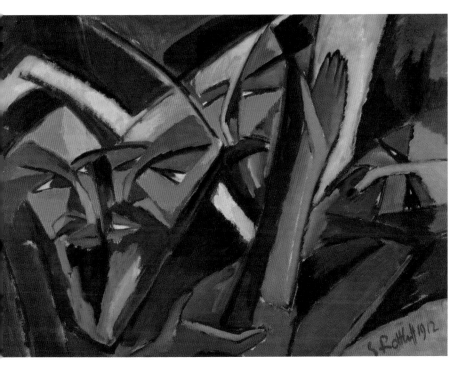

the Futurists, celebrated what they envisaged would be a cleansing destruction. But by 1916 few were so enthusiastic, and the widespread revulsion was eventually channelled into Dada, an anarchic and splintered international association of artists. It first arose in Zurich but quickly found allies in cities elsewhere. In Germany, it often had a political edge: *Republican Automatons* (1920), a street scene with faceless, empty-headed mannequins, by George Grosz (1893–1959), is typical of Dada's bitter satire. In Paris it often had a dandified air. *M'Amenez-y* (1919–20), by Francis Picabia (1879–1953), is a kind of comic portrait that is more text than image (the only object depicted is a machine part), and it delights in crude puns. Although Duchamp's *Bicycle Wheel* (1913)

predates Dada, it is entirely in its spirit: comprised of nothing but a wheel erected on top of a stool, its uselessness as an object seems to mock the uselessness of art itself. It was simple, risible and radical – it was his first 'readymade', a hugely influential sculptural form that takes objects from everyday life and anoints them as art.

Paris may be synonymous with the modern
avant-garde, but, for some, the 20th century
truly began in Vienna. After all, it was from this
city's crumbling bourgeoisie that Sigmund Freud
emerged and, in 1900, published *The
Interpretation of Dreams.* To appreciate Viennese
art, you have to visit the **NEUE GALERIE.** Gustav
Klimt (1862–1918) was among the city's most
influential artists, and his typically decorative
landscapes are represented by *Pond of Schloss
Kammer on the Attersee*, a light-dappled scene
from around 1910. Egon Schiele (1880–1918)
owed much to Klimt; in many ways his style was
more conservative (see landscapes such as *Stein
on the Danube*, 1913), but his erotic drawings,
and the neurotic mood of portraits such as *Portrait
of Dr Erwin von Graff* (1910), have elevated his
reputation. The work of Oskar Kokoschka (1886–
1980) was more Expressionist in style, particularly
after his move to Berlin in 1909: *Rodolf Blumner*
(1910) portrays a figure almost shaking with
agitation, his energy registered as much in the
rich colour as in the picture's surface texture.

The gallery's collection also covers German art.
The explosive *Sunset* (1909) by Emil Nolde (1867–
1956) reveals another talent at one time allied to
Die Brücke. Marc, meanwhile, was influenced by
Fauvism before he became a founder member of
Der Blaue Reiter. *The First Animals* (1913) shows
the visionary quality of some of his painting in the
years before the First World War.

While trying to digest the startling succession of
novel styles that came and went in little more than
a decade at the beginning of the 20th century, it is
also helpful to be able to go to the **METROPOLITAN
MUSEUM** and get a sense of how the public's taste
could lag behind. The Wisteria Dining Room is one
of the museum's excellent period rooms, and was
designed by Lucien Lévy-Dhurmer (1865–1953)
for the house of a Paris industrialist. Cubists
reigned in the galleries during the years it was built
(1910–14), but the room is Art Nouveau in style
and conceived in one gorgeous whole – from the

table and chairs to the light fixtures and wall
paintings. Alongside it, compare *Table by a Window*
(1917), a picture by Jean Metzinger (1883–1956),
who was a member of another late-Cubist circle,
the Puteaux Group.

It is true, of course, that some artists were also
taking more traditional routes during these radical
years. *Reclining Nude* (1917), by Amedeo
Modigliani (1884–1920), clearly looks to the past.
And Pierre Bonnard (1867–1947) was still painting
in an Impressionistic manner in works such as *The
Chequered Tablecloth* (1916), and would continue

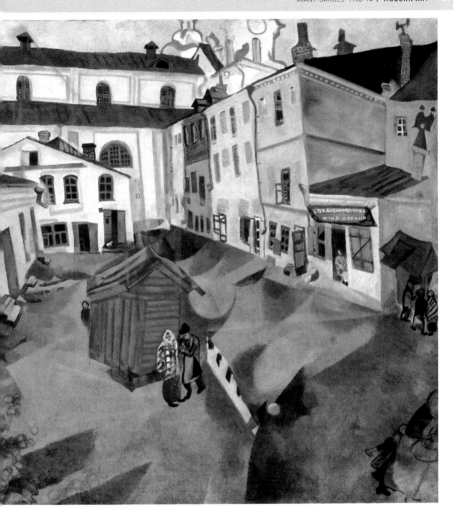

to do so with great success into the 1940s. Looking outside France, the Metropolitan owns Klimt's fine portrait of *Mäda Primavesi* (1912); and its Schiele *Self-Portrait* (1911) is worth comparing with the *Self-Portrait* (c 1910) by Ireland's William Orpen (1878–1939), a picture that, despite the artist's amusing and urbane posing, is far more conventional in style. Looking to the US, you should seek out a picture from the *War Motifs* series by Marsden Hartley (1877–1943): *Portrait of a German Officer* (1914) commemorates a close friend of the artist who was killed in action.

The **WHITNEY MUSEUM** was established in 1931, yet its commitment to modern American art encouraged it to seek out works from earlier in the century. Besides, the museum's founder, Gertrude Vanderbilt Whitney (1875–1942), the great-granddaughter of the railroad and shipping titan Cornelius Vanderbilt, had already been actively involved in American art for two decades, as both a sculptor and patron. The portrait of her by Robert Henri (1865–1929) shows the elegant and independent woman she was in 1916, though apparently her husband refused to hang it in their

Everett SHINN
Revue, 1908
WHITNEY MUSEUM
Shinn (1876–1953) cut his
teeth as a newspaper
illustrator in Philadelphia,
and turned to theatre for
inspiration after he moved to
New York. He selected
Revue to represent his work
in a landmark exhibition of
urban realism. It typifies the
anti-academic style and
subject matter that energised
his peers.

home as he did not want his friends to see his
wife 'in pants'. Henri had been at one time a
leading inspiration for America's urban realists,
and one can see a number of their works here.
Backyards, Greenwich Village (1914), by John
Sloan (1871–1951), shows the snowy streets of the
neighbourhood when it was still a bohemian hang-
out. And William Glackens (1870–1938) shows us
a high-wire act in *Hammerstein's Roof Garden*
(*c* 1901).

American art was slow in catching up with
European trends, but it did have its radicals. Arthur
Dove (1880–1946) was one of the first to pursue
abstraction – though it was nature, rather than the
city, that was his frequent inspiration. *Plant Forms*
(*c* 1912) is almost a modern cornucopia, the forms
simplified and enlarged and bursting with
possibility. Max Weber (1881–1961), meanwhile,
learned much from early Modernists while living
in Paris: *Chinese Restaurant* (1915) borrows from
Synthetic Cubism to produce a portrait of the new
eateries that were beginning to appear in New York
as more Asian immigrants arrived. The Whitney has
another picture from Hartley's enigmatic *War Motifs*
series: *Painting, Number 5* (1914–15).

When Solomon R Guggenheim first opened
the museum we know today, it was called the
Museum of Non-Objective Art, and was devoted
to abstract art that had spiritual and utopian
aspirations. No artist better exemplifies this than
Kandinsky, and the excellent collection of his work
in the **GUGGENHEIM MUSEUM** has long been an

important resource for American artists, not least
the Abstract Expressionists. The museum's
holdings range from early works such as *Blue
Mountain* (1908–9), which contains his beloved
horse and rider motif (symbolic of the romantic
searcher), right up to late, Surrealist pieces such
as *Various Actions* (1941).

Another artist well represented in the collection
– and another devoted to the non-objective – is the
Dutch-born Piet Mondrian (1872–1944). In his
early years he absorbed Impressionism, Symbolism
and academic realism, but encounters with
Cubism prompted radical change. Fascinating to
compare are *Still Life with Gingerpot I* and *II* (both
1911–12): the first angular, but still realist, the
second abstract and geometric. By 1913, in works
such as *Tableau No 2/Composition No VII*, the
objects in Mondrian's still lifes had almost entirely
dissolved to reveal only the Cubist grid that once
subtly underpinned them.

Most artists in Paris, however, were too
preoccupied by the city to linger on the spirit. In
Eiffel Tower (1911), Robert Delaunay (1885–1941)
is enthralled by the built world – his tower seems to
stride across the rooftops.

To conclude – lightheartedly – there is work by
the Russian-born sculptor Alexander Archipenko
(1887–1964). The colourful body of *Médrano II*
(1913–14) is made from painted tin, wood and
glass, and was inspired in part by the circus and
by the contemporary vogue for puppets.

Egon SCHIELE
Portrait of Johann Harms,
1916
GUGGENHEIM MUSEUM

Johann Harms was Schiele's father-in-law, a retired machinist with the Austrian railway. The artist's marriage to his daughter, Edith, was difficult at first, but it had found some happiness by the time this portrait was painted. The picture marks a departure from Schiele's earlier graphic style.

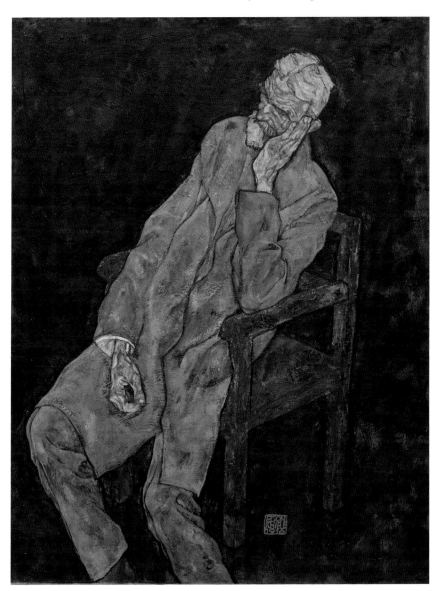

ARTISTS IN FOCUS:
PICASSO & MATISSE

Picasso and Matisse are frequently spoken of in the same breath, and it would be reasonable to assume that this is only because they were two of the greatest artists of the last century. After all, they were not very similar: if Henri Matisse (1869–1954) made colour the abiding theme of his career, Pablo Picasso (1881–1973) made his theme form – shape, mass, volume. Matisse was 12 years older than Picasso; he established himself earlier, as leader of the Fauves; and when Picasso turned to Cubism, and attracted so many around him, Matisse largely rejected it. The pair were, as Matisse said himself, 'as different as the North Pole is from the South Pole'.

Yet they were friends. They first began to meet regularly as early as 1906, after they were brought together by the American collectors, and siblings, Gertrude and Leo Stein. Shortly afterwards they exchanged a picture; in 1918 they held their first exhibition together. Their dialogue continued for decades to come – as much in their art as over the tables of Paris cafés. By the end of his life Picasso could remark: 'No one has ever looked at Matisse's painting more carefully than I; and no one has looked at mine as carefully as he.'

New York is an excellent city to study the art of these titans. The **MUSEUM OF MODERN ART (MoMA)**, the **METROPOLITAN MUSEUM OF ART** and the **GUGGENHEIM MUSEUM** all own major works by Matisse, and together they offer a remarkably deep and encyclopaedic survey of Picasso. Most famously, MoMA owns Picasso's *Les Demoiselles d'Avignon* (1907), and although hair-splitting scholars no longer regard it as the first Cubist painting, many still accept it as the most important picture of the 20th century. American artists throughout the century have felt its challenge, and the works that lead up to it in MoMA's galleries sometimes feel merely like the drum roll that precedes it.

Artists no longer measure themselves against Picasso in quite the same way they once did, but some who come to New York are still regularly put before him and asked to be humble. *Guernica* (1937) was Picasso's response to the bombing of the eponymous Basque town by Fascist forces during the Spanish Civil War, and it is the most famous anti-war artwork of modern times. The original hangs in the Museo Reina Sofia in Madrid, yet you can see a tapestry based on it in New York, hanging at the entrance to the Security Council Chamber of the **UNITED NATIONS HEADQUARTERS**. Whenever the council meets, the delegates are required to pass by it and be reminded, not so gently, of the dangers of disagreement.

Pablo Picasso in his villa 'La Californie' in Cannes, 1957, by Franz Hubman (1914–2007).

Henri Matisse working on the mural 'La danse' for the Barnes Foundation, 1929.

Pablo PICASSO
Les Demoiselles d'Avignon
(detail) 1907
MoMA

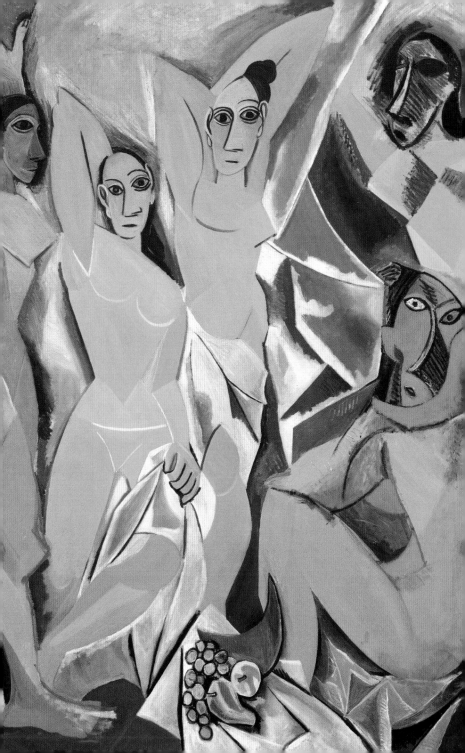

Henri MATISSE
The Blue Window, 1913
This picture was once titled
La Glace sans tain, or 'The
Mirror without Silvering',
referring to the Claude Glass,
the red-bordered object on
the right. Artists often used
one to help them clarify their
compositions, since it muted
colour. Here Matisse does his
own muting, rendering
almost everything in shades
of blue.

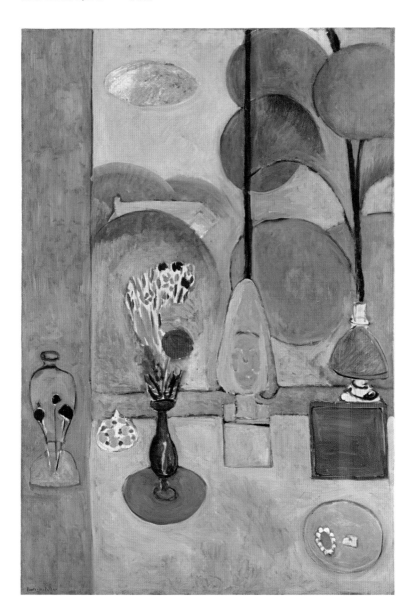

Pablo PICASSO
Les Demoiselles
d'Avignon, 1907
Picasso began making
studies for *Les Demoiselles*
in the winter of 1906–7, and
produced hundreds before
he began work on the
masterpiece the following
autumn. He originally
planned to include a sailor
entering on the left, but,
deciding he did not want any
anecdotes to distract from
the shocking treatment of
form, he ultimately excluded
the figure.

MoMA's coverage of Picasso is, like its collection more generally, sharply focused. You will find only a handful of very early works – a few etchings. The young master only comes fully into view with pictures like *Boy Leading a Horse* (1905–6). You might have seen paintings by Cézanne in the previous gallery – now you will understand who Picasso was looking at as he edged towards Cubism. By the time Picasso came to *Les Demoiselles d'Avignon*, Cézanne's influence had been mixed with ideas drawn from all kinds of sources: African and ancient Iberian sculpture, and perhaps El Greco, Gauguin and Ingres.

Les Demoiselles depicts prostitutes in a brothel, and it so disturbed Picasso's friends when he first showed it to them that he did not exhibit it in public until 1916. It is legendary in its radical, angular treatment of pictorial space, and the work of unpacking all of its discoveries would occupy the artist for years to come. Look at how he starts to render objects schematically, as a series of faceted planes in works such as *Fruit Dish* (1908–9); and how he does the same with a landscape in *The Reservoir, Horta de Ebro* (1909).

Shortly afterwards he would begin, alongside Georges Braque, to pioneer full-blown Cubism. In the phase known as Analytical Cubism he would deliver a minute analysis of all the parts and perspectives of an object: look at works such as *'Ma Jolie'* (1911–12). In the Synthetic Cubist phase he would playfully translate objects and figures into an arrangement of signs and symbols, as in *Card Player* (1913–14). Throughout all this he would pursue similar ideas in sculpture, in *Maquette for Guitar* (1912) and *Glass of Absinthe* (1914). Eventually, with *Three Musicians* (1921), he would call a halt to Cubism and retreat into the more conservative Classicism that had already been percolating through his work for some years: *Three Women at the Spring* (1921) is typical of this phase. Look out for great works from his later years, including *Girl Before a Mirror* (1932) and *Night Fishing at Antibes* (1939).

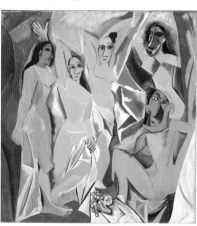

Matisse's career is an interesting example of one that does not follow the traditional path of a succession of new styles that reflect artistic development and progress. It is true that he is associated above all with Fauvism (*c* 1905) and with paintings that make colour both the principal expressive force and the structuring device of the work. See *Study for 'Luxe, calme et volupté'* (1904) and *La Japonaise: Woman beside the Water* (1905). Yet his best work arguably came later: pictures like *Dance (I)* (1909), in which he imagines a whole new approach to decoration; or *Goldfish and Palette* (1914), and *The Piano Lesson* (1916), in which he confronts Picasso's achievements with Cubism; or *The Moroccans* (1915–16) and *The Blue Window* (1913), which evolved out of his enduring interest in Islamic art and North Africa.

If you want to appreciate Matisse's skill as a sculptor, you should seek out the remarkable *Backs* series, on which he worked between 1908 and 1931. And if you want an inkling of that famous dialogue between Matisse and Picasso, try comparing the *Backs* with Picasso's *Two Nudes* (1906).

Henri MATISSE
View of Collioure and the Sea, 1907
METROPOLITAN MUSEUM
Many of Matisse's greatest Fauvist pictures were inspired by Collioure, a small village on the Mediterranean coast. The style's greatest days had passed by the time he painted this scene (whose colours are notably darker), but the serpentine branches that occlude the foreground give an inkling of triumphs to come.

The **METROPOLITAN MUSEUM** offers a similarly deep and detailed sweep across Picasso's career, but the coverage of his earliest years is stronger than at MoMA. *Seated Harlequin* (1901) shows his early identification with a character from Italian popular theatre; *The Blind Man's Meal* (1903) is a classic example of his Blue Period; and the portrait of *Gertrude Stein* (1905–6) is one of the first works to be informed by his taste for ancient and tribal art. Later works to look out for include *Head of a Woman* (1909), which is an important Cubist bronze representing his first great love, Fernande Olivier; and *Nude Standing by the Sea* (1929), an acid, Surrealist portrayal of his later wife, Olga Khokhlova, produced at a time when their relationship was disintegrating.

The Met's coverage of Matisse also offers greats. For a counterpoint to MoMA's *Landscape at Collioure* (1905), a view of the coastal village near the Spanish border where the artist often summered during his Fauve period, look for *The Young Sailor II* (1906), a portrait of one of the village's locals. *Nasturtiums with the Painting 'Dance'* (1912) incorporates a detail from MoMA's *Dance (I)* (1909). *Laurette in a Green Robe* (1916) depicts a professional model Matisse used in a number of works, and is one of the rare occasions when he let the personality of his models shine through; *Reclining Odalisque (Harmony in Red)* (1927) shows a typical work from his Nice period; and *Snow Flowers* (1951) is an example of the cut-paper collages of his last decade.

The earliest picture for which the Picasso collection at the **GUGGENHEIM MUSEUM** is notable is *Le Moulin de la Galette* (1900). Showing an evening at the famous Paris dance hall, it was the first painting the artist produced in the city; influenced by the vivid colours of Symbolism, it is another reminder of the extraordinary range of styles he cycled through in his lifetime. Shortly afterwards, his outlook turned darker: *Woman Ironing* (1904) is another icon from his Blue Period. A marvellous suite of Cubist pictures sketches the transformations his work underwent from 1907 to 1914: the objects in *Carafe, Jug, and Fruit Bowl* (1909) are still discernible behind the sharply faceted surfaces; but the later *Accordionist* (1911) has dissolved behind the grid that structures the work. *Mandolin and Guitar* (1924) shows how his later, Synthetic Cubist style would continue to inform his work long after he had ostensibly abandoned the Cubist project.

More realistic than any of these is *Fernande with a Black Mantilla* (1905–6), which offers an interesting comparison with the Metropolitan's *Head of a Woman* (1909). *Woman with Yellow Hair* (1931) exemplifies his Surrealist portrayals of Marie-Thérèse Walter, his young lover of the late 1920s and early 1930s. The Guggenheim has fewer works to offer by Matisse, but it does have a fine portrait, *The Italian Woman* (1916), which also depicts the model Laurette. It is far darker than most of his paintings (perhaps shadowed by the First World War), and, inspired in part by Cézanne and Cubism, is more angular.

PABLO PICASSO
On the Beach, (overleaf) 1937
METROPOLITAN MUSEUM
Although Picasso was never so inspired by Surrealism as others, it had important effects on his style and, as this scene shows, it destroyed the happy mood of similar, more Classical pieces from the early 1920s. The theme of this picture, painted near Versailles, is voyeurism.

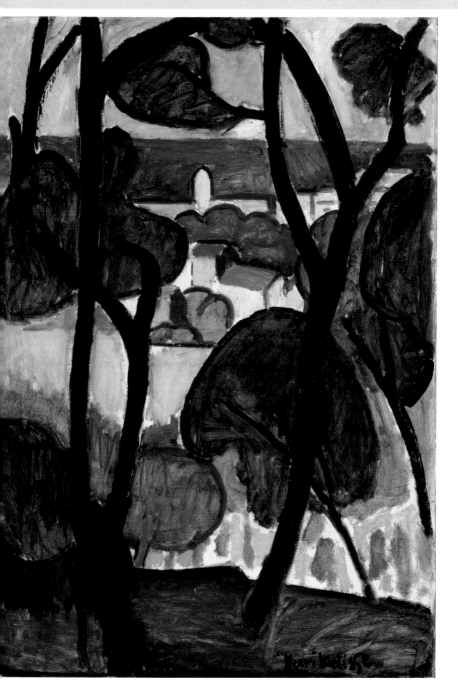

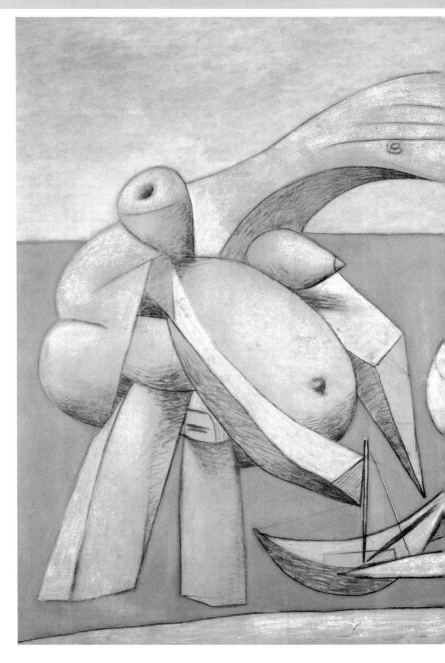

MODERNISM BETWEEN THE WARS

If the beginning of the 20th century failed to produce as many feelings of beginning as feelings of ending – the *fin de siècle* still looming over many – the end of the First World War finally brought them to the surface. A new world was announced even in the names of some of the movements that gained ground in the late teens and early 1920s. Germany had its Neue Sachlichkeit, or New Objectivity. In Russia, while the revolution declared a decisive break with the social and political past, Constructivism arrived. Photography experienced the New Vision. And the poet Jean Cocteau described the mood that would hang over many in France when, in a 1923 essay, he sounded a *rappel à l'ordre*, a call to order, and a renewal of Classicism.

If there was one movement in this period that insisted on the undertow of the past, on how memory can never be escaped, it was Surrealism, and yet even that inspired one of the greatest paintings by Joan Miró (1893–1983), *The Birth of the World* (1925), which hangs in the **MUSEUM OF MODERN ART (MoMA)**.

The 1920s and 1930s were also a time of new beginnings in American art, and certainly in the realm of museums. MoMA opened in 1929, a year later the **WHITNEY MUSEUM OF AMERICAN ART** arrived and, in 1939, the institution we now know as the **GUGGENHEIM MUSEUM** opened as the Museum of Non-Objective Painting. All had a different genesis, but all were vital in encouraging New York's rise to prominence as a heartland of the avant-garde in the wake of the Second World War. Solomon R Guggenheim's unrivalled collection of work by Kandinsky was a cherished resource for the city's painters, showing them one precedent for an expressive, abstract art. In its first decade, MoMA held a series of survey exhibitions of European art that were also vital in seeding American art of the 1940s and 1950s. New York was maturing as a capital of the arts, and the foundation of the Whitney Museum also exemplified this.

Today, all three museums are landmarks of the New York art scene, but each retains its individuality. MoMA's spectacular refurbishment by Japanese architect Yoshio Taniguchi (1937–), in 2004, keeps it current. The Whitney, ensconced since 1966 in an imposing granite box by Marcel Breuer (1902–81), continues to be a barometer of American art, particularly since it hosts a prestigious biannual survey. And the Guggenheim, a beloved adornment to the cityscape since it opened its present quarters designed by Frank Lloyd Wright (1867–1959) the same year as his death, has grown into an international brand, with outposts in Venice, Berlin, Bilbao and Abu Dhabi. If New York is no longer the guardian of the world's avant-garde, as it once claimed, it remains first among equals.

Salvador DALÍ
The Persistence of Memory,
(detail) 1931
MOMA

LE CORBUSIER
Still Life, 1920
Before he found success as
an architect, Le Corbusier
(1887–1965) was a Purist
painter. This *Still Life*
exemplifies the cool,
classically toned Cubism that
he and Amédée Ozenfant
developed as France began
to react against more radical
modern styles in the wake of
the First World War.

To find the most radical beginnings in this
period, we must look to Russia, before the
revolution of 1917, and to the work of Kasimir
Malevich. Malevich led a movement called
Suprematism, which was devoted to a spiritual
abstract art. Perhaps his most influential work was
in reducing painting to its barest essentials, and he
came close in *Suprematist Composition: White on
White* (1918), which consists merely of a white
square sitting askew on a white background. More
in tune with the aspirations of the revolution was
Constructivism; *Spatial Construction no 12*
(*c* 1920), a wooden model of nesting ovals, by
Aleksandr Rodchenko (1891–1956), typifies this
movement's love of everyday materials, and its
determination to experiment in ways that might be
of use to a new, self-consciously modern society.

In contrast, France's *rappel à l'ordre* appealed
for a return to the verities of a past Classicism. This
could be interpreted in modern ways, as it was by
the self-proclaimed Purists: Amédée Ozenfant
(1886–1966), in *The Vases* (1925), borrows from
Cubism, but is far more sober. Fernand Léger, in

Three Women (1921–2), also finds a new balance
– this time between a machine aesthetic and the
academic genre of the female nude. One can even
see the impact of this Classicism on artists in
America, like Arshile Gorky (1905–48). Others in
France, though, were less interested in restoration.
The Surrealists wanted to unleash psychic shocks
which might eventually trigger social revolution:
Meret Oppenheim (1913–85), in *Object* (1936),
better known as the 'fur-lined tea-cup', exemplifies
their taste for the unsettling, and *Two Children Are
Threatened by a Nightingale* (1924), by Max Ernst
(1891–1976), is an enigmatic landscape populated
by scurrying figures, its surface embellished with a
'real' red wooden gate, as if the figures might soon
flee.

Surrealism proved widely influential, and
particularly Salvador Dalí (1904–89) helped to
popularise it. It even inspired the work of those
whose instincts were closer to the *rappel à l'ordre*:
The Street (1933) was the first major painting
by Balthus (1908–2001), and the first of his
controversial career to spark criticism (none

Salvador DALÍ
The Persistence of Memory,
1931
In his famous setting of his
'melting watches', Dali
reflects on mortality and
decay. The melting form in
the centre has been thought
to resemble the artist's
profile, while the cliffs in the
background remember his
home in Catalonia.
Surrealism embraced many
styles of painting; Dali called
his method, which delved
into hallucinations,
'paranoiac-critical'.

of the stiff and composed figures in the street appear to notice the sexual assault taking place on the left).

In Germany, the interwar period saw Dada and Expressionism give way to Neue Sachlichkeit. At times this could be dour and grave: look for *Dr Mayer-Hermann* (1926), by Otto Dix (1891–1969), a deadpan portrayal of a prominent throat specialist; or George Grosz's *The Poet Max Herrmann-Neisse* (1927). But around the fringes of the movement the mood could be more satirical, frenetic, foreboding: *The Departure* (1932), a major allegorical triptych painted by Max Beckmann (1884–1950) at the time of Hitler's rise to power, shows how these moods persisted into the next decade.

To see how political crisis and the Depression impacted on artists in the Americas, look at *Agrarian Leader Zapata* (1931) by Diego Rivera

(1886–1957); a crisp example of the Mexican's influential Social Realism, it depicts the revolutionary leader with the peasant farm workers who followed him. *Homestead* (1934), by Thomas Hart Benton (1889–1975), shows the yearning for old values and certainties that gripped some North Americans during the period. And *American Landscape* (1930), by Charles Sheeler (1883–1965), inspired by a photograph he took of the Ford Motor Company's plant near Detroit, proffers an image of easy productivity that business leaders hoped might calm restive Americans.

One of the greatest attractions of the **METROPOLITAN MUSEUM**, in terms of the interwar period, is its sequence of galleries of American art. Works by the Precisionists (of whom Sheeler was one) reveal how artists attempted to accommodate old and new in a coherent vision. *After Sir Christopher Wren* (1920), by Charles Demuth (1883–1935), borrows from Cubism, yet pays tribute to a landmark in Provincetown, Massachusetts, which was indebted to the English Baroque. Another important asset is its collection of work by the Swiss-born maverick Paul Klee (1879–1940). Klee emerged as an Expressionist, but a trip to Tunisia in 1915 encouraged him towards a playful abstraction. *Ventriloquist and Crier in the Moor* (1923) at the

Arshile **GORKY**
The Artist and His Mother,
c 1926–36
WHITNEY MUSEUM
Although Gorky is often
considered a transitional
figure, this picture shows that
he could be many things. It

was based on a photograph
taken when the artist was
aged eight; his mother died
soon after, weakened by her
suffering during the Ottoman
Turks' campaign against the
Armenians.

Gert **WOLLHEIM**
Untitled (Couple), 1926
JEWISH MUSEUM
Wollheim (1894–1974) was
revolted by his experience of
the frontline during the First
World War and, in its wake,
poured his rage into

Expressionism. But a move to
Berlin in 1925 sobered his
style. This scene from the
very liberal café life of the
Weimar Republic deliberately
leaves us guessing over the
genders of the two figures.

Metropolitan displays the inventive and fantastic
flights for which he soon became famous.

The **WHITNEY MUSEUM** is also an excellent
place to see American art from this period. *House
and Street* (1931), by Stuart Davis (1894–1964),
is a city scene by a much-loved Modernist who
blended lessons learned from Cubism with a
quintessentially American love of popular culture.
Twenty Cent Movie (1936), by Reginald Marsh
(1898–1954), draws on older, academic styles to
render a comical scene of urbanites going into a
cinema. Meanwhile, *Summer Days* (1936), by
Georgia O'Keeffe (1887–1986), takes a far more
symbolic approach to the period's search for the
American soul: an animal skull floats in the sky
above a mountain range.

The **GUGGENHEIM MUSEUM** is notable for its
holdings of work by Joan Miró. *Prades, the Village*
(1917) reveals how Fauvist colour helped introduce
abstraction into his work. *The Tilled Field* (1923–4),
a view of his family's farm in Catalonia, offers the
earliest example of his mature Surrealism, and is
cluttered with all manner of symbols. Shortly
afterwards, in *Painting* (1925), the symbols have
been whittled down to only a few, and Miró lets
lines, dots and washes of colour do the work. The
German artist, poet and typographer Kurt
Schwitters (1887–1948) was more fond of collage,
but he could be no less mysterious than Miró:
Merzbild 5B (Picture-Red-Heart-Church) (1919)
may have a number of buried autobiographical
references.

At the **NEUE GALERIE** one can also see good
German and Austrian art. Dix's portrait of *Dr Fritz
Glaser* (1921) adds to what our notion of Neue
Sachlichkeit is: the lawyer does not sit so much as
lurk in his chair, the icy building in the backdrop
evoking the ice in his soul. There are also works by
Christian Schad (1894–1982), Beckmann, Grosz,
and, although outside that movement, Schwitters.
In addition, the gallery offers insights into the art
and design of the Bauhaus, the renowned school of
design that flourished in Dessau before it was

closed by the Nazis. László Moholy-Nagy (1895–
1946) was one of its later guiding spirits, and his
austere, geometric abstraction, *A XI* (1923),
suggests something of the school's experimental
ethos.

The **JEWISH MUSEUM** lends another
perspective on some artists you might already have
encountered. Marc Chagall turns to the Hasidic
Jews of his native Vitebsk in *Untitled (Old Man
with Beard)* (c 1931), though the figure, depicted
against a snowy backdrop, is more a type than a
particular individual. Max Weber emigrated with
his Orthodox family from Bialstok in Russia, and
settled in Brooklyn's Williamsburg: his *Sabbath*
(1919), rendered with Cubist dynamism, is most
likely a scene from his life in the New World.

ARTIST IN FOCUS:
EDWARD HOPPER

Success came painfully late for Edward Hopper (1882–1967). It was 1924 and he was in his forties when he had his first taste of it, with a sell-out show of watercolours. Yet only six years later his *House by the Railroad* (1925) was the very first painting to be acquired by the new **MUSEUM OF MODERN ART (MoMA)**. Three years after that, MoMA granted him a solo show and lauded him as America's quintessential Modernist. He was not fussy and academic, as some regarded the French; he was robust and plain-spoken, and a *Self Portrait* (1925–30) in the collection of the **WHITNEY MUSEUM OF AMERICAN ART** agrees: this is not a bohemian, or a dandy, but a common man, respectable in collar and tie.

Not everyone was persuaded by Hopper, however. Many critics wondered whether he was modern enough to warrant inclusion in the city's new pantheon of the avant-garde, and *House by the Railroad*, at MoMA, did nothing to reassure them: a lonely 19th-century house sits by the railroad tracks that have moved life on elsewhere. Hopper's tastes were ever nostalgic. Even decades later, when Hopper's reputation was secure, critics continued to complain: one mid-century commentator said that even if he had been more talented as a painter (virtuosity, it is true, was not

his forte), he would still not have been a better artist. But time has mellowed such hostile views. The passing of Modernism has made him seem less conservative, and even the rise of Pop art has cast him in a better light, making him seem like one of the movement's forefathers.

Hopper was born in Nyack, a town on the Hudson River, and he spent most of his life in New York City. In his early days he lived in his studio at **53 EAST 59TH STREET**; from 1913 until his death he lived and worked at **3 WASHINGTON SQUARE NORTH**. Yet part of Hopper always yearned to be elsewhere. He regularly summered on Cape Cod and, back in the city, while buildings rocketed skywards, and artists such as Georgia O'Keeffe and Joseph Stella (1879–1946) celebrated their height, Hopper turned his canvases towards the low-rise buildings that could still be found throughout the ordinary America he loved.

If keeping track of the man is easy, keeping track of his art is less so. Critics have often wanted to explain him away by slotting him into a movement – to say that French Symbolism shaped him, or, more often, the American Scene painting of the 1920s and 1930s. Hopper always rejected such labels, and it is true that his work stands apart from most currents. He did not want to report on America so much as hymn its ideal. Characters sit in very ordinary cafés and offices and theatres in Hopper's pictures, but they sit there as if on a stage, as if playing a part. Hopper loved theatre, and he brought to his painting the imagination of a set designer. If today we see scenes such as those in *Early Sunday Morning* (1930) or *New York Movie* (1939) and wish life were like this once again, we would do well to remember that it probably never was like that at all.

Edward HOPPER
Self Portrait, 1925–30
WHITNEY MUSEUM

New York Interior
(detail) *c* 1921
WHITNEY MUSEUM

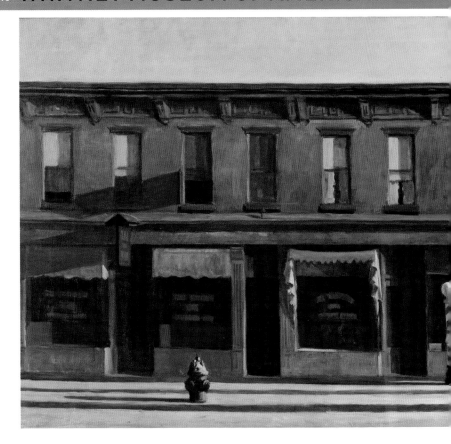

Since making its own first purchase of Hopper's work, just a year after MoMA made its investment, the Whitney Museum has been the painter's strongest supporter, and it has the largest collection of his work. Good Hoppers are scattered in provincial museums throughout the US, but none has the sweep of the Whitney's collection, and it contains some surprises. One revelation – and one that has done much to revive Hopper's fortunes among curators in recent years – is its similarity to more recent painting – look at work by Luc Tuymans (1958–) or Maureen Gallace (1960–).

Even for those unfamiliar with the current scene, Hopper's earliest work can come as a shock. He would produce pictures in nothing but a palette of cold blue-grey: look at *Solitary Figure in a Theatre* (*c* 1902–4) or *Man Seated on a Bed*

(*c* 1905–6). When he was younger he made several long trips to Paris, but rather than enjoy its monuments or its broad boulevards, he would often settle on a dismal corner, as in *Interior Courtyard at 48 rue de Lille, Paris* (1906). Or he would paint stairs. Nothing but stairs – and stairs observed for their repetitive simplicity alone. The Whitney holds an almost malevolent image of the stairway in the same building as that interior courtyard.

The mature Hopper, painting with a far brighter palette, starts to appear in pictures such as *Summer Interior* (1909). This is also the first work in which we see a partially clothed woman, a motif that was to recur and recur: *A Woman in the Sun*, from as late as 1961, might almost be a reprise of that earlier piece. Degas certainly influenced much in Hopper's work, from his use of dramatic cropping to his inventive perspectives, and one can

Early Sunday Morning,
1930
This picture was originally titled *Seventh Avenue Shops* after the buildings it depicts on the New York street, but, characteristically, Hopper eventually opted for an evocation of everywhere, anytown. The scene may also have been inspired by the set design for Elmer Rice's *Street Scene*, a play Hopper had seen the year before.

much that of the American Scene painter – consciously searching for the nation's soul – as it is that of the ordinary city-dweller with memories of trips out of town. Hopper was a fine printmaker, as well as a draughtsman and painter, and *Night Shadows* (1921) is one etching that seems to capture the city-dweller's mood. The view is from far above, down onto a shadowy street with a figure walking past a corner store. The scene might be one from a film noir, but it contains as much love of the street as it does fear of it.

New York Interior, *c* 1921
Around the time he painted this piece, Hopper produced several images of women sewing – some of them prints, since he was initially better known for etching. In part they were inspired by Rembrandt; some bear comparison with work by contemporary Realists such as John Sloan. This work may also have a debt to Degas.

see echoes of Degas in his treatment of the female figure, too. Look at *New York Interior* (*c* 1921), in which we see only the woman's back, her arm thrown up to the side. She is sewing, though her frozen gesture seems strange enough to import much more. A precedent has also been found in Degas' work for *Soir Bleu* (1914), an unusual, Paris-themed piece, which shows a café scene with a clown figure, a Pierrot, sitting at one of the tables – off-duty and sullenly smoking.

Hopper surely enjoyed his time in France, and his immersion in French art, but in time he would realise that his true love was for America. He captured the look of its towns in pictures such as *Early Sunday Morning*; he depicted its outlying symbols in images like *Railroad Sunset* (1929); and he celebrated its coastal motifs in pictures like *Light at Two Lights* (1927). But his outlook is not so

Both **MoMA** and the **METROPOLITAN MUSEUM** also own major pieces by Hopper, and such is his popularity that you can generally be assured of coming upon a few whenever you visit. Starting at MoMA, *New York Movie* (1939) is one of the better pieces, and it encapsulates so much of Hopper's work – his love of the cinema, and his sympathy for the ordinary soul. And, of course, his melancholy: one does not have to see many of Hopper's pictures to realise that he was a melancholic. Not simply that he was occasionally sad, or contemplative, but that he saw himself as a melancholy artist. It is as if Hopper imagined it was his purpose to carry about the burdens of others, and to speak of them in his art, so that in some way those burdens might be relieved. Thus in *New York Movie* he reaches out to the usherette, and so, too, he consoles the lonely gas station attendant in *Gas* (1940). But along with his melancholy came anxiety and desire, and one can sense this in *Night Windows* (1928): the canvas gazes down through the darkness on a woman, momentarily bent over, and dressed for sleep, in the corner of her apartment. Wind sucks the lace curtain through the window as if a crime has been committed and the thief has fled.

There is a lot to puzzle over in the sexual tension that courses through Hopper's paintings of women, and one might pursue this riddle further at the Metropolitan, where an etching entitled *Evening Wind* (1921) uses many of the same motifs as *Night Windows*. Once again we catch a woman unawares; once again a strong wind tugs at the curtains. Hopper seemed to have had no scruples about confessing his desires. But he could also be a fairly sober commentator on social changes around the city. *Tables for Ladies* (1930) is a simple enough scene glimpsed through the window of a restaurant. But Hopper wants us to note that a waitress is arranging a display of fruit in the foreground, and another is attending to the cash till – women are making new inroads into the workplace. The title alludes to signs that had begun to appear in restaurants in the period to welcome in more liberated women; previously, a woman dining alone might have been suspected to be a prostitute.

If Hopper seems to have little to say about this particular change, he was not always so silent.

From Williamsburg Bridge,
1928
METROPOLITIAN MUSEUM
Today, descending in a car
from the Williamsburg
Bridge, which carries you
from Brooklyn to Manhattan,
delivers a scene of noise and
chaos – with no room for the
pedestrian who might
glimpse this scene. What
Hopper gives us instead is an
ambiguous, empty silence,
the only figure visible being
the woman sat in a distant
window.

He loved an America that – if it had ever existed –
was certainly disappearing. So it is significant that
after decades in which he had painted mostly low-
rise buildings, his *Office in a Small City* (1953)
should show a figure at a desk in the corner of a
building edging over those around it – and that the

figure should seem so trapped. Hopper began the
picture in the country, in a rented cottage in Truro,
Massachusetts; he finished it back in New York,
a city that had no doubt changed beyond his
imagining.

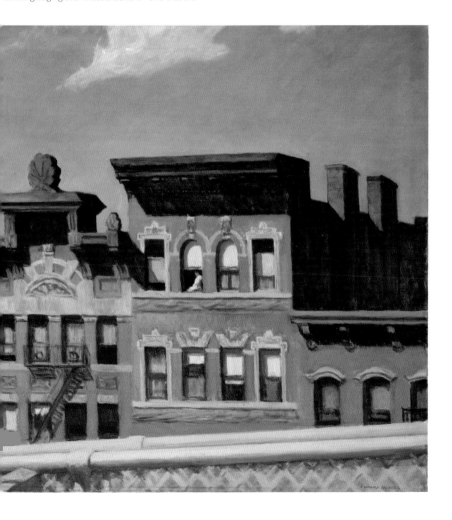

New York Movie, 1939
MOMA

Hopper made several sketches of New York movie theatres before he settled on the composition for this piece. Initially, the usherette played only a minor role. She is an amalgam of the features of Hopper's wife, Jo, who was his only model after the couple married, and the artist's own ideal.

TRANSATLANTIC MODERNISM

It is sometimes said that New York 'stole' the idea of modern art. Paris had nurtured successive modern styles and movements since the 1860s, but the fall of France in 1940 put a stop to this, and New York saw its chance. Of course, many dispute this account. The startling work of postwar French creators such as Jean Dubuffet (1901–85) and the Paris-based Alberto Giacometti hardly lacks power. Besides, one could not say that America was without modern art before 1945: the famous Armory Show did much to introduce the nation to radical trends as early as 1913. But America had never had a true avant-garde. It had never had a group that consciously sought to bind together and set itself apart – to antagonise and revolutionise. This is what began to occur in New York in the 1940s as the Abstract Expressionists emerged.

American artists were not accustomed to adopting a group spirit, but the Depression had brought many of them together in government-sponsored programmes, which had fostered a new sense of community. Artists clustered in studios around 10th Street in Manhattan; in the evenings they would drink in the Cedar Tavern on University Place or talk at the Eighth Street Club (both now gone). This group spirit encouraged them to challenge the pre-eminence of mighty Paris, and when many Europeans arrived in the city, fleeing the war in Europe (Ernst, Dalí, Chagall, Léger and Mondrian all arrived at this time), the Americans realised that their rivals might not be the gods they had imagined from afar. And so the postwar age came to be America's, came to be New York's, moment, and you should not be surprised if the city's galleries trumpet its achievements.

Of course not everyone sees this era as exclusively that of America's triumph. Gestural abstract painting was an international, or at least a Transatlantic, phenomenon. Europeans such as Wols (1913–51), Hans Hartung (1904–89) and Willi Baumeister (1889–1955) all evolved different approaches to Expressionist Abstraction, styles that were commonly described as *informel*. In Paris these efforts were guided in part by philosophical developments such as Phenomenology and Existentialism. One can sense these in the sculpture and painting of Alberto Giacometti; his figures always glimpsed as if from afar, always isolated and alone, and always so slender that they would seem to be at risk of disappearing altogether.

Europe departed from America in its continued regard for figurative art. Thinking of the London art scene of the postwar years, it is figure painters such as Francis Bacon (1909–92) and Lucian Freud (1922–) that we remember over and above their many abstract artist peers. Paris, meanwhile, contributed artists such as Jean Dubuffet (see illus p 181) and Jean Fautrier (1898–1964), who retained elements of figuration but built up the surfaces of their pictures into thick, dirtied layers of paint. For them, as for many, painting – like European civilisation more generally after the war – was perhaps at an end. The sand and straw and gravel that Dubuffet trowelled on to his canvases were just one way of acknowledging that humanity had descended so far as to have to start anew, and like Neanderthals, from whatever ordinary materials were available.

Jean DUBUFFET
Will to Power, 1946
GUGGENHEIM MUSEUM
Dubuffet's picture makes a mockery of the Nazi ideology referenced in its title. Rather than suggesting that humanity can rise above itself, the coarse texture and accumulation of material on the canvas suggest that we are ultimately bound by brute matter. The artist's approach to materials is typical of the European *informel* style.

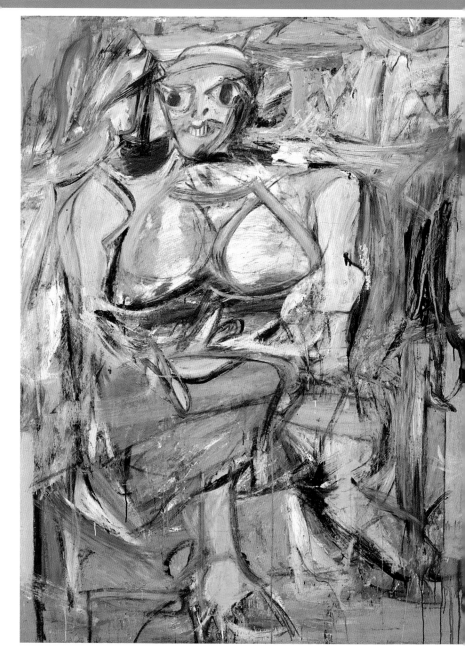

Willem de KOONING
Woman I, 1950–2
MoMA

De Kooning's vicious portrait excited attacks from some of his abstract-painter peers, and later from feminists. Nevertheless he would frequently return to the motif of the woman, which here straddles fertility goddess and pin-up. Cut-out pictures of women's smiles helped him settle on this figure's awful mouth.

'Abstract Expressionism' is an awkward, inadequate label for the various styles that New York painters developed in the late 1940s, since it hints at the two different tendencies that dominated the period. One is represented by painters of expressionistic gestures: Franz Kline (1910–62), Willem de Kooning (1904–97) and Robert Motherwell (1915–91). Their motifs might be abstract, but they were often inspired by memory: Kline's *Chief* (1950) is characteristic of the calligraphic, black-and-white style that was his signature, and it takes its name from a locomotive the artist remembered from his childhood – though the image evokes an animal as much as a machine.

One critic dubbed this group the 'action painters', describing their process of creation as a rapid and violent encounter with the canvas. But this ignores the painstaking compositions that underpin the pictures of a talent like de Kooning. *Painting* (1948) shows his early abstract style, and its black-and-white palette reminds us of his influence on Kline. Not long after completing it, de Kooning produced *Woman I* (1950–2), a change in direction that excited the wrath of some of his peers, for whom pure abstraction was an important refusal of a tainted world.

Mark Rothko (1903–70) is typical of those who valued abstraction, and who occupy the other wing of the Abstract Expressionist movement, the colour field painters. Rothko's work evolved slowly, moving through a Surrealist phase in pictures such as *Slow Swirl at the Edge of the Sea* (1944), and only achieving its mature style with later works like *No 3/No 13* (1949), in which clouds of colour hover in shallow space. Barnett Newman (1905–70) might also be grouped into this camp, though his peers were slow to appreciate the power of his work, and its greatest impact was perhaps felt by the subsequent generation of Minimalist sculptors.

MoMA is lucky to own *Onement I* (1948), Newman's breakthrough piece; here, for the first time in his work, a zip of colour bisects the canvas, hinting at everything from the spark of creativity to the dawn of time, to the human figure, alone in the world.

MoMA is less rich in the contemporary work of America's rivals, but some artists are well represented. Dubuffet was influential in promoting the notion of Art Brut, or 'raw art' – the art of children, the mentally disturbed and other outsiders. One can see this admiration in the graffiti-like quality of paintings like *Building Facades* (1946), which evokes the mood of forced jollity that might have reigned amid the deprivation of postwar Paris. The figures in Giacometti's sculpture can be similarly spindly and austere – look at *Man Pointing* (1947) or *City Square* (1948) – but he was more swayed by the philosophies of Existentialism and Phenomenology.

For a view of what was happening elsewhere in Europe, look out for works by Francis Bacon, the Irish-born, London-based painter. *Painting* (1946) contrasts the brutality of war with the civility of politics, showing the almost headless figure of a suited man sat before a huge flayed animal carcass. *Spatial Concept* (1957), by the Italian painter Lucio Fontana (1899–1968), brings wounds to the surface of the canvas itself, which is dominated by a circle of puncture holes.

At the **WHITNEY MUSEUM OF AMERICAN ART,** *Untitled* (1956), by Clyfford Still (1904– 80), shows the innovative approach of the artist – arguably the first of the Abstract Expressionists to settle on a style of colour field abstraction. His pictures have been likened to the surface of caves momentarily illuminated by crackling flares of light. The clouds of stained colour animating *Flood* (1967), by Helen Frankenthaler (1927–), show how the ideas of that first generation of colour field painters inspired a second. Although the reigning style of the period favoured painters over sculptors, David Smith (1906–65) absorbed many of his ideas about myth and memory from the milieu of the New York School. The wiry *Hudson River Landscape* (1951) is an example of his welded metalwork, the somewhat pictorial motifs coming in and out of view as the strands allow.

The style of Louise Bourgeois (1911–2010) was shaped by her encounter with Paris Surrealists, but she made her career in the US, and so is presented at the Whitney by sculptures such as *Quarantania* (1941). Its tall, slender, painted wood forms evoke a huddle of figures. Ellsworth Kelly (1923–) matured around the time that Abstract Expressionism first surfaced, but he also did so in Paris, and the very different interests this encouraged can be seen in the important early canvas *La Combe I* (1950). Its sequence of shattered red lines is reminiscent of geometric abstraction, yet it is something quite different, and when Kelly returned to the US, few knew where to place him. For a glimpse of how some borrowed from the reigning Abstract Expressionist style and yet began to challenge it, look for early works by Robert Rauschenberg (1925–2008), including the fiercely black *Untitled* (1951), and *Yoicks* (1953) with its splashy strips and spots resembling the wrapping from some dreadful gift.

While the **METROPOLITAN MUSEUM OF ART** contains important demonstrations of the period's mainstream, one might also look here for traces of its byways. Surrealism remained a vital tradition in

Europe after the war, infusing the period's interest in art by outsiders. One can see that in the work of the CoBrA group (named after its principal centres of activity – Copenhagen, Brussels and Amsterdam). Pierre Alechinsky (1927–) was one artist who was strongly shaped by his involvement in CoBrA, and *Gong* (1967), even though it points to the influence of a trip to Japan, is marked by the interests in myth and animal imagery that permeated the movement.

Back in the US, William Baziotes (1912–63) was an Abstract Expressionist who maintained the movement's early inclination towards Surrealism. The greens, blues and purples of *Flesh Eaters* (1952) evoke an underwater world inhabited by malevolent creatures. Look out also for de Kooning's *The Glazier* (1940), which shows his earlier figurative style; the figure here is already becoming flat and fragmented in ways that anticipate *Woman I* (1950–2). Look also for the German-born artist Josef Albers (1888–1976) who was an important presence in America at this time, particularly as a teacher. The Metropolitan owns a number of examples of his much-loved series *Homage to the Square*.

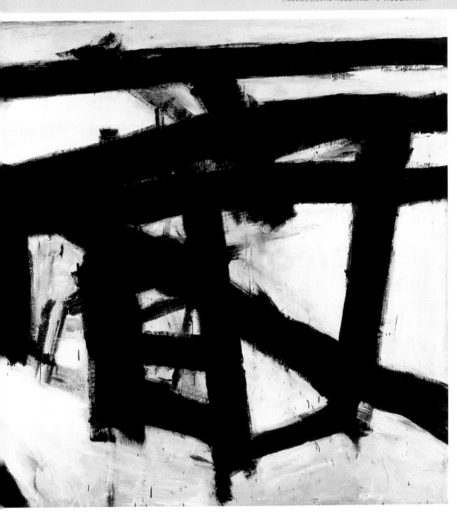

The **GUGGENHEIM MUSEUM** has some excellent work from both sides of the Atlantic, but its Fifth Avenue quarters leave little room to display it, so it can usually only be seen in temporary exhibitions. Other museums offer opportunities for different perspectives on these years. The **JEWISH MUSEUM** has pieces by Robert Motherwell and Morris Louis (1912–62). The **STUDIO MUSEUM IN HARLEM**, which focuses on African-American art, has work by Jacob Lawrence (1917–2000) and Norman Lewis (1909–79), and on the outskirts of Long Island City, across the East River in Queens, is the **NOGUCHI MUSEUM,** which stands on the site of the prominent Japanese-American sculptor's studio, hosting displays of his work as well as temporary exhibitions. Isamu Noguchi (1904–88) was first inspired by the biomorphic abstraction of Surrealists such as Miró and Jean Arp (1886–1966), but throughout his long career he was as versatile as he was prolific, and the museum encompasses everything from models for public gardens to stage sets and light sculptures.

ARTIST IN FOCUS:
JACKSON POLLOCK

In its edition of 8 August 1949, *Life* magazine ran a feature article about Jackson Pollock (1912–56) under the headline: 'Is he the greatest living painter in the United States?' New York's critics certainly thought so and, today, the city's pantheon of Modernist art, the **MUSEUM OF MODERN ART (MoMA)**, has the richest and widest collection of his work anywhere. But back then, *Life*'s editors were not so sure: could a painter who flung paint at canvases with a stick, who poured and hurled it to create roiling vortexes of colour and line, possibly be considered 'great'?

Pollock was born to a family of Scotch-Irish decent in Cody, Wyoming, in 1912, and was determined to be a painter from an early age. He left home for Los Angeles to train as an artist when he was only 16, and two years later he joined his two brothers, who were also artists, in New York, where he studied at the Art Students League under the prominent Regionalist painter Thomas Hart Benton. It was a good beginning, but in subsequent years he struggled: he lived in poverty, and often depended on his brothers, with whom he lived for a time in Greenwich Village. Those who knew him considered him difficult, emotionally immature and unstable – he was born with 'too big an engine inside', said Betty Parsons, one of his dealers. For release, he turned to drink: he became a regular,

roistering figure at the Cedar Bar, which used to be situated near his studio on 10th Street. In 1938 he spent several months in a psychiatric hospital.

Pollock's great turning point came following his marriage to fellow painter Lee Krasner (1908–84). The relationship brought him much-needed stability, as did the new rural surroundings of Long Island, to which the couple moved in 1945. Thus from 1947 to 1952 Pollock created his most important work. He started to place his canvases on the floor and to apply paint with overloaded brushes, sticks and even turkey basters. He danced about them in a graceful ballet, and embedded the surfaces of some of them with all kinds of debris. His method could seem haphazard, but many critics saw his work as a significant step forward. He had uncoupled the old unity of painterly space, line and colour, totally redefined the categories of drawing and painting, and found a new means to articulate pictorial space. As one influential critic put it, he had reimagined the canvas not as 'a space in which to reproduce, re-design, analyse or "express" an object', but as 'an arena in which to act'.

Pollock found great critical and commercial success with these paintings, but continued to be troubled by alcoholism, and his health deteriorated until, on 11 August 1956, he was killed in a car accident. His death, aged 44, came barely a year after James Dean had been killed in a car crash, and the tragedy secured Pollock's image as a modern American hero.

Jackson Pollock, January 1950, by Rudolph Burckhardt (1914–99).

Jackson POLLOCK
Easter and the Totem, 1953
MoMA
In the late 1940s, Pollock began to turn away from the radical abstraction of the drip paintings and tried to reclaim some figurative imagery. But in this unusual late canvas he also renewed his earlier, fleeting interest in Matisse.

MoMA has rich and comprehensive holdings of Pollock's work, and they give a full sense of the style he had evolved by the late 1930s and early 1940s when he began to hit his stride. By this stage he was evolving his own distinctive approach that drew on Surrealism, tribal art, and the work of Mexican muralists such as José Clemente Orozco (1883–1949) and David Alfaro Siqueiros (1896–1974). The drawings Pollock produced during psychiatric therapy were also undoubtedly important: as one critic put it, his work in this period had 'a whiff of the shaman and Jung in the atmosphere and Freud's primal hordes'.

Bird (c 1938–41), its wings outstretched over two prone heads, is typical of this period, its totemistic imagery and sprinklings of sand on the surface hinting at the influence of American-Indian art. Stenographic Figure (c 1942) represented an important breakthrough: it powerfully reinterpreted the subject of the reclining nude, and channelled

Full Fathom Five, 1947
A Long Island neighbour of the artist suggested the title for this uncharacteristically vertical canvas: it comes from Shakespeare's The Tempest ('Full Fathom Five thy father lies/ Of his bones are coral made'), and it perfectly conjures the painting's oceanic mood. Pollock even fixed pebbles to the surface.

The Flame, c 1934–8
In the mid-1930s Pollock began to abandon the anecdotal subjects of his earlier works. In canvases like The Flame, he maintained the contrasting colours and interlocking, twisting forms of his earlier style, but tried a more abstract imagery. This was exhibited in his first major group exhibition, in 1942.

the work of leading European artists like Miró and Picasso. When Mondrian saw it, he was intrigued: 'something very important is happening here,' he told Pollock's dealer at the time, Peggy Guggenheim.

Exactly how Pollock came upon his drip technique has been a matter of long and inconclusive scholarly argument, but his work was already taking steps towards it in the mid-1940s. He began to lose the symbolic imagery of his earlier pictures and instead to look for more abstract means of expression. His experience of painting a mural for Guggenheim's apartment was also important in spurring him on, and in 1945 he painted *There Were Seven in Eight*, a picture in which the recognisable imagery is thoroughly suppressed and the surface is knitted together by a vivid tangle of lines.

In 1946 his style became more boldly abstract still, in works like *Shimmering Substance* of that year, and the year after he finally hit on the idea of flinging and pouring paint, and thus found the means to create the light, airy and apparently endless webs of colour that he was reaching towards. 'There is no accident,' Pollock once said, 'just as there is no beginning or end … Sometimes I lose a painting, but I have no fear of changes, of destroying the image, because a painting has a life of its own.' This led to works like *Number 1A* (1948), a larger canvas than Pollock was familiar with, and dense with a dazzling web of colour.

Pollock's radical abstraction seemed to herald an incredible new freedom for painting, yet recognisable imagery continued to hover in the background of his pictures, particularly in canvases like *One: Number 31* (1950), which retains a sense of rhythmically dancing figures. It is a picture that employs a remarkable diversity of effects, from areas of stained canvas to those of pooled paint. Pollock might have abandoned all direct references to the natural world, but he still managed to make his paintings eloquently metaphorical. Like many of his canvases from this time, *One* evokes a mood of

grandeur which ties it to the tradition of sublime landscape which stretches back into the 18th century. It also glistens as if it were dappled with light in the manner of Monet's canvases, and many critics have speculated on whether Pollock was influenced by the Frenchman. Certainly, *One* bears comparison with some of Monet's late work, also in MoMA, such as *Water Lilies* (*c* 1920). Most conclude, however, that Pollock had no access to

The She-Wolf, 1943
Possibly inspired by an
Etruscan-style bronze in the
Frick Collection, the
protagonist of this picture
appears to be Lupa, an
animal of Classical legend
who suckled the founders of
Rome. Pollock's mother
visited him in New York in
1943, and *She-Wolf* may
have been a response to that
upsetting experience.

Monet's work in this period, and the Impressionists' reputation was not nearly so great then as it is now, and so Pollock would have been unlikely to have sought out their pictures.

Despite the freedom that his new method seemed to lend him, Pollock continued to be preoccupied with figurative imagery, and it gradually began to resurface more emphatically in the late 1940s. He began to drink more heavily

again, he also returned to drawing more frequently, and looked again at some of his old motifs, and in 1950 began work on a series of mainly black-and-white poured paintings. Some, like *Echo (Number 25, 1951)*, are calligraphic in style and only residually figurative, but others bear clear images of heads. They were badly received when Pollock first exhibited them, but he continued to work on them right through 1953, his last productive year of work.

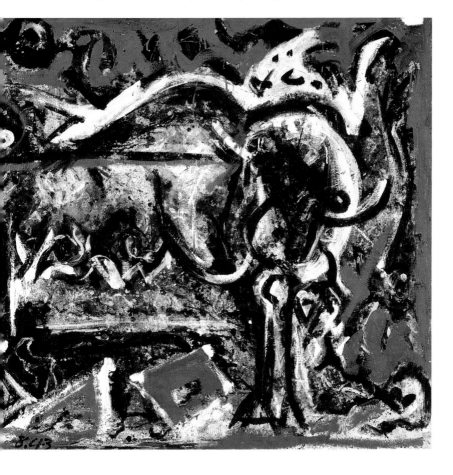

Although there are no major pictures from
Pollock's early figurative phase in New York's
collections, there is a marvellous example of the
style that shaped him in the mural *America Today*,
by Thomas Hart Benton. Originally completed in
1930 for the New School for Social Research in
New York, it was bought by AXA Equitable in 1984,
and now hangs in the foyer of the **AXA EQUITABLE
CENTER** at 1290 Sixth Avenue, only a few blocks
from MoMA. Pollock learnt much from Benton: his
expansive, lyrical mood, his patriotism and his
serpentine forms – not to speak of his love of heavy
drinking and his boisterous masculinity. And
America Today is a classic statement of the
Regionalist movement of the 1930s, a proud hymn
to the diversity of American life during a time when
the Depression had almost brought the nation to its
knees. There can be no better guide to the mood,
moment and style that forged the young painter.

The **GUGGENHEIM MUSEUM** has a strong
group of pictures from the 1940s, including *Moon
Woman* (1942), which offers an intriguing insight
into Pollock's preoccupation with archetypes of
motherhood (his relationship with his mother was
torturous). The two works owned by the
METROPOLITAN MUSEUM OF ART – *War*, from
1947, and the unmissable *Autumn Rhythm
(Number 30)*, from 1950 – also derive from this
period. The three works in the collection of the
WHITNEY MUSEUM OF AMERICAN ART,
Number 27 (1950), *Number 17* (1950) and
Number 18 (1951) all derive from his phase of
pure, drip-and-splatter abstraction.

Pollock's residences in New York included
46 CARMINE STREET (1932–3); his brother's
apartment at **46 EAST 8TH STREET** (1935–45);
and a carriage house at **9 MACDOUGAL ALLEY**
(1949 and 1950). In the years Pollock frequented
the Cedar Tavern it was situated at 24 University
Place; the bar closed in 2006. Peggy
Guggenheim's gallery, Art of This Century, was
situated at **30 WEST 56TH STREET**.

War, 1947
METROPOLITAN MUSEUM
War, the only drawing Pollock
ever titled, harks back in
style to his work of 1943–4,
when he was trying to
combine the influence of
Picasso, Surrealism, and the
work of Mexicans Orozco and
Siqueiros. Some of the
imagery may be traced to
Picasso's *Guernica* (1937).

*Autumn Rhythm
(Number 30),* 1950
METROPOLITAN MUSEUM
Pollock laid down a skeleton
of black lines to support the
web of white, brown and
turquoise lines that rise to the
surface of *Autumn Rhythm*.
The imagery may be
abstract, but the colours and
the horizontal format lend a
sense of expansive space
that is reminiscent of
landscape.

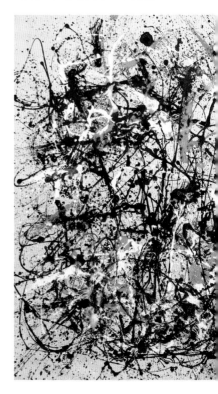

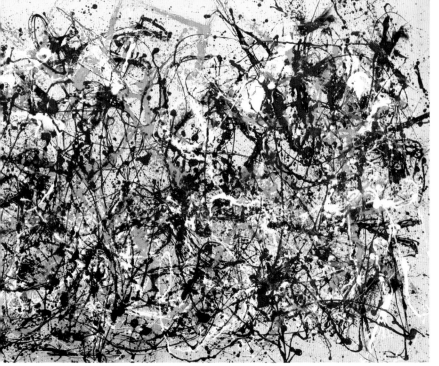

THE ART OF THE REAL: POP TO MINIMALISM

In a guidebook devoted to the art of New York City, we do not lightly recommend an excursion. Several of the city's museums, particularly the **MUSEUM OF MODERN ART (MoMA)**, are richly stocked with the art of the 1960s. However, none offers quite the experience of a tour around **DIA:BEACON**, an outpost of the **DIA ART FOUNDATION** which lies in the small town of Beacon, a pleasant train ride from Grand Central Terminal, on the banks of the Hudson River. There, in the shell of a former printing factory, sharply and perfectly illuminated by natural light and generously spread over nearly 300,000 square feet (27,870 square metres), is one of the world's most outstanding collections of Minimalist and Post-Minimalist art.

The 1960s presented many challenges to traditional museums and galleries. Art was venturing beyond their walls – out into the streets, into the landscape and, in the hands of artists such as Michael Heizer (1944–) and Walter de Maria (1935–), even into the desert. Dia (which comes from the Greek for 'through') was born from this new beginning, and initially it was devoted to facilitating the production of such unconventional projects, often using its deep pockets to provide sites for the permanent exhibition of chosen artworks.

Several of these still exist in New York, most notably Walter de Maria's *New York Earth Room* (1977) and *Broken Kilometer* (1979), both of which provide arrestingly tranquil departures from the commercial bustle of SoHo. Eventually, however, a collection began to grow. It is slightly eccentric, shaped as it once was by the personal tastes of its founders, and it does not offer the comprehensive survey to which conventional museums aspire. But it is excellent. For many years

it could be seen at a site in New York's Chelsea (and there are plans afoot for a new site in the same area), but since Dia:Beacon opened, it has been essential.

If you really cannot spare the time for the journey, the city's other museums still offer a great deal and, it is true, a more accurate picture of the 1960s: if the art of that decade deserves to be called the Art of the Real, this is because *all* of its tendencies – Minimalism, Pop, Conceptualism and so forth – addressed the gap between art and life. To appreciate the full extent of these explorations you should visit MoMA and the **WHITNEY MUSEUM OF AMERICAN ART**. If the **GUGGENHEIM MUSEUM** has an exhibition focused on this period in town, you should visit there too, as its collection also has significant holdings. The **METROPOLITAN MUSEUM OF ART** has far fewer pieces, but you can always expect to find something in its compendious displays. The **JEWISH MUSEUM** has in its collection works by Nancy Spero (1926–2009), Anni Albers (1899–1994), Alex Katz (1927–) and others. The **STUDIO MUSEUM IN HARLEM** can offer an African-American perspective with works by artists including Barkley Hendricks (1945–), Betye Saar (1926–) and Romare Bearden (1911–88).

If you enjoy excursions, you might consider another short journey to the **STORM KING ART CENTER**, the sculpture park that nestles in a 500-acre (202-hectares) landscape of rolling hills in the Hudson Valley. Here you can see work by Mark di Suvero (1933–), David Smith and other leading sculptors from the 1960s to the present day.

Frank STELLA
Die Fahne Hoch!, 1959
WHITNEY MUSEUM

Although a painter, Stella (1936–) was crucial to the emerging generation of Minimalist sculptors, for whom he inverted all the

underpinnings of Abstract Expressionism. In his work there is no mystery or tragedy – as he put it himself, 'what you see is what you see'. The title comes from a Nazi Party anthem.

Sol LEWITT
Drawing Series—
Composite, Part I–IV, #1–
24, B, 1969
At first associated with the
Minimalists, LeWitt (1928–
2007) was later recognised
as a Conceptual artist, and a
rigorous system always
underpins the wall drawings
that he began creating in the
late 1960s. In this piece the
starting block is a square:
'There is no need to invent
new forms,' he once said.

While Conceptual art remains – at least in the
public imagination – the pinnacle of obscurity
and difficulty in modern art, Minimalist art can be
far harder to grasp, such is its deceptive simplicity.
A good place to start is the *Untitled* installation, by
Donald Judd (1928–94), from 1976, consisting of
15 plywood boxes constructed from finely finished
Douglas fir. Stand over one of the boxes. Sense its
scale, its dimensions, the character of its subtly
articulated interior: measure yourself against it.
Minimalism removed sculpture's traditionally
representational function, and threw itself into
dramatising the viewer's experience of the space
described by the object. The long sequence of
polished metal panels that make up Walter de
Maria's *Silver Metres* (1976) and *Gold Metres*
(1976–7) performs a similar role, but centres more
on the experience of distance and measurement.

If all this seems too rigorously rational, look
for work by Dan Flavin (1933–96), who trained
for the priesthood before he turned to art. His
series of *'monuments' for V Tatlin* (1964–81)
comprise a sequence of wall-reliefs constructed

from cleanly, brightly glowing fluorescent light
tubes. They pay tribute to a building-cum-
monument that was devised but never built by
the Russian Constructivist Vladimir Tatlin (1885–
1953), a building that for Flavin represents failed
utopias.

Dia:Beacon also contains good work by the
Postminimalist generation that emerged fast on the
heels of artists such as Judd and Flavin. Robert
Smithson (1938–73) is perhaps the most
celebrated of this group. His *Gravel Mirrors with
Cracks and Dust* (1968) consists of a series of
mirrors piled with gravel; it contains something of
both Conceptual and Land art in its preoccupation
with how we represent the landscape beyond the
gallery. *Map of Broken Glass (Atlantis)* (1969) uses
a pile of splintered glass to evoke that mythical
undersea city; it also has that touch of the futuristic
that often enlivened Smithson's work. The artist's
life was cut short by an aeroplane accident in 1973,
but Richard Serra (1939–), also of that generation,
went on to have a long career. The museum
contains several of the monumental *Torqued*

Bernd & Hilla BECHER
Plant for Styrofoam Production, Wesseling near Cologne, Germany, 1997
Bernd began photographing industrial architecture simply as a source for his paintings, but soon the habit became an end in itself, opening out onto questions of cataloguing, and of what beauty can be found in things that are ostensibly ugly.

Ellipses that Serra began working on in the 1990s. Like abbreviated mazes, their twisted plates of Cor-Ten steel invite the viewer to sense the drama of irrational spaces, the thrust and threat of leaning walls.

Dia's collection is not the rationally ordered one encountered in most museums, and it happily digresses to take in other trends and artists from beyond the stricter confines of Minimalism. Photographs of vernacular industrial architecture by the German photographers Bernd (1931–2007) and Hilla (1934–) Becher remind us of how similar interests were expressed in Europe. As does *Arena*

(1973), by Joseph Beuys (1921–86), which, via a series of photographs encased in heavy metal frames, retrospectively surveys the career of the influential German artist.

If you want to see how ideas were passed down through the generations in Germany, you might also look for *Room 19* (1968), by Imi Knoebel (1940–). Knoebel was still Beuys' student when he assembled this strange accumulation – wood and fibreboard objects emulating canvas stretchers, boxes and other ambiguous containers. It speaks, as Beuys often did himself, of the raw materials of art.

Yves KLEIN
Blue Monochrome, 1961
MOMA
Klein (1928–62) worked with
a chemist to develop his own
proprietary shade of blue,
International Klein Blue, and
he often lavished it on

monochromatic paintings
such as this. The tradition of
the monochrome reaches
back to Russian painters
such as Malevich and
Rodchenko; for Klein, it
represented an 'an open
window to freedom'.

MoMA is bedecked with riches from this
period. *Flag* (1954–5), by Jasper Johns
(1930–), is one of the seminal paintings of the
1950s, providing a bridge between the styles of the
Abstract Expressionists and the Pop generation
who would emerge soon after. Not only its popular
motif but its deadpan ambiguity proved influential
(is it a painting or a flag?), with some worrying that it
was unpatriotic. Roy Lichtenstein (1923–97) was
among the first fully fledged Pop artists to emerge,
pictures like *Girl with Ball* (1961) being bolder still
in eliding pre-existing, popular sources (in this case
comic books) with the supposedly 'fine' art of
painting.

Pop, concerned as it often was with media,
proved more fertile for image-makers than for
sculptors, but Claes Oldenburg (1929–) provides
one powerful exception to that rule. *Floor Cone*
(1962), an over-sized ice-cream cone on its side,
is one of his unsettlingly melancholic 'soft
sculptures'.

Conceptual art would also soon gain ground
in the 1960s. *One and Three Chairs* (1965), by
Joseph Kosuth (1945–), is a classic, if somewhat
dry, probing into the difference between a
dictionary definition of a chair, a photograph of one,
and the real thing. Far more comic, and less
analytical, is the work of the British duo Gilbert
(1943–) & George (1942–), whose video *Gordon's
Makes Us Drunk* (1972) shows them drinking hard
in their typically genteel way, a sight which gives
onto thoughts about the difficulty of depicting such
altered mental states.

For a look at how one painter influentially
skipped from Abstract Expressionism back to
figuration while bypassing Pop, look for work by
Philip Guston (1913–80). *City Limits* (1969)

shows three Klu Klux Klan members improbably
crammed into a car against the backdrop of a
contemporary city.

The **WHITNEY MUSEUM** also suggests other
directions aside from those of Pop and Minimalism.
One was to confront painting with photography:
Phil (1969), by Chuck Close (1940–), is a
monumental, and extraordinarily finely detailed,
black-and-white painted portrait of the composer
Philip Glass. Another was to find a new style of
painterly figuration: Alex Katz's *Red Smile* (1963)
retains Pop's stridency and simplicity of motif, but
avoids its inhumanity. An artist who certainly
encouraged Pop, but whose work never fully
succumbed to it, was Robert Rauschenberg.
Satellite (1955) is one of his early *Combines*, wild
collages that straddle painting and sculpture and
splice everything from newsprint to stuffed animals;
here a pheasant struts over the top of the frame.

Meanwhile, on the American West Coast, Pop
took a slightly different tone from that of Warhol
and his peers in New York. Edward Ruscha (1937–
) became one of the leaders here, and his *Large
Trademark with Eight Spotlights* (1962) booms
with the logo of 20th Century Fox, suggesting a
landscape blacked out but for lights and signage
glimpsed from a passing car. Quite outside the
ambit of Pop, and in the realm of sculpture, Mark
di Suvero's *Hankchampion* (1960) loosely binds
lengths of wood and chains to create a somewhat
gestural sculpture reminiscent of Abstract
Expressionist paintings. A decade on, *Untitled
(Rope Piece)* (1969–70), a straggly net of material
by Eva Hesse (1936–70), shows how
Postminimalist sculpture became preoccupied
with gravity, abstraction and formlessness.

ARTIST IN FOCUS:
ANDY WARHOL

Andrew Warhola (1928–87) of Pittsburgh, Pennsylvania, was a young man unsure of himself when he arrived in New York in 1949. He was just 20. His first home in the city was a roach-infested, sixth-floor walk-up apartment on the Lower East Side. He moved into it in June, and would survive the summer on $200. Seven years later, so-called Raggedy Andy was the best-known, highest-paid fashion illustrator in New York. Another decade and he would be America's most fêted Pop artist.

Today he is synonymous with New York, but unfortunately the city is not the best place to see his work; to really explore it you might consider a journey to Pittsburgh, home of the Andy Warhol Museum. New York's major museums certainly own important pieces, but unless there is a major exhibition ongoing, you are only likely to see a few celebrated examples – a *Marilyn*, or some *Campbell's Soup Cans*. The drawings he produced before 1960 are less often shown and, by 1965, he had essentially stopped painting to concentrate on experimental film. Critics no longer agree that his later career is purely a tale of decline, but it is not easy to see those films that have recently attracted interest.

In the absence of the work, though, there is still the life, and you might consider seeking out the places where Andy spent his days. That first roach-infested home overlooked Tompkins Square. The fabled Factory began in November 1963 in an old hat factory at **231 EAST 47TH STREET.** It was far from most artists' downtown studios, but it suited, and this was where he did his best work. Visitors included Lou Reed and the Velvet Underground. Billy Name – a hairdresser who styled himself a Buddhist and a black magician – was responsible for its look, tin-foiling it entirely in silver. 'It must have been the amphetamine,' Warhol said, 'but it was the perfect time to think of silver!'

The Factory gave Warhol his social scene and, when he was filming, his casting couch. But in 1968 the fun spilled over and people started to arrive with guns, so the Factory moved downtown, to **33 UNION SQUARE WEST.** There, a new crowd arrived and it developed a more elegant tone. It then moved across the street, to **860 BROADWAY.** Finally, in the 1980s, it moved into a disused electricity generating station on **EAST 32ND STREET** (between Madison Avenue and Fifth Avenue). Warhol paid $2 million for the property, and saw the renovation expenses skyrocket to $3 million. 'Getting rich isn't as much fun as it used to be,' he said. Nevertheless, Warhol died richer than he could ever have imagined. In 1975 he bought a five-storey Georgian-style mansion at **57 EAST 66TH STREET**, in the prestigious Upper East Side. He needed the space: he had shopped avariciously for decades – Art Nouveau and Art Deco furniture, Native American art, folk art, 175 cookie jars. When he died, the house was found to contain such a hoard that few rooms remained habitable.

Andy WARHOL
Andy Warhol (with Banana),
1982

Nine Jackies, 1964
WHITNEY MUSEUM

MoMA has by far the most extensive collection of Warhol's work in the city. It begins early, with many of the shoe drawings on which Warhol's reputation as a commercial illustrator rested in the 1950s. At his height, he produced a campaign for I Miller shoe stores that ran weekly in the *New York Times*. Most artists wrestle with their art in some obscurity before they emerge, but Warhol already had success, and his decision to begin making work to exhibit in galleries was fairly sudden. The change in his work was also sudden, shifting from ingratiating Rococo frivolity to cold spectacle: shortly after Marilyn Monroe's death in 1962, Warhol immediately recognised a subject, and produced the tomb-like *Gold Marilyn* (1962). His love of other aspects of popular Americana is

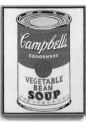
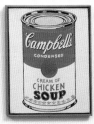
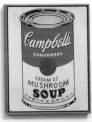
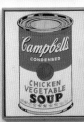
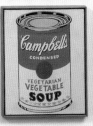
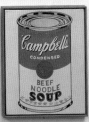

Campbell's Soup Cans,
1962
Campbell's Soup Cans
borrows its structure from the
brand itself, with the 32
canvases corresponding to
the 32 flavours Campbell's
then produced. Warhol does
not even seem to have
intended them to appear in
any particular sequence,
though MoMA exhibits them
in the order in which the
flavours were introduced.

revealed in the silkscreen *Cagney* (1962), and in *Double Elvis* (1963). And with *Campbell's Tomato Juice Box* (1964) he delved into sculpture, aping the form of a common cardboard box.

The series *Flowers* (1970) saw Warhol toying with saccharine sentiments, but in subsequent years he would touch on various moods and themes. Among the many portraits of his later years are *Mao* (1972) and *Jean Cocteau* (1983). His interest in abstraction produced both the series *Rorschach* (1984) and *Camouflage* (1987). In his penultimate year, 1986, he returned to an early masterwork, Leonardo's *Last Supper*, though Warhol's version is blazoned with the logos of General Electric and the cosmetics giant Dove.

One of the intriguing puzzles that hangs over Warhol's classic Pop art of the early 1960s is his attitude to the subjects he addressed. The **WHITNEY MUSEUM OF AMERICAN ART**'s collection offers a good place to confront that, because it contains some pictures that seem emphatically deadpan, and others perhaps inspired by genuine sorrow. Take *Green Coca-Cola Bottles* (1962): its simple line-up of bottles seems to epitomise the flat, affectless quality of some Pop. But then look at the images of Jackie Kennedy – happy, then sad – that appear in *Nine Jackies* (1964), part of a series Warhol produced in the wake of her husband's death. It may be one of the rare instances in which Warhol let sorrow show through in his pictures.

It is said that Warhol carried on working on 22 November 1963, the day JFK was shot, following the events on his television. He was fascinated by the media spectacle of mourning, but it took him some time to fix on Jackie Kennedy as the event's emblem, and longer to find the eight cropped portraits of her that formed the basis of his *Jackie* series.

Some believe that he was highly motivated by his sympathies, and to demonstrate this they also point to pictures like the Whitney's *Birmingham Race Riot* (1964), one of a number of images he produced that address the civil rights protests. But what of the screenprints included in the 1971 portfolio *Electric Chair*? The prints are so richly inked that they almost occlude the chair itself. The pictures speak of death, but they seem to have little to say about the death penalty.

From here one might consider a trip to the **GUGGENHEIM MUSEUM** or the **METROPOLITAN MUSEUM OF ART**, but be warned that neither have deep collections of his work, and the holdings of the former are generally only exhibited when a temporary exhibition demands it.

Self-Portrait (in Drag), 1981
GUGGENHEIM MUSEUM
Warhol adored Polaroids. Often he used them simply as tools, particularly for the society portraits of his later years, but this print comes from a series of portraits in drag that Warhol produced with the photographer Christopher Makos (1948–). It reflects his interest in drag queens, but it might also reference similar portraits of Marcel Duchamp.

What is contemporary art? This question is asked not only by those who find the whole gamut of modern creation, from Picasso to Damien Hirst (1965–), a perplexing riddle. One might reasonably ask why sometimes Francis Bacon is considered a 'modern', while Lucien Freud, his peer, is a 'contemporary'. The answer is not simply that one lived later than the other. In the auction world, which does much to fix these labels, the contemporary art market was born with the so-called Scull sale, the auction of New York taxi tycoon Robert Scull's collection, back in 1973. Since then, the phrase 'contemporary art' has come into common use, with most accepting that something divides the art of the 1960s from that of the postwar years. But the artists themselves, the artists of our time, also do much to establish our sense of what is contemporary. For them, it is the art that seems more recognisable, most pressing, and rarely do they need to look back much further than a generation.

A day spent in New York's commercial galleries will make this plain. The time of great movements, of 'isms', has largely passed. Now it seems we have only moods and micro-trends. This is not necessarily a bad thing; in fact it reflects the situation art arrived at in the closing years of the 1960s, as Pop, Minimalism and Conceptual art all declined. In their place arose video art, land art, performance and various other directions that might be collectively described as Postminimalism. Of course, art history may tell a tale of sensible progress from one trend to another, one generation to the next, but changing times always present artists with new perspectives on the past, and reveal inspiration where before there seemed only art that was old and dead. Hence, despite reports of its demise, painting continues to thrive, particularly in the commercial galleries. Some painters reach so far back in search of ideas that they entirely slip the net of the contemporary and look sometimes postwar, or even 19th century. Artists continue to surprise.

As to the question of whether New York is still the best place to experience this shock of the new, some jaded insiders will tell you that it is provincial, nowadays, as a centre for contemporary art. In a sense they have a point, as nearly half a century has passed since the city could claim to be sheltering the most avant-garde tendencies of the day. The art world is now a far larger, more truly global affair than it once was – and those same insiders love to tell us how Krakow, or Leipzig, or Nairobi, or that special part of Siberia is now where it is at. But the truth is that the muscle is still in New York. The most powerful galleries and periodicals, and some of greatest artists and collectors, all maintain outposts here. Navigating the city is a life's work, but a day spent in the museums – the **MUSEUM OF MODERN ART (MoMA)** and the **WHITNEY MUSEUM OF AMERICAN ART**, principally, for their collections of recent art – and maybe a day visiting the smaller museums and the Chelsea galleries, will assuredly still give you a taste of the best contemporary art in the world.

Gerhard RICHTER
October 18, 1977, 1988
MOMA
On the date that titles this series, the three principal members of the Red Army Faction, a German terrorist group of the 1970s, were found dead. Here, based on photographs of the individuals, Richter (1932–) proposes a new role for painting as a vehicle for memorial now that photography has usurped its job of describing the world.

Tacita DEAN
Crowhurst, 2006
Dean (1965–) has long been fascinated by the story of Donald Crowhurst, who disappeared while on a round-the-world yacht race. This picture shows the Crowhurst yew, an ancient, coincidentally named tree, which she found on the grounds of a 12th-century church. The unknown age of the tree echoes the unknown fate of the sailor.

The 1970s was a time of splintered radicalism in the arts, and one can follow various routes through the decade. Performance art was particularly important, with many artists placing a new stress on the body. *Seedbed* (1972), a video by Vito Acconci (1940–), documents an infamous performance in which he lay under a ramp in a New York gallery and masturbated, vocalising his fantasies to those visitors walking above him. Also placing the body front and centre is the *Food for the Spirit* (1971) self-portrait series by Adrian Piper (1948–), though it inclines more towards the domain of Photo-Conceptualism. It shows the artist's naked body so smothered in darkness that the series seems poised between themes of mind and matter.

Photography would be increasingly important as the decade came to a close, with a new generation emerging who had been influenced by both Pop and Conceptual art. Cindy Sherman (1954–) is perhaps foremost among this group, and her series of *Untitled Film Stills* (1978–80) is a famously insightful look at how Hollywood has stereotyped women, with the artist herself taking on the mantles of the different types.

While trends such as these continued to be fruitful in the 1980s, with artists such as Richard Prince (1949–) and Sherrie Levine (1947–) looking at themes of advertising and appropriation, many others returned to painting. *Perseverance* (1981), by Francesco Clemente (1952–), with its naked figure grasping a model of the Pantheon, exemplifies the return of the human figure, and of references to the Classical past, in contemporary Italian painting. Similar in its preoccupation with history – this time German – is *To the Unknown Painter* (1982), a watercolour by Anselm Kiefer (1945–), which is a vision of a building reminiscent of a Nazi-era monument.

The 1990s proved to be a fruitful period in British art, and MoMA's collection documents this too, though it has little major work by Damien Hirst, and only later work by many of the decade's leading figures. Many were inspired once again by Pop and Conceptualism: one might see a reprise of Cindy Sherman's work in the Gillian Wearing (1963–) photograph *Self Portrait at 17 Years Old* (2003). Others returned to sculpture: *Untitled (Mattress)* (1991), by Rachel Whiteread (1963–), renders the soft bed in pale white plaster, bringing a sense of bodily presence and time to the austere vocabulary of Minimalism.

The 1990s were marked by the rise of identity politics in the US, and by the work of politicised black artists such as David Hammons (1943–). His *African-American Flag* (1990) renders the Stars and Stripes in the colours of pan-African unity: red, black and green. *Felix in Exile* (1994), an animated tale of the tycoon Felix Teitelbaum by William Kentridge (1955–), also addresses race but from the perspective of South African politics.

For a look at how Pop has been reinterpreted by a new generation sensitive to the changed borders between art and commerce, see the video *Green Pink Caviar* (2009) by Marilyn Minter (1948–). It evolved from a photo-shoot in which the artist directed models to lick brightly coloured candies while she shot the strangely gorgeous and grotesque effects from underneath a glass plate.

SEE ALSO

Your first stop should be the **WHITNEY MUSEUM**, and it is reassuring to find, at the beginning of the museum's coverage of the 1970s, the portrait of *Andy Warhol* (1970) by Alice Neel (1900–84). Neel found her distinctive style of figurative realism, and her love of portraiture, in the 1930s; she maintained it throughout the years when other styles reigned supreme and, today, artists still look back to her example. There is always an alternative route through history. The work of Duane Hanson (1925–96) is more conventionally Pop in tone, but it too is distinct in its reliance on sculpture, and on a super-realistic imitation of the world. His *Woman with Dog* (1977) is a perfect life-sized imitation, a vignette of domestic life far beyond the gallery world.

Pop was clearly also an inspiration behind the arrival of graffiti art in the galleries in the 1980s. *LNAPRK* (1982) by Jean-Michel Basquiat (1960–88) is a tangle of primitively scratched figures and letters; it may refer to the long-lost Coney Island amusement attraction, Luna Park. The attraction of graffiti for some such as Basquiat and Keith Haring (1958–) was its echo of Expressionism, but others such as Jeff Koons (1955–) wanted a cold, ambiguous kind of Pop. Koons' *New Hoover Convertibles* (1981–7) shows the approach that launched his meteoric career, with a series of vacuum cleaners standing in an illuminated vitrine, more like domestic gods than humble machines. New York's Lower East Side was the home of a

vibrant art scene in these years, giving shelter to a diverse bohemia, and to emerging galleries, and something of its myth is captured in *Big Heat* (1988), in which Martin Wong (1946–99) shows two firemen embracing under the shadow of one of the old tenement buildings that give the neighbourhood its character.

While many artists borrowed from Pop in these years, some returned to traditions of figurative sculpture, among them Kiki Smith (1954–) and Robert Gober (1954–). They rarely did so to console: Gober's *Untitled* (1991) is deeply unsettling, consisting of a trousered leg, mounted with a candle, protruding inexplicably from the wall. Here, rather as in Duane Hanson's sculpture, the domestic intrudes on the public world of art. Figurative painting took a little longer to return to popularity, but perhaps its most important force, John Currin (1962–), was already at work producing pieces such as *Skinny Woman* (1992). He was swiftly followed by Elizabeth Peyton (1965–), and among several works by the artist the museum owns *Live to Ride (EP)* (2003), a tongue-in-cheek self-portrait that has the soft, boyish features of the artist clothed in a Harley Davidson T-shirt. Still in the field of painting, but mining different, vernacular traditions, *Souvenir IV* (1998) by Kerry James Marshall (1955–) adopts the style of an old American embroidery tester, to pay tribute to stars of black music such as Otis Redding. Exemplifying the importance of the projected image in recent art, *1st Light* (2005) by Paul Chan (1973–) evokes natural disasters and manmade catastrophes, with silhouettes of human figures apparently falling from the sky.

New York is blessed with some first-class museums that hold only small collections (or none at all) and devote themselves to staging temporary exhibitions. The **NEW MUSEUM**, since relocating to a spectacular white boxy construction on the Bowery, is the most glittery, and it is a good starting point. More ramshackle is **MoMA PS1**, located in an old public school in Long Island City, Queens. It

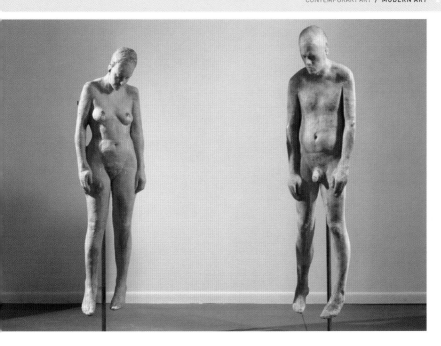

has had a long involvement with the grassroots of New York's art scene, and is a reliably fast-reacting barometer; since it became an affiliate of MoMA, in 2000, it has new power.

PS1 might also introduce you to the attractions of the city's outer boroughs, for nearby in Queens is the **SCULPTURE CENTER**, and further out is the **QUEENS MUSEUM OF ART**, whose exhibitions tend to reflect the extraordinary ethnic diversity of the borough. Leaving Queens, the **BROOKLYN MUSEUM** has a strong commitment to collecting contemporary art, and its Elizabeth A Sackler Center for Feminist Art provides a permanent home for *Dinner Party* (1974–9), a landmark installation by Judy Chicago (1939–) that has elaborately designed place-settings for 39 historical women. The Bronx has the **BRONX MUSEUM OF THE ARTS**.

Returning to Manhattan, the **DRAWING CENTER** in SoHo sheds light on one of art's humbler media, and further north the **STUDIO MUSEUM IN HARLEM** has a good collection as well as a lively programme of temporary exhibitions. We should not forget the **METROPOLITAN MUSEUM OF ART**, the **GUGGENHEIM MUSEUM**

and the **JEWISH MUSEUM**, all of which have collections of contemporary art.

Turning to the city's commercial galleries, your starting point should be Chelsea. Long ago, their home was 57th Street, and an important few, such as the **MARIAN GOODMAN GALLERY**, remain. In the 1980s, most headed for SoHo, but when the retail sector followed and rents rose, they moved on north to Chelsea. Starting at around 18th Street, you can weave up and down between 10th and 11th Avenues and take in hundreds of galleries before they peter out, at around 27th Street. There are some good new small venues and some bad old ones, naturally, but the kingpins of the area, which can usually be relied upon, include the **GAGOSIAN GALLERY, GLADSTONE GALLERY, MATTHEW MARKS GALLERY, LUHRING AUGUSTINE, ANDREA ROSEN GALLERY** and **DAVID ZWIRNER GALLERY**.

From here, if you still want the newest, lowest-budget and maybe the most cutting-edge, go to the Lower East Side, below East Houston Street, where numerous smaller operations have set up. You will always find a nearby bar in this neighbourhood where you can stop for a well-earned rest.

The English polymath William Henry Fox Talbot (1800–77) had only been experimenting for a few months with photography, his latest invention, when he created *The Oriel Window, South Gallery, Lacock Abbey* (1835), a picture not much larger than a postage stamp. It records with remarkable felicity the stone mullions and elegant leading of one of the windows in his English country home. And it is sweetly appropriate that such a picture should be the earliest in the **METROPOLITAN MUSEUM OF ART**'s photography collection, for it hints that the medium, even at birth, was recognising its ambition to be art's clearest, sharpest window on the world.

From there, of course, various paths beckoned. Photography might continue in this vein, attempting to capture the world in the most accurate manner possible – and for much of the later 19th century it did, documenting the world and its people. Portraiture had once been the preserve of the rich who could afford to pay for painted likenesses, but photography opened that field to the middle classes.

A glance at the collection of the **MUSEUM OF MODERN ART (MoMA)** will show a portrait of an actress, *Jenny Lind* (1840–51). It was taken by Louis-Jacques-Mandé Daguerre (1787–1851), the inventor of the Daguerreotype, a rival photographic process to the Calotype invented by Talbot. Decades on from this, in the 1930s, the portrait subject had become interestingly complicated, with the famous *People of the 20th Century* series by August Sander (1876–1964), of which MoMA owns many examples, marrying the depiction of individuals *and* social types. But a Victorian such as Talbot would have been keenly aware that beyond his window lay not merely people and places, but trouble – poverty, war, disease.

For those acutely aware of this, photography soon became the handmaiden of campaigning and social change. One of the earliest champions of this approach was Jacob Riis (1849–1914), who is famous for his photo-book exposé *How the Other Half Lives*. MoMA has several of his pictures that have since become famous, such as *Bandit's Roost, 59½ Mulberry Street* (1888), a shot of thieves lurking in an alleyway. This tradition blossomed in the mid-20th century, when some of the greatest photographers also considered themselves impassioned reporters.

Finally photography could content itself with the beauty of Talbot's window alone, and give itself over to art. This it also did from an early date, though few in the world of fine art were keen to accept it as an equal until well into the 20th century. Today the medium is ubiquitous, and there are photographers who exhibit in galleries as well as 'artists who use photography'; telling them apart is rarely easy.

From the collection of the **WHITNEY MUSEUM OF AMERICAN ART**, *Untitled (North by Northwest)* (2004), by Gregory Crewdson (1962–), shows a cityscape that might have been shot by an old-fashioned street photographer – were it not so strangely theatrical, so stage-managed. *Untitled* (2008) by Cindy Sherman would seem to be a society portrait of one of Manhattan's *grandes dames* – except that the face is so similar to the others in the series. So similar, indeed, to the artist's own. Photography, today, is changing once again, losing its love of truth, and revelling in fiction

Julia Margaret CAMERON
Zoe, Maid of Athens, 1866
METROPOLITAN MUSEUM
Cameron (1815–79) knew some of the greatest minds of Victorian England – Ruskin, Carlyle, Tennyson and Darwin.

She took to photography after her children gave her a camera in 1863, and the model for this picture, inspired by a poem by Byron was May Prinsep, her sister's adopted daughter.

William Henry Fox TALBOT
Wrack, 1839

Talbot, a polymath and a serious amateur botanist, first described his world-changing invention as 'photogenic drawing', and one can see why, looking at this fine silhouette of seaweed. The picture was made without a camera; the plant was simply laid on sensitised paper, blocking the light that darkened the rest of page.

Photography's infancy is a complex story of struggles between rival inventors – between different chemical treatments and different vehicles for the captured image. But what is striking about the Metropolitan's collection is the speed at which the medium found purpose. Documentation was among its first goals, and *Large Figures on the North Porch, Chartres Cathedral* (1852), by Henri Le Secq (1818–82), was among many of the photographer's pictures that won praise from the French government, which was keen to see the medium used to detail the nation's heritage. Important too was art: *Newhaven Fishwives* (1845) was the product of a collaboration between photographer Robert Adamson (1821–48) and painter David Octavius Hill (1802–70), one which resulted in many self-consciously artful scenes of social life.

Art took a back seat to documentation for most of the 19th century, but towards its end, technical advances encouraged another generation to promote photography as a legitimate fine art. One of the most accomplished was Alfred Stieglitz (1864–1946): *The Flatiron* (1904) shows a foggy view of the charismatic early skyscraper that had only recently been erected at the intersection of Broadway and Fifth Avenue. The public's belief in the veracity of the camera eye also encouraged progress in documentary around this time. *Newsies at Skeeter's Branch* (1910), by Lewis Hine (1874–1940), captures swaggering, smoking young newspaper vendors, and was taken for the National Child Labor Committee, an organisation established to protect children from exploitation in the workplace.

Photography's next step was a union of art and document. The Straight Photography movement saw practitioners celebrating the clarity that could be achieved with the photographic image, but borrowing ideas from avant-garde art. *Abstraction, Twin Lakes, Connecticut* (1916), by Paul Strand (1890–1976), uses the sharp shadows falling on a porch to create a Cubist pattern. Industry often fascinated this generation, but so too did the beauty of plants, animals and the human body. *Nude* (1925), by Edward Weston (1886–1958) manages to leave little hint of limbs and muscles, only the contour of a back that rolls evenly like a hill.

In Europe, meanwhile, many photographers were using handheld cameras to find beauty in the drama of street life. *Lovers in a Small Café in the Italian Quarter* (c 1932), by Brassaï (1899–1984), gives us a scene now synonymous with Paris. The growth of photojournalism ensured that this tradition remained powerful in the 1940s and 1950s, with talents like Henri Cartier-Bresson (1908–2004) becoming household names. *Shanghai* (1948) derives from his *Life* magazine commission to photograph the region's transition to Communist rule (the chaotic crush of queuing bodies suggests it did not go well). At this time fashion, film and advertising also elevated figures like Richard Avedon (1923–2004), whose portrait of *Marilyn Monroe* (1957) captures her body posed for the picture but her eyes and mind clearly, and tellingly, drifting.

The great age of photojournalism has perhaps passed, but the medium's ambition to document remains strong, even in those who consider themselves closer to artists than the photographers of yesteryear. In *Kolobrzeg, Poland* (1992), Rineke Dijkstra (1959–) simply shows an adolescent girl in a swimming costume against the pale background of the seashore. Although a full-length portrait, it leaves us wondering how much we can really know about her from a picture that gives so little away.

SEE ALSO

Nan GOLDIN
Ballad of Sexual Dependency, 1979–96
WHITNEY MUSEUM
Goldin (1953–) established her reputation with this unswervingly honest portrayal of life among the subcultures of downtown Manhattan in the early 1980s. The series is now regarded as a monument to the lost bohemia of the Lower East Side, and the years when AIDS ravaged the city.

The Metropolitan Museum's collection is rich in work from the early years of the medium and if you want a historical survey it is likely the place to start. However, **MoMA**'s collection covers much of the same ground, is in fact even larger, and its galleries are arguably more spacious and attractive. If you are hoping to see more recent work, and particularly that of emerging artist-photographers, MoMA should be your destination, particularly since it hosts an annual showcase of new talent. Among its recent exhibitions has been one of British photographer Paul Graham (1956–), whose work proves that contemporary photography has not been entirely consumed by trends more familiar in art. *New Orleans, 2004 (Woman Eating)* is an innovatively sequenced series of images, but is faithful to the long tradition of street photography.

The work of Vik Muniz (1961–), meanwhile, is more explicitly invested in art: *Narcissus, after Caravaggio* (2005) depicts a figure from the work of the 17th-century Baroque painter, but renders it by means of a collage of assorted junk; the photograph does the work of capturing the final arrangement.

A tour around New York's other contemporary art venues will no doubt introduce you to much more in this vein. The **WHITNEY MUSEUM** and the collection of the **GUGGENHEIM MUSEUM** (although the extent of the latter's collection is only intermittently visible) are good places to look. For American and European documentary photography from the mid-20th century, visit the **INTERNATIONAL CENTER OF PHOTOGRAPHY**. It has comprehensive archives of work by Robert Capa (1913–54), brother of the centre's founder, Cornell Capa (1918–2008), and by Chim (1911–56), Roman Vishniac (1897–1990) and Weegee (1899–1968). It also has work by Cartier-Bresson,

Andreas GURSKY
Times Square, New York,
1997
MOMA
Gursky (1955–) is among a
generation of German
photographers who were
influenced by Bernd and
Hilla Becher (see Chapter
19). He retains their
documentary approach, but
often uses it to describe,
from striking angles, the
sometimes strangely
inhuman contours of the built
environment.

Robert Frank (1924–), André Kertész (1894–1985)
and many others. Its temporary exhibitions can be
very lively affairs.

If you would like to see shots of what was once
affectionately known as 'little old New York', you
should visit the **MUSEUM OF THE CITY OF NEW
YORK**, which has a vast archive of photography.
Headlining this is the work of noted practitioners
such as Berenice Abbott (1898–1991), who is
renowned for her series *Changing New York*
(1935–9), which captured aspects of the city then
coming in and passing out of view. *'El', Second and
Third Avenue Lines* (1936) shows shadows falling
under one of the elevated railroad lines that were
soon dismantled after years of complaints from the
shopkeepers beneath. *Manhattan Bridge, Looking
Up* (1936) offers a vertiginous view of the bridge

that joined Brooklyn and Manhattan when it was
erected in 1909.

The museum also holds archives from
commercial organisations such as the Byron
Company, which, between 1890 and 1942, was
one of the city's pre-eminent photography studios.
Byron was nothing if not comprehensive, and its
archive will reveal everything from life during the
blizzard of 1899 to the interiors of Delmonico's,
a restaurant that was in its heyday in the early 20th
century. Straying slightly from photography, the
museum also has the most comprehensive set of
Currier & Ives prints in existence (see Chapter
11 on American Art), which shows the city as
its inhabitants liked to imagine it – before
photography pricked the illusion, and told them
the truth.

One of the running jokes in Frank Capra's 1936 film, *Mr Deeds Goes to Town*, concerns *Grant's Tomb* (1897), the sombre memorial to the Civil War leader General Ulysses S Grant, which overlooks Riverside Drive. The film's hero, the bright-eyed provincial Mr Deeds, is eager to pay a visit, but few of the cynics that he encounters have ever heard of Grant, or his tomb – they are too distracted by the momentum of the city. Ultimately, of course, Mr Deedes teaches them a thing or two, and Grant gets a visit, but times have changed, the city has even more dazzle than it once did, and one doubts he would have the same luck today persuading New Yorkers to hunt out older landmarks. We pay our respects to Frédéric-Auguste Bartholdi's **STATUE OF LIBERTY** (1875–84), the colossus of New York Bay, and, maybe if we are strolling in Central Park, we will pause to take in some of the curiosities of similar vintage that are hidden away there. But what of all the rest?

In fairness, the problem is not merely the city's myriad other distractions, but also the quantity and breathtaking quality of more recent installations. The Public Art Fund is a regular fount of lively temporary projects, and for more than 20 years the city's Metropolitan Transit Authority has also been brightening subway stations with impressive commissions: look for *Under Bryant Park* (2002) by Samm Kunce (1956–), which imagines life below ground and is, as the name suggests, under the **42nd St-Bryant Park station**; or the dynamic *Passing Through* (2004), by Al Held (1928–2005), at **Lexington Avenue-53rd Street**. Some of the city's recent endeavours have also exploded the boundaries of traditional public art, embracing landscape and architecture. The *National September 11 Memorial*, due to open in September 2011, will be a major landmark. Michael Arad (1969–) and Peter Walker (1932–) have devised two massive pools to sit within the footprints of the Twin Towers, and these will carry the largest manmade waterfalls in the country.

Already worth visiting is the *High Line* (2009 and ongoing), a feat of landscaping that has brought greenery to a long stretch of what was once a disused elevated railroad on the lower West Side of the city. So too is the *Irish Hunger Memorial* (2002), by Brian Tolle (1964–), in **Battery Park City**, which remembers victims of the Irish potato famine of the 19th century. It incorporates the ruins of an Irish stone cottage, as well as rocks and plants imported from across the Atlantic, and the whole memorial is canted so that a climb to the top is rewarded by a view of *Liberty* – just as hungry immigrants might have glimpsed her as their boat rounded the harbour.

If the city is getting too much and you want an excursion, try taking a trip to the **STORM KING ART CENTER**, the extraordinary collection of postwar sculpture set within 500 acres (202 hectares) of rolling landscape in upstate New York.

Gertrude **VANDERBILT WHITNEY**
Peter Stuyvesant, 1941
Stuyvesant Square, Manhattan
Peter Stuyvesant was the last Dutch governor of New York before the state was ceded to the British in the late 17th century. His monument stands in a park that was once part of his farm, and was sold to the city by his descendants. The sculptor of the statue also founded the Whitney Museum of American Art.

Augustus SAINT-GAUDENS
Sherman Monument,
1892–3
Grand Army Plaza
This magnificent gilded
statue is one of the last and
greatest works by the Beaux
Arts sculptor who gave
several enduring pieces to
New York's streets. It
commemorates the Civil War
leader General Sherman, and
the sculptor modelled it from
him directly, in a series of 18
lengthy sittings.

A day spent searching for public art in New York should begin **downtown**, at the southernmost tip of Manhattan. There you will not only have a clear view of the **STATUE OF LIBERTY**, but will also be able to see much more in the parks and plazas, and along the waterside paths that link **The Battery** and Battery Park City (in time, here, you will also be able to see the *National September 11 Memorial*). Looming largest in The Battery are the granite slabs of the *East Coast Memorial* (1963), designed by the architectural firm Gehron and Seltzer, which commemorate those who died in the Atlantic during the Second World War. Closer to the waterfront is the *American Merchant Mariner's Memorial* (1991) by Marisol (1930–), a moving figurative tribute that has one bronze figure reaching down as if to save another who appears and disappears with the waves. Less contemplative, meanwhile, is *Charging Bull* (1989), by Arturo di Modica (1941–), which drives on the financiers on nearby Wall Street.

Further north, but still below 23rd Street, **Washington Square** is an essential stop if you want to see an icon of the Beaux Arts period, *Washington Arch* (1889–92), by Stanford White (1853–1906), which was built to commemorate the centenary of George Washington's inauguration as president. Another tribute to the first president can be found at **Union Square**: the equestrian statue,

from 1852–5, by Henry Kirke Brown (1814–86), was the city's first important piece of public art, and it sits amidst a number of other 19th-century public sculptures. More distracting, though, is the *Metronome* (1999), by artist collaboration Jones/Ginzel (Kristin Jones [1956–] and Andrew Ginzel [1954–], which occupies the facades of two buildings at the south of the square. Its outlandish references to time are the subject of constant speculation by passersby.

Further north again, the finely kept **Madison Square Park** contains the *Farragut Monument* (1880), a collaboration between Augustus Saint-Gaudens (1848–1907) and Stanford White, commemorating Civil War hero David Farragut. The park also has a strong programme of projects by contemporary artists.

Midtown lends more Beaux Arts landmarks, most notably the extravagant *Transportation* (1912–14), by Jules-Felix Coutan (1848–1939), which has the god Mercury striding forth across the roofline of **Grand Central Terminal**. But the neighbourhood is also notable for the quality of its Art Deco: do not miss the *Transport and Human Endeavour* (1930) mural, by Edward Trumbull (1884–1968), for the lobby of the **Chrysler Building**. And from there go to the **ROCKEFELLER CENTER**: the golden *Prometheus* (1934), by Paul Manship (1885–1996), descending from Olympus

Alexander CALDER
*Le Guichet (The Box
Office)*, 1963
LINCOLN CENTER FOR THE
PERFORMING ARTS
New York is a good place to
see the late-career move of

Calder (1898–1976) into
monumental *Stabiles*.
Saurien (1975) stands at the
corner of 57th Street and
Madison Avenue, and there
are many more upstate, at
Storm King.

with the gift of fire, hovers in the sunken plaza at
the centre of the complex; nearby, on **Fifth Avenue**,
Atlas (1936–7), by Lee Lawrie (1877–1963) and
Rene Chambellan (1893–1955), lifts his globe. The
exteriors of many of the buildings around the
Rockefeller Center are set with excellent relief
sculpture, but it is worth going into the lobby of **30
Rockefeller Plaza** (in the Rockeller Center) to see
the murals by José Maria Sert (1874–1945).

To continue exploring midtown, visit the
UNITED NATIONS HEADQUARTERS if you want
to see an assortment of mid-century artwork,
including pieces by Henry Moore (1898–1986),

Norman Rockwell (1894–1978) and Marc Chagall;
then perhaps the **LEVER HOUSE ART
COLLECTION**, on **Park Avenue**, which often
accompanies exhibitions in its lobby with
adventurous public art outside. On **Sixth Avenue**,
look out for three monumental renditions of the
Venus de Milo, *Looking Towards the Avenue* (1989)
by Jim Dine (1935–); and the famous *Love*, by
Robert Indiana (1928–), which, as a motif,
originally decorated one of MoMA's Christmas cards
in 1966, and was turned into a sculpture in 1999.

The public art in **Central Park** is best
approached from the southeast, as here you can

Doug and Mike STARN
See it split, see it change,
2009
South Ferry Terminal
One of the more monumental
examples of the MTA's Arts
for Transit scheme, the fused
glass walls by identical twins

Doug and Mike Starn
(1961–) draw on imagery of
the natural life and history of
the site above ground:
Battery Park. There is also a
topographical map of
Manhattan in 1640, overlaid
with a contemporary view.

begin by exploring **Grand Army Plaza**, then stroll up the winding path past the zoo, taking in the entertaining *Delacorte Clock* (1964–5) by Andrea Spadini (1912–83). At the heart of the park is **The Mall**, which is lined with monuments to cultural heroes including Robert Burns and William Shakespeare. At its conclusion are a set of stairs that will take you through the **Bethesda Terrace Arcade**, which is decorated with gorgeous, newly restored tiles by Minton; it opens out onto a square which contains a fountain crowned with the *The Angel of the Waters* (1868) figure by Emma Stebbins (1815–82).

From here on in you can wander at will and be sure to come across some fabulous hidden treasures, but do look out for *Alice in Wonderland* (1959), by José de Creeft (1884–1982), a bronze that invites children to clamber all over it and has Alice presiding on a giant mushroom. If you are visiting in the summer, it is worth going to the roof of the **METROPOLITAN MUSEUM OF ART**, not least for the view, but also for the temporary installations of outdoor sculpture.

The notable public artworks elsewhere in the city will probably require more adventurous travels, though the *Duke Ellington Memorial* (1997), by Robert Graham (1938–2008), stands at the northwest corner of Central Park. Hoisted on a stage-like platform, it shows the entertainer next to a grand piano. Further into Harlem, in a playground

at **Second Avenue and 126th Street**, is the mural *Crack is Wack* (1986), by Keith Haring, his trademark outlined figures vibrating with energy.

If you were to take a tour of the outlying boroughs, there are a few other sites to visit. **Staten Island** lost a disproportionate number in the attacks of 9/11, and it has a rousing memorial to those victims on its North Shore Esplanade near the **Ferry Terminal**: *Postcards* (2004), by Masayuki Sono (1969–), rhymes the shape of those messages home with wings that hoist the spirit aloft. In the **Bronx**, the late 19th-century **Woodlawn Cemetery** contains work by a number of prominent sculptors. **Brooklyn**, similarly, has **Green-Wood Cemetery**, Prospect Park and **Grand Army Plaza** as

its principal homes for more traditional, late 19th- and early 20th-century sculpture.

If you want something more unconventional and are out strolling the boardwalk at **Coney Island**, you cannot miss the *Parachute Jump* (1939), a tower which has evolved from amusement ride to derelict ruin to renovated and beloved local landmark. **QUEENS** offers the **SOCRATES SCULPTURE PARK**; the **NOGUCHI MUSEUM**, devoted to the Japanese-American sculptor Isamu Noguchi; and, in **Flushing Meadows Corona Park**, the *Unisphere* (1964), by Gilmore D Clarke (1892– 1982), a massive globe that was one of the centrepieces of the 1964 World's Fair, and is today the unofficial logo of the borough.

REFERENCE
SECTION

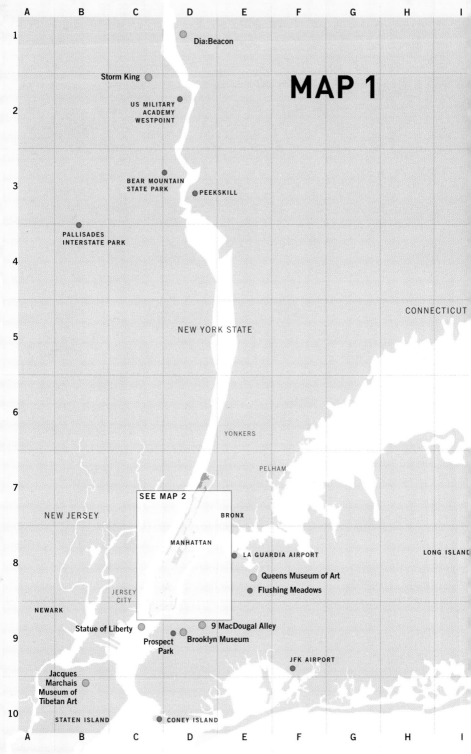

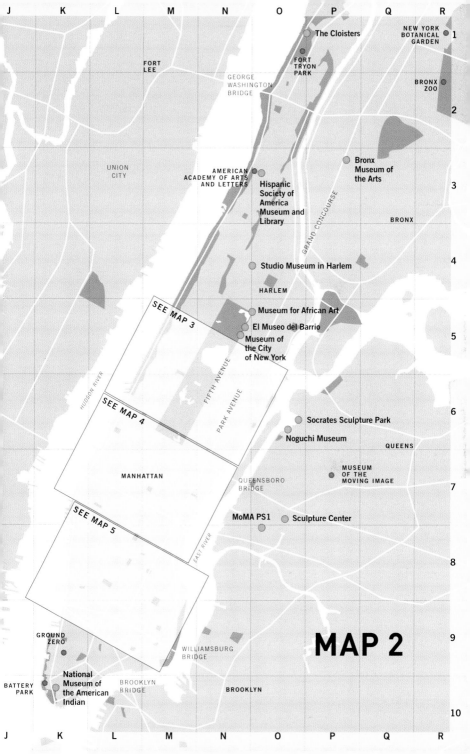

MAP 2

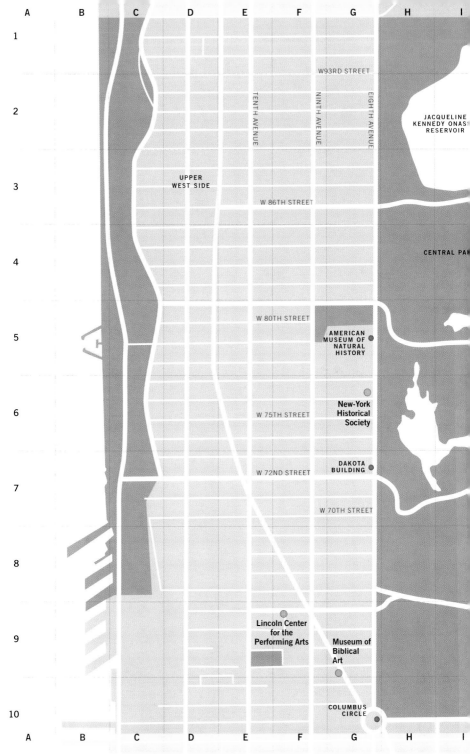

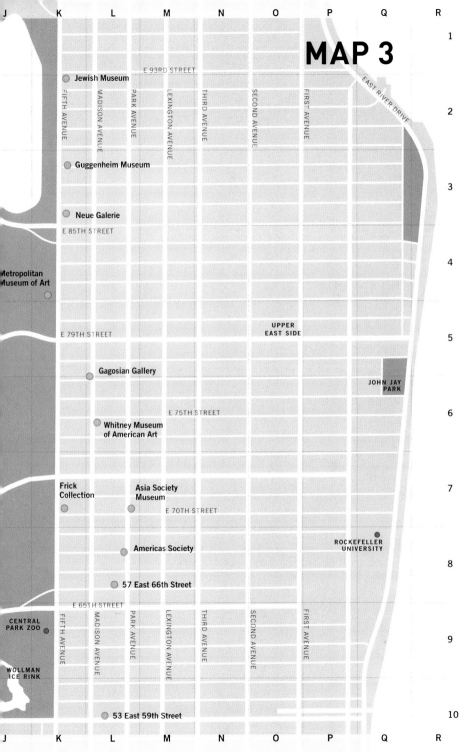

MAP 3

E 93RD STREET

Jewish Museum

FIFTH AVENUE
MADISON AVENUE
PARK AVENUE
LEXINGTON AVENUE
THIRD AVENUE
SECOND AVENUE
FIRST AVENUE

EAST RIVER DRIVE

Guggenheim Museum

Neue Galerie

E 85TH STREET

Metropolitan
Museum of Art

E 79TH STREET

UPPER
EAST SIDE

Gagosian Gallery

JOHN JAY
PARK

E 75TH STREET

Whitney Museum
of American Art

Frick
Collection

Asia Society
Museum

E 70TH STREET

Americas Society

ROCKEFELLER
UNIVERSITY

57 East 66th Street

E 65TH STREET

FIFTH AVENUE
MADISON AVENUE
PARK AVENUE
LEXINGTON AVENUE
THIRD AVENUE
SECOND AVENUE
FIRST AVENUE

CENTRAL
PARK ZOO

WOLLMAN
ICE RINK

53 East 59th Street

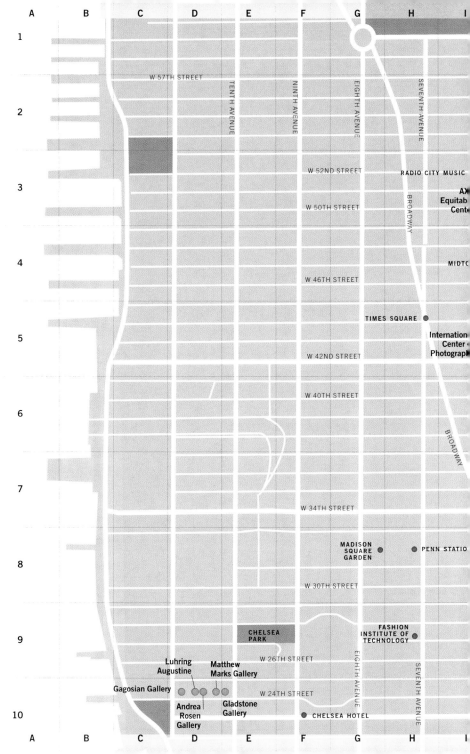

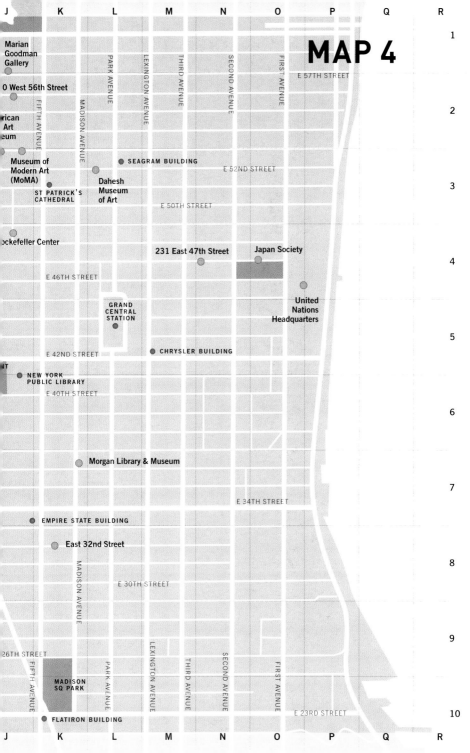

MAP 4

Marian Goodman Gallery

0 West 56th Street

rican Art eum

Museum of Modern Art (MoMA)

ST PATRICK'S CATHEDRAL

Dahesh Museum of Art

SEAGRAM BUILDING

ckefeller Center

231 East 47th Street

Japan Society

United Nations Headquarters

GRAND CENTRAL STATION

CHRYSLER BUILDING

NEW YORK PUBLIC LIBRARY

Morgan Library & Museum

EMPIRE STATE BUILDING

East 32nd Street

MADISON SQ PARK

FLATIRON BUILDING

E 57TH STREET

E 52ND STREET

E 50TH STREET

E 46TH STREET

E 42ND STREET

E 40TH STREET

E 34TH STREET

E 30TH STREET

26TH STREET

E 23RD STREET

FIFTH AVENUE

MADISON AVENUE

PARK AVENUE

LEXINGTON AVENUE

THIRD AVENUE

SECOND AVENUE

FIRST AVENUE

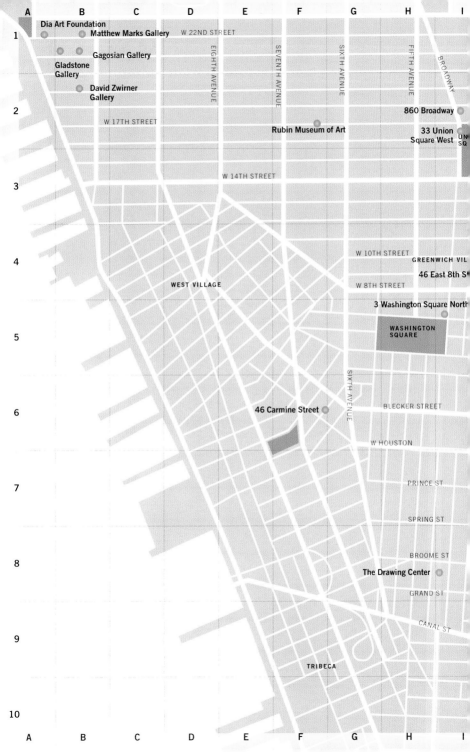

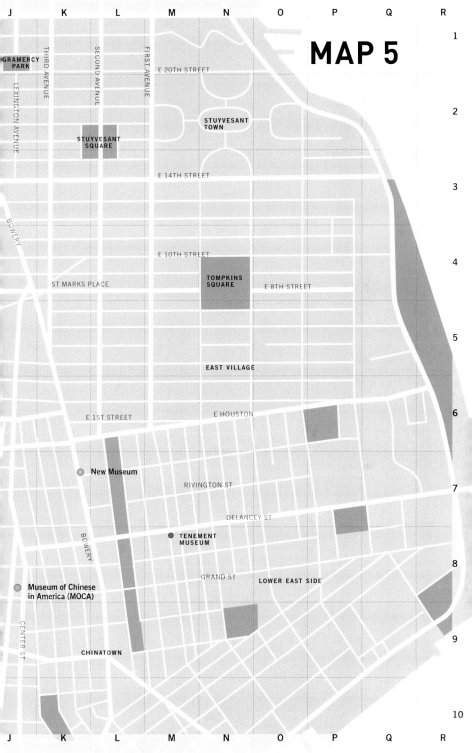

*numbers in **bold** indicate that an artist's work is illustrated on these pages*

*numbers in **bold** indicate that a museum's collection is illustrated on these pages*

David Zwirner Gallery
519 West 19th Street, NY 10011
+1 212 517 8677
525 & 533 West 19th Street,
NY 10011
+1 212 727 2070
www.davidzwirner.com/
Tu–Sa: 10:00–18:00
p207
MAP 5: 2 B

Dia Art Foundation
535 West 22nd Street, NY 10011
+1 212 989 5566
www.diacenter.org/sites/site_in_nyc
Phone for details
p190
MAP 5: 1 A

Dia:Beacon
3 Beekman Street, Beacon,
NY 12508
+1 845 440 0100
www.diabeacon.org/sites/main/
beacon
12 November 2010–11 April 2011:
Fr–Mo: 11:00–16:00
14 April 2011–17 October 2011:
Th–Mo: 11:00-18:00
pp190, **192–3**
MAP 1: 1 D

The Drawing Center
35 Wooster Street, NY 10013
+1 212 219 2166
www.drawingcenter.org/
Fr–We: 12:00–18:00
Th: 12:00–20:00
p207
MAP 5: 8 I

East 32nd Street
(between Madison Avenue & Fifth
Avenue), NY 10016
Not open to the public
p196
MAP 4: 8 K

Frick Collection
1 East 70th Street, NY 10021
+1 212 288 0700
www.frick.org/
Tu–Sa: 10:00–18:00;
Su: 11:00–17:00
pp68, **76–7**, 78, 90, **91–3**, 94,
102–3, 104, **109**, 110, 113,
114–15, 187
MAP 3: 7 K

Gagosian Gallery
522 West 21st Street, NY 10011
+1 212 741 1717
555 West 24th Street, NY 10011
+1 212 741 1111
980 Madison Avenue, NY 10075
+1 212 744 2313
www.gagosian.com
Tu–Sa: 10:00–18:00
p207
MAP 5: 1 B
MAP 4: 10 D
MAP 3: 5 L

Gladstone Gallery
530 West 21st Street, NY 10011
+1 212 206 7606
515 West 24th Street, NY 10011
+1 212 206 9300
www.gladstonegallery.com
Mo–Fr: 10:00–18:00
p207
MAP 5: 1 B
MAP 4: 10 D

Guggenheim Museum
1071 Fifth Avenue (at 89th Street),
NY 10128
+1 212 423 3500
www.guggenheim.org/
Su–We: 10:00–17:45;
Fr: 10:00–17:45;
Sa: 10:00–19:45
p132, **142**, 144, 152, **153**, 154,
162, 167, **181**, 188, 190, 200, **201**,
207, 212
MAP 3: 3 K

**Hispanic Society of America
Museum and Library**
Audubon Terrace, Broadway
(between 155th & 156th Streets),
NY 10032
+1 212 926 2234
www.hispanicsociety.org/
Tu–Sa: 10:00–16:30;
Su: 13:00–16:00
pp52, 60, 104, **105–7**
MAP 2: 3 O

International Center of Photography
1133 Avenue of the Americas (at
43rd Street), NY 10036
+1 212 857 0000
www.icp.org/
Tu–Th, Sa, Su: 10:00–18:00;
Fr: 10:00–20:00
pp212–3
MAP 4: 5 I

**Jacques Marchais Museum
of Tibetan Art**
338 Lighthouse Avenue, Staten
Island, NY 10306
+1 718 987 3500
www.tibetanmuseum.org/
Th–Su: 13:00–17:00
pp42, 51
MAP 1: 10 B

Japan Society
333 East 47th Street, NY 10017
+1 212 832 1155
www.japansociety.org/
Gallery (during exhibition dates):
Tu–Th: 11:00–18:00;
Fr: 11:00–21:00;
Sa–Su: 11:00–17:00
p42
MAP 4: 4 O

Jewish Museum
1109 5th Ave (at 92nd Street),
NY 10128
+1 212 423 3200
www.thejewishmuseum.org
Sa–Tu: 11:00–17.45;
Th: 11:00–20:00
Fr: 11:00–16:00
p**167**, 181, 190, 207
MAP 3: 2 K

Lever House Art Collection
390 Park Avenue, NY 10022
www.leverhouseartcollection.com
Mo–Fr: 11:00–19:00 & by
appointment
p217
MAP 4: L 2

**Lincoln Center for
the Performing Arts**
NY 10023
+1 212 875 5456
www.lincolncenter.org
Phone for details
p**217**
MAP 3: 9 F

Luhring Augustine
531 West 24th Street, NY 10001
+1 212 206 9100
www.luhringaugustine.com/
September–June:
Tu–Sa: 10:00–18:00
July–August:
Mo–Fr: 10:00–17:30
p207
MAP 4: 10 D

New-York Historical Society
170 Central Park West, NY 10024
+1 212 873 3400
www.nyhistory.org/web/
Tu, We, Th, Sa: 10:00–18:00;
Fr: 10:00–20:00;
Su: 11:00–17:45
pp116, **124–5**
MAP 3: 6 G

Noguchi Museum
9-01 33rd Road (at Vernon
Boulevard), Long Island City,
NY 11106
+1 718 204 7088
www.noguchi.org/
We–Fr: 10:00–17:00;
Sa–Su: 11:00–18:00
pp181, 219
MAP 2: 6 O

Queens Museum of Art
New York City Building, Flushing
Meadows Corona Park, Queens,
NY 11368
+1 718 592 9700
www.queensmuseum.org/
We–Su: 12:00–18:00;
Fr until 20:00 in July & August
p207
MAP 1: 8 E

Rockefeller Center
NY 10111
+1 212 632 3975
www.rockefellercenter.com
Phone for details
pp216–17
MAP 4: 4 J

Rubin Museum of Art
150 West 17th Street, NY 10011
+1 212 620 5000
www.rmanyc.org/
Mo, Th: 11:00–17:00;
We: 11:00–19:00;
Fr: 11:00–22:00;
Sa–Su: 11:00–18:00
pp42, **50**, 51
MAP 5: 2 F

Sculpture Center
44–19 Purves Street, Long Island
City, NY 11101
+1 718 361 1750
sculpture-center.org/
Th–Mo: 11:00–18:00
p207
MAP 2: 7 O

Socrates Sculpture Park
32-01 Vernon Boulevard (at
Broadway), Long Island City,
NY 11106
+1 718 956 1819
www.socratessculpturepark.org/
Mo–Fr: 10:00–18:00
p219
MAP 2: 6 O

Statue of Liberty
Liberty Island, NY 10004
+1 212 363 3200
www.nps.gov/stli/
By ferry, phone for details
p42, 78, **79**, 214, 216
MAP 1: 9 C

Storm King Art Center
Old Pleasant Hill Road,
Mountainville, NY 10953
+1 845 534 3115
www.stormking.org/
April–mid-November:
We–Su: 10:00–17:00
pp190, 214, 217
MAP 1: 2 C

Studio Museum in Harlem
144 West 125th Street, NY 10027
+1 212 864 4500
www.studiomuseum.org
Th–Fr: 12:00–21:00;
Sa: 10:00–18:00;
Su: 12:00–18:00
pp181, 190, 207
MAP 2: 4 N

United Nations Headquarters
NY 10017
+1 212 963 8687
http://visit.un.org
Daily guided tours:
Mo–Fr: 09:45–16:45
pp154, 217
MAP 4: 4 O

Whitney Museum of American Art
945 Madison Avenue (at 75th
Street), NY 10021
+1 212 570 3600
www.whitney.org/
We, Th, Sa, Su: 11:00–18:00;
Fr: 13:00–21:00
pp116, 144, 151, **152**, 162, **166**,
167, 168, **169–71**, **180**, 181, 188,
190, **191**, 195, **197**, **200**, 202, **206**,
207, **207**, 208, **212**
MAP 3: 6 L

Reader's Notes

AN IQON BOOK

This book was designed and produced by
Iqon Editions Limited
Sheridan House
112 – 116a Western Road
Hove BN3 1DD

Publisher, concept and direction:
David Breuer

Design and cartography:
Isambard Thomas

Editor and Picture Research:
Caroline Ellerby

Printed in China

First published in the United States
of America in 2011 by
Skira Rizzoli Publications, Inc.
300 Park Avenue South
New York, NY 10010

www.rizzoliusa.com

Copyright © 2011 Iqon Editions Ltd

2011 2012 2013 2014 / 10 9 8 7 6 5 4 3 2 1

ISBN: 978-0-8478-3627-7

Library of Congress Control Number:
2010932872

Cover:
Edward Hopper, *From Williamsburg Bridge*
(detail), 1928
Image © The Metropolitan Museum of Art /
Art Resource / Scala, Florence